The Monkey King

72 Transformation of the Mythical Hero

Introduced and Edited by
Vincent Zhao

INSIGHT EDITIONS

San Rafael, California

The Monkey King

Preface
Vincent Zhao

Searching for the Monkey King, Searching for Oneself
"The Monkey King is me, the undefeatable me, but I still lost the battle to loneliness without knowing." Listening to this song one afternoon six years ago, I escaped my crazily busy life and considered the Monkey King in my mind. It was the first time I thought about the extended meanings of this image. The adventure was set one thousand and three hundred years ago; the fiction was written four hundred and sixty years ago. I had distanced myself from others' definitions, literary depictions, and commercial promotions and tried to confront this icon who has exemplified unyielding pursuit of freedom and awe-inspiring courage to defy the conventions.

"I have never succeeded in capturing the Monkey King in my mind." I still remember what Liu Dongzi said to me in pity some years ago. He is the most passionate about the Monkey King of everyone that I know. How could it be that the more we know about the Monkey King and what he emblematizes, the more difficult it becomes to identify him? If he is a visible totem, a well-known symbol, then we will find it easy to draw him, like those who have made a living on this character over the years.

Two years ago, I heard the song again in a live concert. When tens of thousands of people were screaming in ecstasy in the stadium, I was boldly expressing my emotions with them. At that moment I suddenly found that the image of the Monkey King had become clearer and clearer in my mind. It occurred to me that we could not capture the Monkey King not because of his multiple transformations or fictive nature, but because we knew nothing about ourselves. When struggling in this secular world as mortals, the extraordinary self will be outpowered by the loneliness. We are no longer the "Great Sage, Equal of Heaven" who travels on clouds without being afraid of anything.

In this sense, the Monkey King is nothing but a feeling, the true self in our mind.

At this thought, I determined to produce a book for all those who are searching for a true self like me. I have invited seventy-two artists with their own knowledge of and passions for the Monkey King—in alignment with the seventy-two transformations he is capable of. I asked everyone to put down the Monkey King in their mind on paper, without caring much about the subject, theme, and creative approach—because the Monkey King has never subjected himself to any restraint. Moreover, I asked everyone to say something about how he or she interprets the Monkey King—because everyone has a distinctive interpretation.

I had full confidence that this would be an interesting and remarkable book. Therefore, I submitted the proposal for this project to the publisher after swiftly collecting my thoughts. The blurry concept in my mind excited me so much that I could even put up with my discomfort with the overwhelming popularity of this subject and have the patience to prove the international acceptance and global influence of the Monkey King subject. I hope that the publication of this book will give me an unprecedented sense of fulfillment and endow me with strength.

It always takes a long time to produce a book. To my pleasure, more and more friends have embarked on this journey with me and remained passionate and enthusiastic along the way. The excitement I experienced when receiving the works from these friends in the past year could equal that of the Monkey King when he met evil spirits on his way to the west one thousand and three hundred years ago. Yes! I want to surprise the readers. Throughout the process, I always kept in mind that every page of this book is intended to amaze the readers, and that no unqualified work will be found in this book. I don't want anybody to have any bad experience with the book on Monkey King. We have already been fed up with so many crappy movies, cartoons, and works based on this subject, so I want my book to be different.

My friends have helped me a lot with this book. Here, I want to extend my heartfelt thanks to four friends of mine in particular—Su Haitao, Sun Zhenhua, Sun Guoliang, and Liu Yong. They have not only offered their own works, but also introduced this proposal to their friends, trying to invite more artists to get involved. Thanks to their contribution, they have not only inspired me but also added diversification to this book. Besides, I also want to thank some friends on the deviant ART forum, including Thierry Doizon, Sonny Liew, Nick Edwards, and many other artists from all over the world. Their contributions have infused varied styles into this book and attracted more foreign readers to pay attention to this Chinese hero. These seventy-two contributors have redefined the original image,

reinterpreted what he stands for, reproduced some well-known stories, and presented their imaginings of the Monkey King in the post–Journey to the West age. I believe their craftsmanship, creativity, and ideas in this book will be perceived by readers; we really appreciate their efforts.

Of course, this book also has some imperfections. Some artists failed to submit their works or demonstrate their true competence when rushing through the works due to the tight schedule. Therefore, their works could not be showcased in this book. I'm really sorry for their unpaid passions and efforts. However, just as the Monkey King can actually perform more than seventy-two transformations, what the figure "72" signifies is something countless and endless. Therefore, this book "Seventy-two" is only a start. If it turns out to be well received as expected and succeeds in attracting more people, I believe that we'll have good reasons to continue with this proposal and produce more titles with similar styles.

Just as the lyric goes, "after retrieving the Buddhist sutras from the west, we can still reorient to the east. Let's save the planet once again, shall we?"

Let us hope that we can all find the Monkey King in our mind and find the true self to save ourselves and the planet.

Vincent Zhao
March 1, 2011

72 Contents

Berk Öztürk

Screen Name_**berkozturk** Profession_**I'm currently studying in Marmara Fine Arts University**

Öztürk has been drawing since he was little, and he has been illustrating for three years now for children's books and magazines. He loves dark and melancholic themes.

http://www.berkozturk.deviantart.com barontieri@gmail.com

Monkey King in My Eyes

As a Turk, I have heard of many Asian legends. For geographical and historical reasons, I was much influenced by Asian culture during my childhood. Among all these legends, *Journey to the West* is the most lively and appealing, all thanks to the charisma of the Monkey King. He is an exemplification of the adventurous and courageous spirits. To me, his miraculous journey is no less interesting than "The Adventures of Sinbad" in *A Thousand and One Nights*. The Monkey King is also known as "Traveler," because he is always on the road. Whether it is his 108,000-*li* flip or his pilgrimage with the other three characters, he can never take a break. I think maybe it is because he has spent too much time in the rock or in the prison under the Five-finger Mountain. Therefore, once freed, he is reluctant to stop his journey.

He took his journey hoping to experience the beauty and ugliness of the world, which impressed me most.

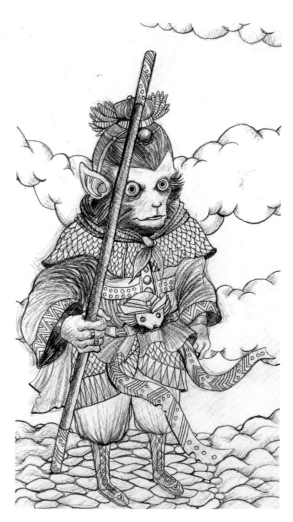

Monkey King in My Work

My job is to draw for children. It was when I was a child that I first saw the Monkey King. Therefore, the Monkey King in my illustration may seem to be a little childish. But I still shaped him as a "traveler" who wears martial attire and holds a golden band. Rains and fogs are trying to shroud him from behind, and the road ahead is ragged, which indicates he is ready to embark on a challenging journey. I have used my favorite yellow as the dominant color, which is also a good choice for the narration of ancient legends.

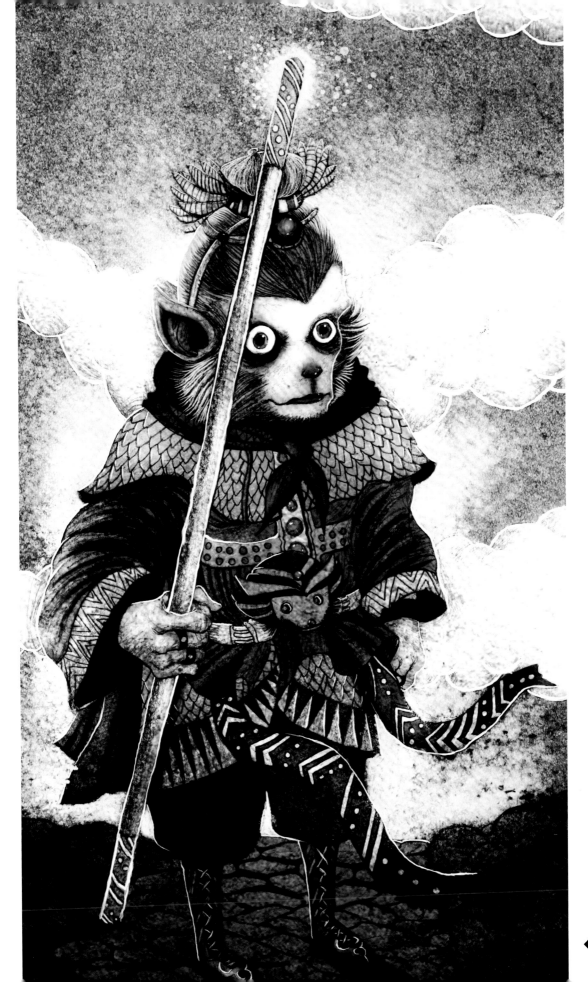

Chen Dawei

Screen Name_**E9** Profession_**art executive for game development**

Chen is a game development artist, painter, illustrator, webpage designer, graphic designer, and advertisement planner.

http://www.e9studio.com ✉ hi.david@e9studio.com

Monkey King in My Eyes

Monkey King was in every sense a heretic. There is a Chinese saying, "jumping out from the rock," which refers to someone parentless and undisciplined, and Monkey King perfectly fits the description as an orphan born from a rock. That is to say, he is a loner since birth and has no idea about cultivation and parental love. Thus, all the conceptions concerning authority and nobleness, richness and poverty, and status are alien to him. Instead, he believes that all beings are born equal. In this sense, he is a natural "revolutionary." Haha!

Monkey King in My Work

The Monkey King is also known as the "Handsome Monkey King." In my opinion, the best-looking monkey is the golden snub-nosed monkey in Sichuan, on which the Monkey King in my work is based. There is an evident trend to imagine the Monkey King as an imposing and powerful ape, which is intended to accentuate his heroism during the havoc in heaven. However, I think that even a lovely monkey without an intimidating stature is also likely to do something extraordinary. Haha! Maybe that's because I always prefer heroes with ordinary looks but awesome skills.

Now let's come to the conception part. Like most artists, I have also chosen the scene when the Monkey King created a tremendous uproar in the heavenly palace. However, most artists focus on the battling process between Monkey King and heavenly guards, which means that all the characters are in a variety of combat postures. Such pictures are too common to be impressive. Thus, I have selected another scene, when Monkey King returns to the Mountain of Flowers and Fruit after breaking into the Festival of Immortal Peaches. The Heavenly Palace felt so offended that some heavenly troops were sent to subdue him. These troops located the Monkey King, who was enjoying his peach with ease, and were about to throw themselves on him. In response, the Monkey King unhurriedly produced his golden band from the ear. My work is to capture this very moment, when a fierce battle would break out in a flash.

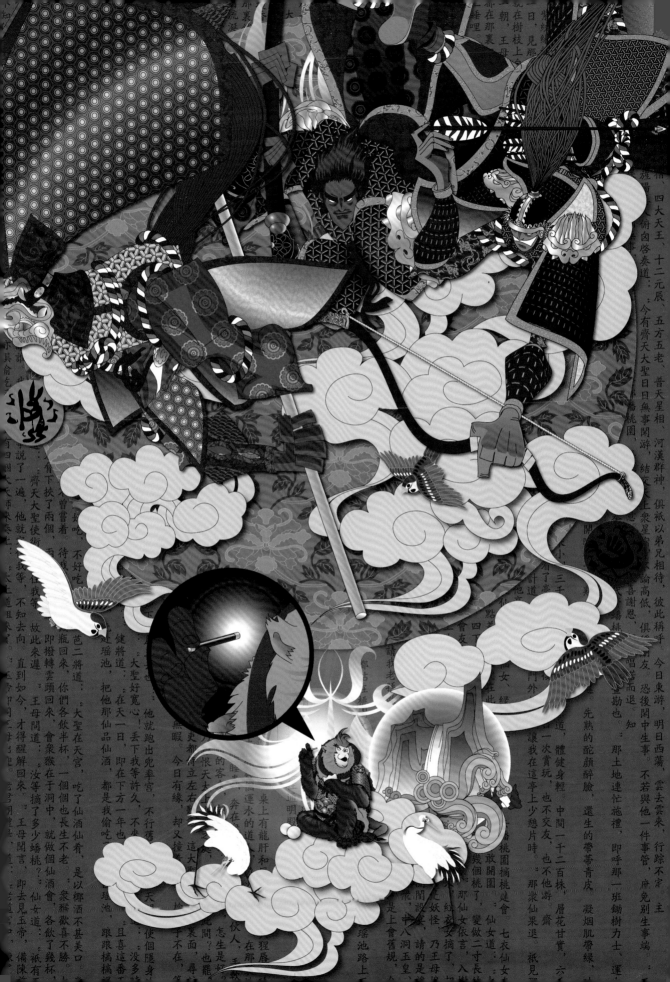

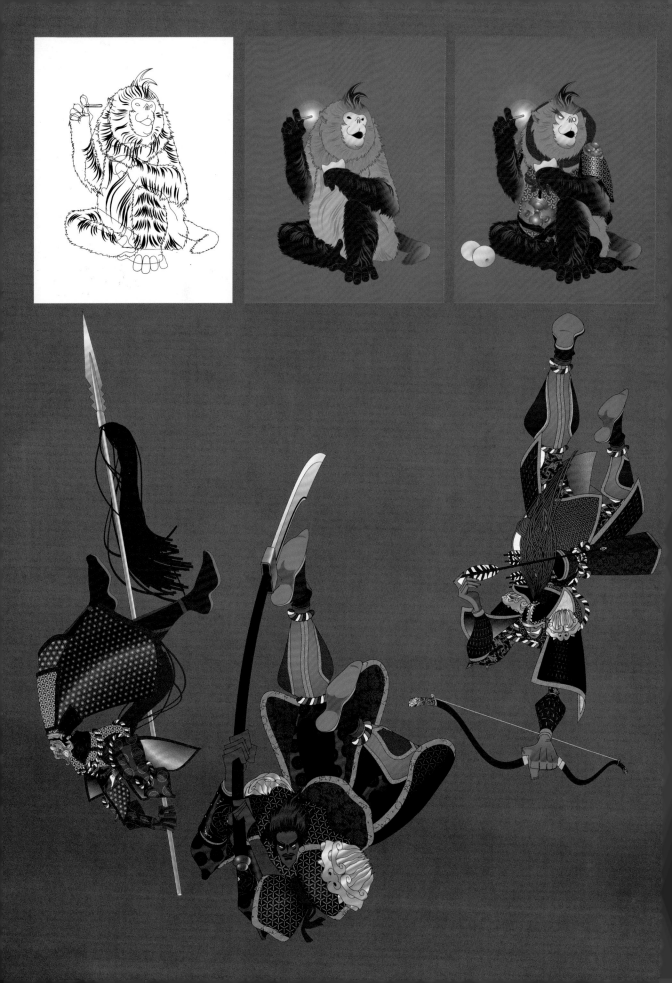

to transform the golden snub-nosed monkey into the Monkey King.

Step 4: One of the heavenly generals.

Step 5: A second heavenly general.

Step 6: A third heavenly general.

Step 7: The first draft featured a chaotic composition, which was unwanted.

Step 8: The composition in this draft was acceptable but still lacked details.

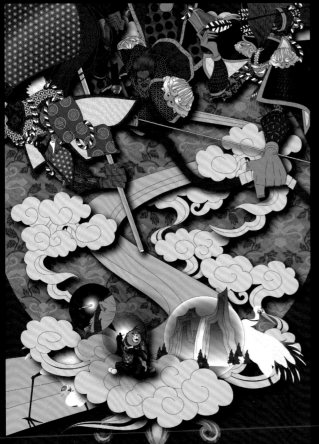

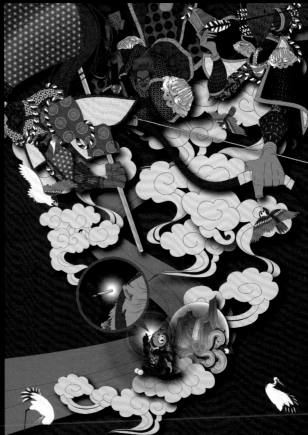

Chen Wei

Screen Name_**cacooca** Profession_**graffiti artist, concept artist**

Chen set up the brand "cacooca" in 2005, focusing on design toys, fashion toys, and derivative products.

http://cacooca.blogbus.com cacooca@hotmail.com

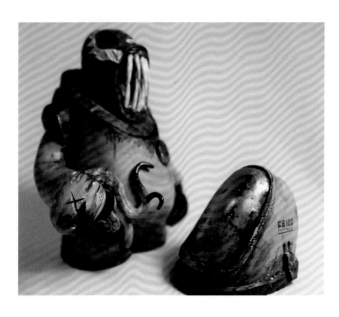

Monkey King in My Eyes

There are incarnations of supernatural power in both China and other countries. The Monkey King is one of them. Fans of *Journey to the West* must be passionate about him. I have seen many interpretations of the Monkey King, and contemporary styles have prevailed in the recent decades. I want to start with a well-developed, distinctive concept so that my illustration will be distinct from others. Therefore, I focused on the spiritual realm when researching this character. I have identified some defining features of the Monkey King. I love him for his almightiness, resourcefulness, and his courage to safeguard justice and subdue evil spirits. Therefore, I have decided to incorporate some mechanical elements into the illustration. After all, we are living in the age of machines.

Monkey King in My Work

I have seen many interpretations of the Monkey King. For a long time, I have always wanted to present to the audience a Monkey King featuring my trademark style or technique. Recently, I have been experimenting with outer space subjects. Therefore, I decided to assign my Monkey King to subdue the evil spirits on other planets.

In the stage of concept development, I decided to retain only the most classical facial features and to invest much effort on the texture and details while keeping the sense of volume in mind. However, my top concern was how to capture his spiritual world. This Monkey King is mysterious, different, but still recognizable. I wanted to respect the prevailing assumptions about him when highlighting his distinctive properties and inner world.

Having decided on the concept, I chose to make a three-dimensional toy instead of a graphic illustration to exhibit my Monkey King. Therefore, I spent two days in model-making, mainly by using engraving clay to create the rough mold and elaborating on the details with resin clay. After that, I finished the application and detailing processes within a day. Violence is not the highlight. This rendition is primarily intended to enable the readers to feel his spiritual strength.

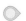

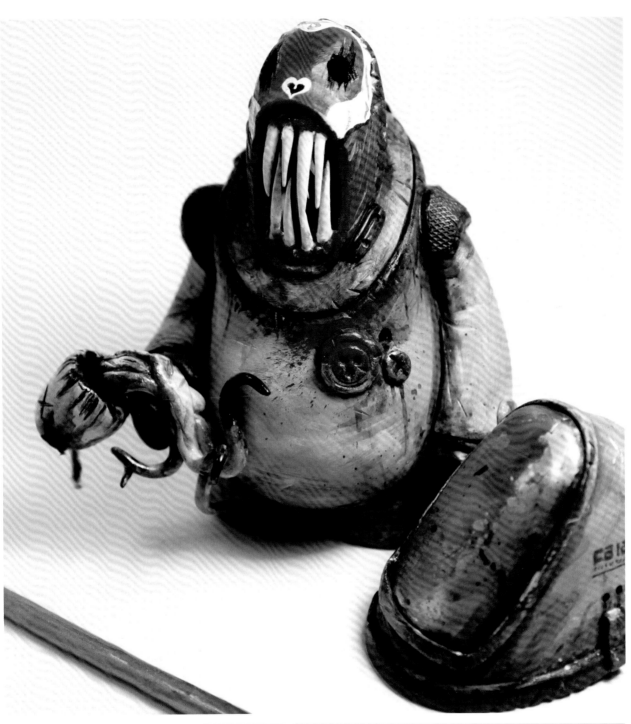

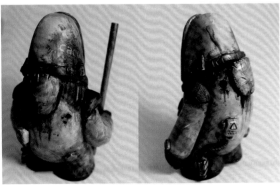

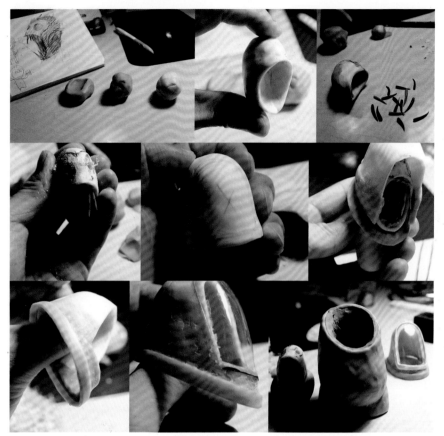

Step 1: I drew several drafts before determining the facial expressions and body ratios of the Monkey King. Afterward, I began preparing materials including resin clay, engraving clay, resin primer, etc. Different materials were applied to different body parts. For example, polymer clay was used to make the helmet, which featured complex curves; engraving clay was used as the base for the body; while resin clay was applied to the surface so that I could capture the details during the elaborating process.

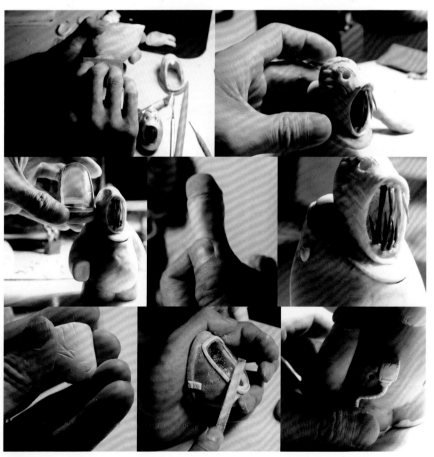

Step 2: After finishing the basic structure, I polished the surface before starting to make tiny parts. I chose P 120 abrasive paper to retain the coarse surface. Later, I started to etch on the armor, which was a highlight in the details. This process would help make the figure look more real. The figure would have a good sense of texture even though only flat color was used.

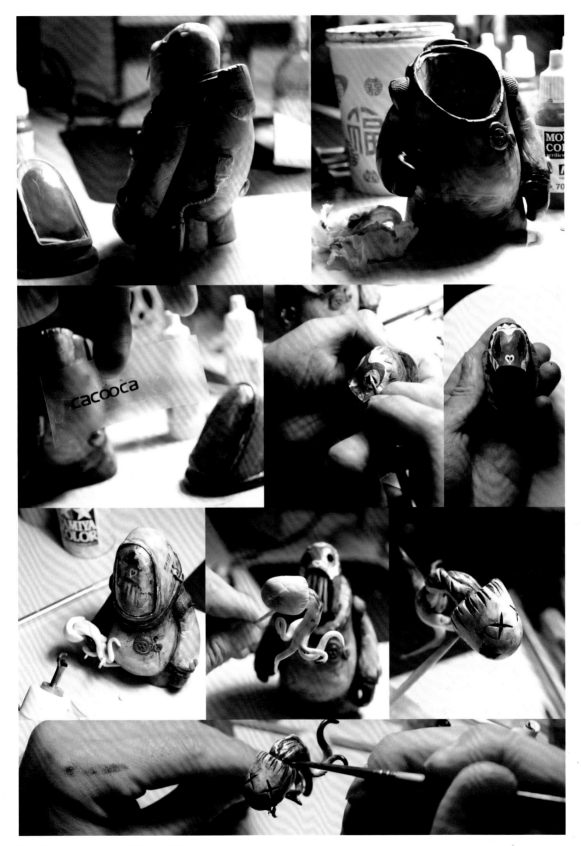

Step 3: I chose three paint vehicles, applying matte texture to the armor, chromeplate to the armor's PVC surface, and gloss agent to the aliens. Therefore, the figure has a stronger sense of volume.

Chu Wanchun

Screen Name_**Fish Bone, Divine Spine, and Jet Black Fish, etc.** Profession_**art director**

Chu has worked in game design since 2006.

http://blog.sina.com.cn/chuchu1225 kkukk1225@hotmail.com

Step 1: After finishing several drafts, I decided to depict the scene of the Monkey King combating the Bull Devil.

Step 2: The withering tree in the draft's background looked dull. Therefore, I painted a bamboo forest instead. Somewhat screened by the bamboo leaves, the monkey and the bull could be highlighted.

Step 3: I moved on to the drawing of the monkey. I made him bigger on the basis of the draft and put a lot of effort into depicting his facial expressions.

Monkey King in My Eyes

Journey to the West is one of the most oustanding novels on gods and spirits in Chinese literature. It crystallizes the ultimate imagination of ancient China and gives birth to a classical image—the Monkey King. He possesses some magical skills and prowess that may cause serious destruction; he is unrestrained, refusing to submit to authority and daring to defy the powerful heaven; he has a firm belief and never holds back despite all the hardships and difficulties on his journey to the west. He is the first protagonist in *Journey to the West* in the real sense.

Monkey King in My Work

Ever since my childhood, I have been awed by the wide imagination exemplified by *Journey to the West*. It is out of hope to illustrate the Monkey King in my heart that I came to be addicted to drawing. To me, the Monkey King must be a courageous warrior of an undisciplined nature and impressive intelligence, holding his head up in front of high-rank deities and fierce rivals.

I used to work in the cartoon industry. Years ago, I had drawn a full-length cartoon based on *Journey to the West* on commission. However, this project came to an abrupt end due to the agent's financial issues. The drafts were all gone, which was a great pity to me. Having failed to come to terms with my frustration, I stopped drawing and switched to other professions.

It was five years later that I picked up the drawing pen again when entering the game industry. Therefore I really appreciate the opportunity to participate in the project this time. After serious considerations, I chose to demonstrate the monkey's martial valor through the fierce battle between him and the Bull Devil. I adopted a black-and-white approach for two reasons: firstly, this battle is the most impressive among all the combats in *Journey to the West*; secondly, this is intended to appease my etching desires to draw cartoons. It is also hoped that readers would like the two illustrations of Monkey King, whose qualities might not have been fully expressed due to my limited capabilities. I'd like to select one of them to briefly explain the production process.

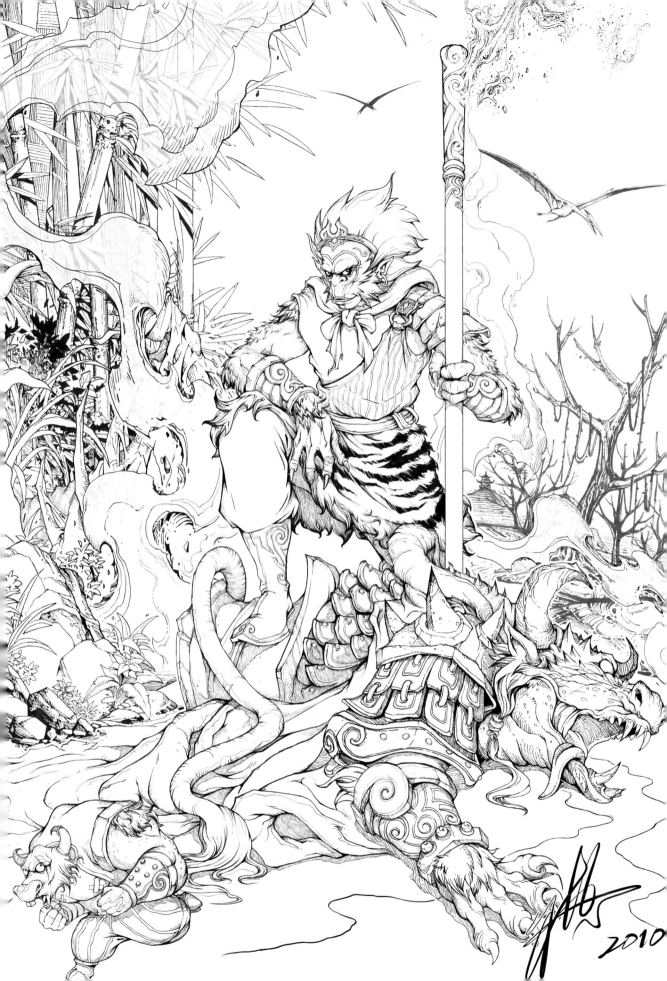

2010

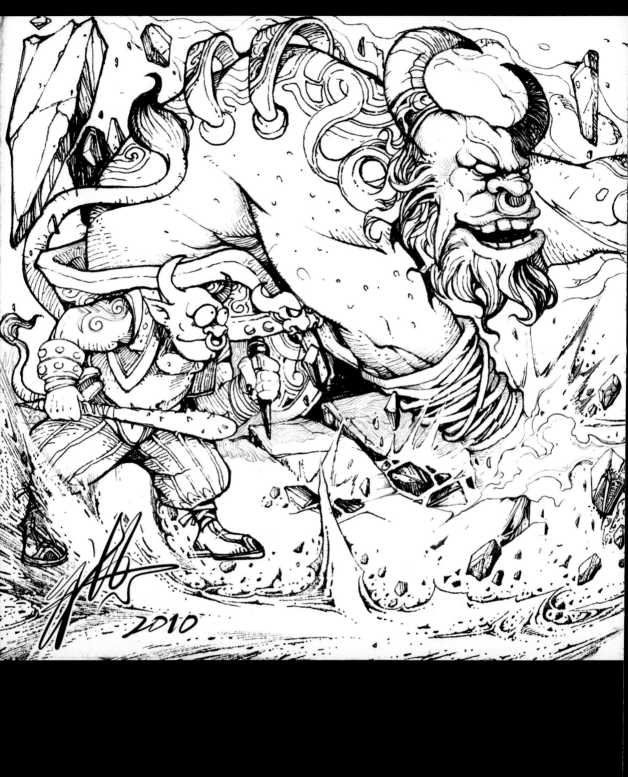

Da Li

Screen Name_**Kong OPEN** Profession_**cartoonist**

Da Li always planned to earn his living as a professional artist but still puts up with his job in an advertising agency. Thus, he has to rack his brain to squeeze out some spare time to realize his dream of becoming a cartoonist. Up to now, his creations have seldom been formally published. In the last three years, he has thrown himself into helping polish cartoon illustrations for the cartoon collection *LOST CITY*.

http://i.yoho.cn/lostcity guiguiba@126.com

Monkey King in My Eyes

Who is Monkey King? The Monkey King is the "Great Sage, Equal of Heaven." In my opinion, all his soul and spirit are highlighted when he proclaims himself as the "Great Sage, Equal of Heaven." He is arrogant and unyielding. Whether making fun of others or cursing angrily, he never bothers to hold back his true emotions. He is an innocent child, a fearless warrior. He is who he is. He is born the "Handsome Monkey King." In my adolescence, I started to dream of becoming the "Great Sage, Equal of Heaven," defiant and dauntless.

However, I found myself confronted with all manner of ugliness without acquiring the powers of seventy-two transformations; I had not learned the 108,000-*li* somersault, nor did I have the fiery eyes and golden gaze to distinguish virtue from evil. Now, I still long to become the "Great Sage, Equal of Heaven." However, now, I only hope to put the "Great Sage, Equal of Heaven" in my mind, the hero in my childhood, and totem of my adulthood on paper.

Monkey King in My Work

I racked my brain to come up with an idea to depict the Monkey King. There is no doubt that this is such an established character that it is challenging to bring out a new image and go further to explore his inner world. He is known as "Handsome Monkey King," which means that he must have an outstanding appearance among monkeys and command a grand air in the eyes of monkeys. In order to highlight my personal style, I gave him a pair of extended horns made of hair. Then, I selected two scenes from my favorite *Havoc in Heaven*—one is "Teasing God Erlang", the other is "Meeting between the Sage and the Buddha." The former is intended to accent that the Monkey King is so aggressive and all-powerful that he tends to strike first. Without any hesitation or misgiving, he creates a tremendous uproar in the Heavenly Palace to appease his indignation. The latter is given to illustrate the battle between the Monkey King and the Mighty Miracle God while incorporating traces of my personal emotions. The Monkey King had transformed some of his hair into the Buddha. This concept not only takes account of his nature but also presents a protest to

what later happened between him and the Buddha. I always believe that the Monkey King is battling with himself for self-perfection more than defying heaven. The Buddha had already acquired his Buddha status before the battle, but the Monkey King was not made a Buddha until later. Thus, I want to highlight the idea "the Sage encounters the Buddha" in my work, which has inspired me to switch to "Meeting between the Sage and the Buddha" in the final stage.

As to the elements in the picture, they are intended to capture the hallmarks of the time when the stories took place. Thus, I have used some brilliantly contrasting red, blue, green, and orange to give the picture a color property reminiscent of the tricolored glazed pottery of the Tang dynasty. In illustrating the golden band, I employed a combination of cloud and water graphics to speak to its original identity as a holy artifact to pacify the sea. In short, all the details are intended to demonstrate the Monkey King's spirit, time-honored and eternal.

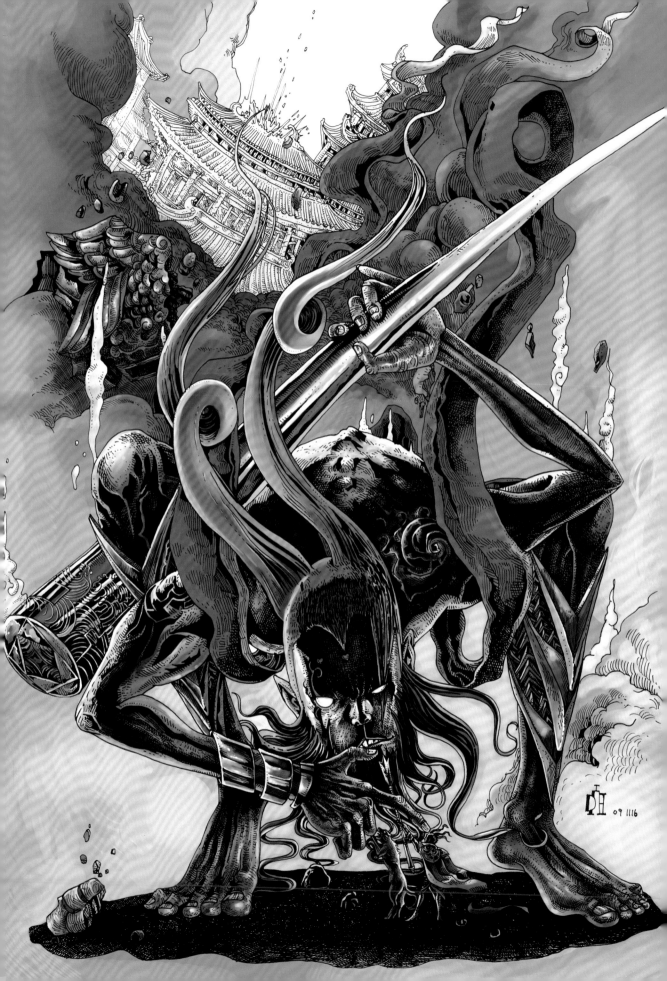

06

Edward Kwong

Screen Name_**Kwonger** Profession_*illustration*

Edward Kwong is a freelance artist based in Montreal, Canada.

http://www.edkwong.com/ mail@edkwong.com

Step 1: Thumbnail. Very loose and rough initial sketch to mold the idea for the image in my mind. It doesn't have to be pretty, just enough to make me excited for the visual.

Step 2: Finished line drawing. Normally, there's a step between a comprehensive rough and a finished work, and this step would help me develop the natural final drawing.

Monkey King in My Eyes

Frankly, I never really had a strong connection to the Monkey King growing up and I can't really recall where I first heard of him. I'd find out much later that one of my favorite childhood cartoons, *Dragon Ball*, was loosely based on the *Journey to the West*. Over the years I've seen plenty of interpretations of him, some serious looking, some less so. I can't really put my finger on why I like him, but I do.

Monkey King in My Work

I like the Monkey King rough around the edges, gangly, and unpredictable. So here you have him, falling out of the sky, ready to throw down and have a laugh.

y

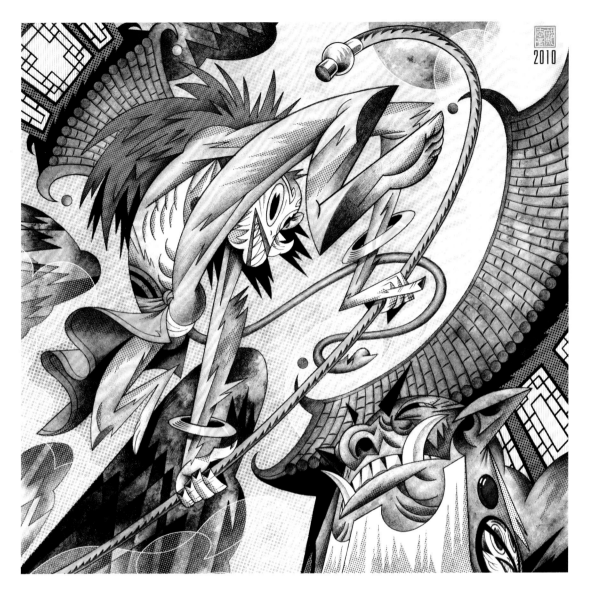

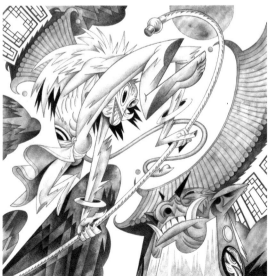

Step 3: Traditional media stage. Drawing was transferred to heavy watercolor paper. Tone, textures, and broad shapes were filled in with watercolor and pencil crayon.

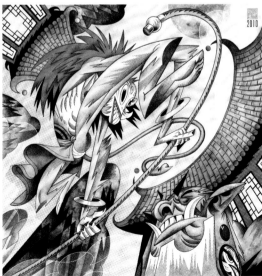

Step 4: Digital media stage. Color flats, half tones, and additional textures were applied via Photoshop and Illustrator. Finished.

07 Enrique Fernandez

Screen Name_**Enrique Fernandez** Profession_**animation designer, illustrator, comic artist**

Fernandez has been working in the animation field for ten years, doing almost all kinds of works related to media, storyboard, character design and artistic direction.

http://enriquefernandez0.blogspot.com/ raijuro@gmail.com

Monkey King in My Eyes

For me he's a kind of mix between warrior and apprentice that has to resume the history of a whole nation, and that task has to be such a great responsibility!

Monkey King in My Work

I thought about the common idea of "the warrior's rest," a space between adventures and epic stories, where the character would take advantage of its own abilities to make a break on its saga, making it as no other character in the world could do it.

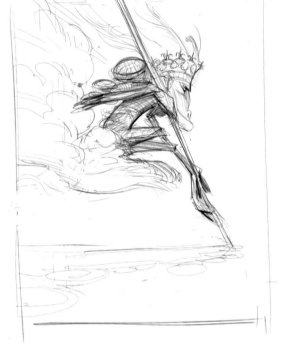

Step 1: The rough stage. I planned to make the composition as simple and equilibrated as posible. I believed a single-character image would do well. I came up with the idea of some relaxing moment for the character, and to make the composition easy to read, I followed a diagonal reading, from up-left to down-right.

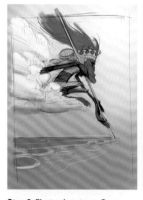

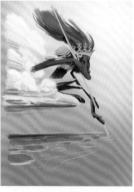

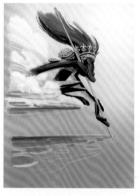

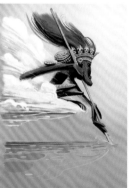

Step 2: First color stage. On a separate layer on "multiply" mode, I "kill the white paper" with all the main colors, leaving flat colors only. Used "scratchboard tool" under "pen" category.

Step 3: Shadow rough stage. I used 2B pencil for the main shadows.

Step 4: Started to give detail to the picture; used pencils again, but this time with more detailed strokes and colored ones, to give some texture and precise volumes.

Step 5: Added lights. This time I added some reflection on the shadow parts of the picture, using some red colored pencil and chalks. For the clouds I used some acrylics and a brush.

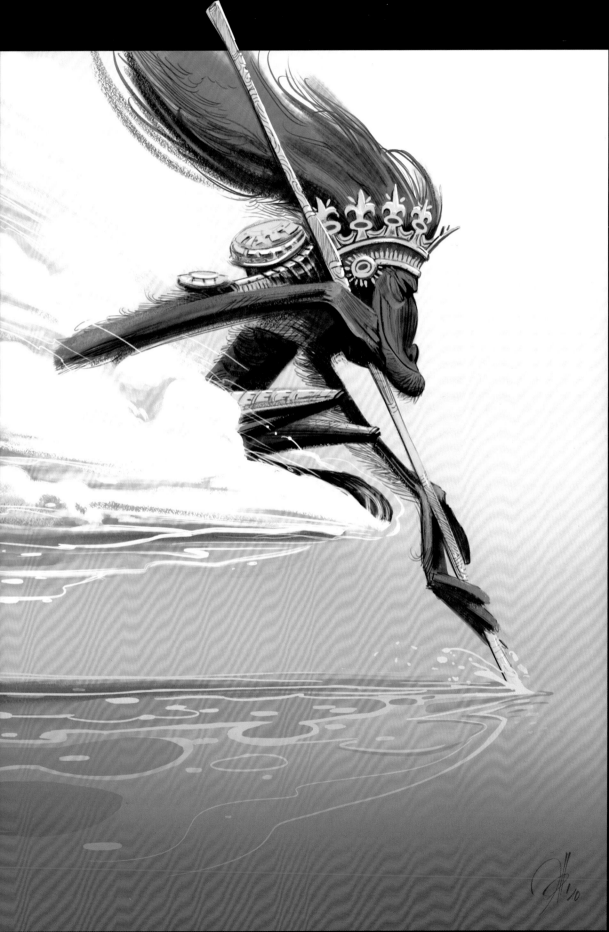

Luis Melo

Screen Name_**Luis Melo** Profession_**illustrator, concept artist**

Luis Melo is an illustrator from Lisbon, Portugal. He was born in 1981, and he has enjoyed drawing for as long as he can remember.

http://www.sketchitos.blogspot.com luis.m.melon@gmail.com

Monkey King in My Eyes

When asked to draw a picture about the Monkey King story, I was really excited. My knowledge of the books is not very deep, but I remember watching a TV show about it as a kid, which totally fascinated me. It was one of my first contacts with Chinese aesthetics, and it was very inspiring.

Monkey King in My Work

As I put more thought into what to draw, I got a bit lost on how to approach it in a relevant way.

I didn't feel comfortable drawing the characters and details traditionally, in Chinese style, since however fascinated I might be by traditional images, many other local artists could certainly do it much better and with less effort.

Instead, I researched the story a bit more and started to think about ways to translate its meaning to a different setting, one that I could feel more at home drawing. So I picked up from the concept of a "journey to the west," and the first idea I had was to turn it into an American road movie.

American road movies are generally about crossing the continent toward the west (usually to California), with or without an objective, but regardless of that, it always ends up being an adventurous journey of self-discovery for the characters. I thought it could very much relate to the Chinese tale's heroes' journey to India.

I started developing an initial sketch that set the characters in a car (instead of the Tang Monk's white horse) and would feel like something from the late 1940s or 1950s. The heroes could be some kind of outlaws traveling together to perform one final "hit."

But I felt there was something missing, and it was when my picture was developed pretty far that I thought of a way to twist it and make it more powerful.

What if they were women? I thought of the movies *Thelma and Louise* and Tarantino's *Death Proof* and realized that women on the road would make much more interesting heroes and their struggle in the world would be more superhuman, in accordance with the original story.

So I tried to use the characters' traits as well as I could, for my womanly versions. They'd be defying the law, chased by relentless highway patrols and truck drivers with a killer instinct. There would be guns and explosions, and there would be a climax encounter with their ultimate male antagonist—the Buddha (a corrupt senator or a vicious crime lord, whichever you prefer). In the end, a valuable life lesson would be learned.

For the look, I took inspiration from some 1970s movie posters. That's how I imagined this take on the story if it were a movie—a gritty violent 1970s film.

As for the execution, it's pretty straightforward. I had a basic idea for the composition, and I had a lot of help from my girlfriend in composing, posing as reference for some of the characters, and coloring. She helped me a lot in finishing this picture. But the painting itself didn't involve any special techniques. Simple Photoshop brushes were used for sketching and rendering, and a bit of texture was overlaid to make the "poster" look older.

I hope the final image is not too much of a twist to the Chinese classic… It was a lot of fun to plan out, make, and especially imagine how this movie could turn out if someone decided to take on this adaptation!

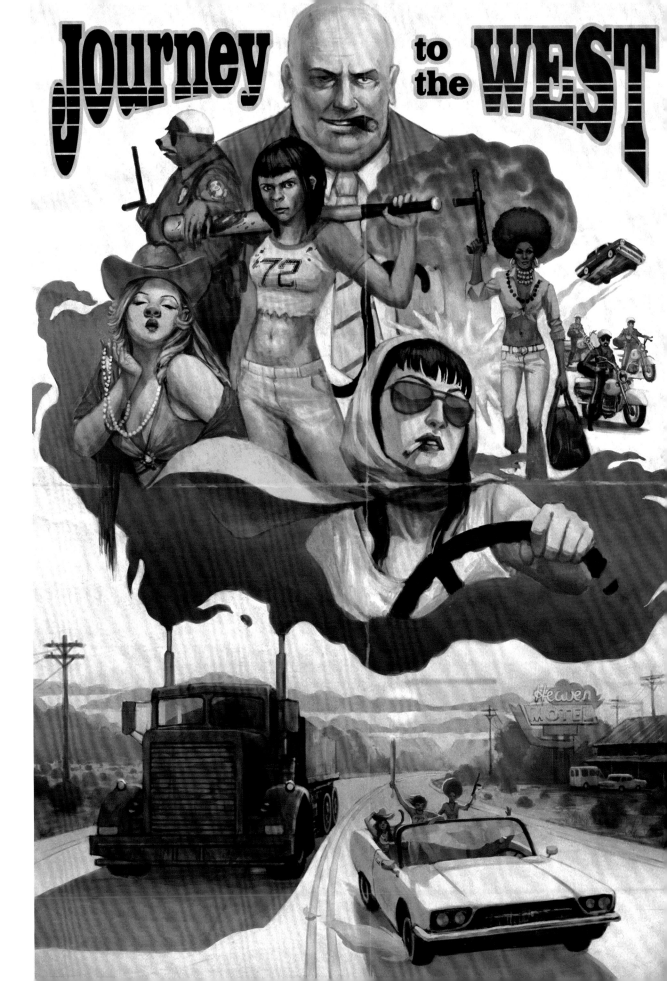

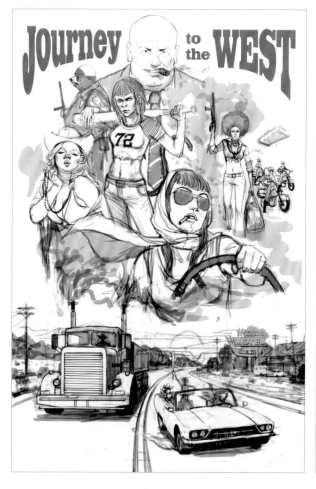

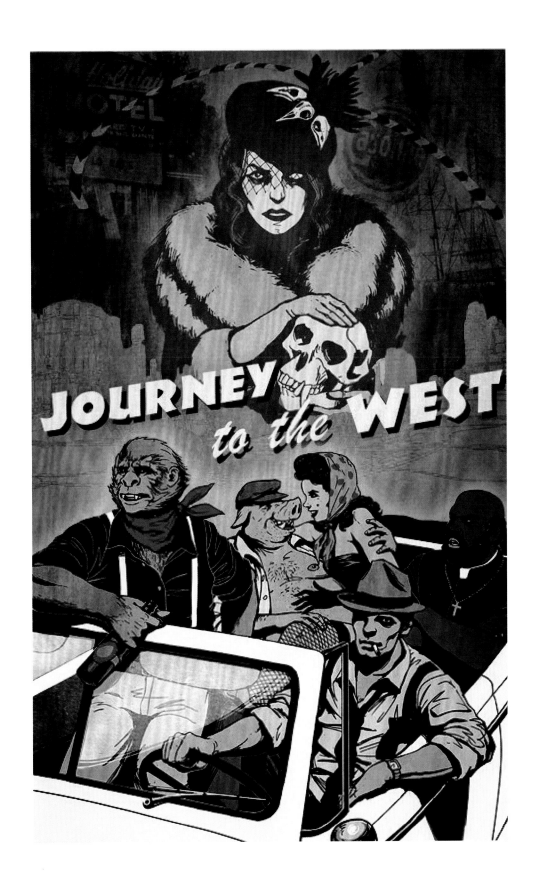

Feng Hanxin

Screen Name_San Profession_art director in the game industry, illustrator

Born in Hong Kong in the 1980s, illustrator Feng Hanxin has no formal training in art. Currently, he is committed to design work for his own game brand Taplay and art direction work for a Flash game. Meanwhile, he works in illustrating, graphic design, and T-shirt motif design in the name of Crazy Enough.

http://www.crazy-enough.com www.taplay.com san_studio@yahoo.com.hk

Monkey King in My Work

There seems to be a chemical relationship between the legendary figure Monkey King and me. I was born in the year of the monkey according to the Chinese lunar calendar and loved *Dragon Ball* in my childhood. Therefore, I had a profound understanding of the Monkey King as well as other characters in *Journey to the West*. As I grow up, it is no wonder that I want to reinterpret these characters in my own illustration.

Why have so many illustrators and designers chosen the Monkey King as the subject for their creative activities? I think it is because he is distinctive both in image and character. He is always full of vigor, agile in action, and somewhat mischievous. He wears the magical headband, swings the golden band, travels on the clouds, and covers a long distance in a split second. By reading the texts we have already felt his vitality and agility. If we put down these illusions on paper, the effect must be more expressive. Such an image fits perfectly with my personal drawing style and concept. Most of my illustrations capture the moment when the Monkey King has jumped high in the air. I hope that the audience can experience the vitality and feel happy at the sight of these illustrations.

Monkey King in My Work

First of all, I'd like to thank the sponsor for inviting me to participate in the "Seventy-two Transformations" project, which is based on the Monkey King, without posing too many restrictions on the expressive approaches. Therefore, I chose the illustration style that I'm good at. Influenced by Japanese and American comics since childhood, I incorporated somewhat exaggerative comic elements in my illustration, hoping to capture the dynamics of the characters in *Journey to the West* with rich compostion and intense strokes. The images of the Monkey King, Pigsy, Sandy, and the Tang Monk I shaped are much different from traditional ones, because I want to make the illustration more interesting.

The entire illustration is done in Adobe Illustrator, except the draft, because I always have a passion for the vector diagram. But the storyboard production approach is determined halfway. The process seems disordered and chaotic, without thorough thinking beforehand. However, I enjoy it! That's enough!

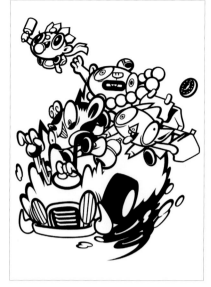

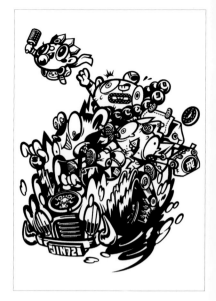

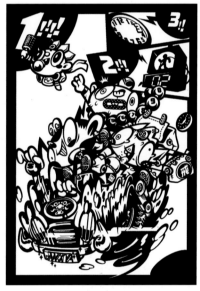

Step 1: Firstly, I scribbled the draft in a random way in a sketchbook using ballpoint pens, wondering what the final picture will look like in the meantime. Of course, there is always a huge difference between the drafts and the final.

Step 2: After taking a photo of the draft with a digital camera, I adjusted the resolution using Photoshop and then imported the file into Illustrator for the later processes.

Step 3: Based on the draft, I used the fountain pen tool to roughly outline the characters in Illustrator.

Step 4: As to the black outline, I prefer using the Offset Path function in Illustrator (Object > Path > Offset Path), which is very easy.

Step 5: After finishing the basic composition, I added some details to the characters, such as attaching some adornments to the costumes and enhancing the lights and shadows and the reflective effects of the metal. By doing this, the illustration gained a sense of volume and became more diversified. This process took a considerable time.

Step 6: The black-and-white effect was striking. However, the entire illustration did not look well developed and could not be used as a finished illustration. How to remedy this problem? What about adding some storyboards and making a simple comic? Thus I added two storyboards to highlight the countdown effects.

Step 7: Added more details and some colors to the background. Finished!

Step 8: The outline was really messy.

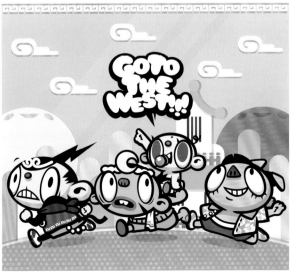

Florian Satzinger

Profession_designer for feature animation, comics, and computer games

Florian Satzinger's drawing style is heavily influenced by the classical Anglo-American hand-drawn animation form and European comics like *Spirou et Fantasio* and *Gaston*.

 http://www.satzingerhardenberg.com/ office@satzingerhardenberg.com

Monkey King in My Eyes

For one thing, the idea behind this illustration was to put the Monkey King character not in a typical action-driven scene but in a behind-the-action scene. For another thing, I decided to dip the whole piece in my own "Motorpunkish" duck style, which, of course, resulted in a lot of mad machinery, a big riding creature, and, of course, orange beaks.

Monkey King in My Work

The situation or story in the finished artwork can be described in detail as follows: The Monkey King, cooperative as he is to my taste, spares a little piece of his flying cloud to a traveling birdman and his wingless riding lindworm or dragon, in the hope of making this big beast fly. The piece of cloud, clutched by the motor claw of this apparatus the Monkey King is sitting in, is embedded in a transparent capsule of sorts. In the picture, the Monkey King inserts the capsule with the assistance of this quite unspecified (even to me) apparatus into the creature wherein the cloud can deploy its flying features, like a pill that would make you fly in an instant.

What I really like with this "character meets character" subject is the interaction. The Monkey King shares something in common with the creature, and the character's configurations and lines make up an integral whole.

I'm also happy with the warm, sandy color concept behind this piece. It has a strong reference to the corporate colors of Indiana Jones, by the way.

Another feature I'm happy with is the retro-futuristic look of the machinery in this picture, which again is quite my style. This style is, I guess, for the most part a sort of symbiosis of my love for André Franquin's motor gadgets and vehicles and George Lucas's *Star Wars*.

Finally, I want to lay great stress upon the "Chinese features" in this subject. On one hand, it's the passion or love for detail and graphic clarity in the picture. On the other hand, it's the Chinese dragon symbol, which has a special meaning to the Chinese.

Step 1: I always start with very, very rough sketches aiming at a silhouette of the character. At this very early stage I don't pay attention to clear line work or a fine drawing. I just think of line of action, shape, weight, perspective, and volume.

Step 2: I scanned the rough drawing and continued to edit the drawing in Photoshop. I added a lot of details, adjusted weak points of the design, and defined the incidence of light roughly.

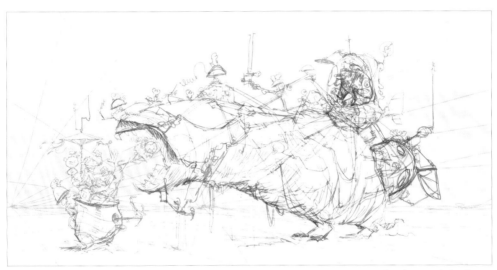

Step 3: After having finished the rough process, I continued with the cleanup by turning the visibility of the rough sketch to 30 percent in Photoshop and creating the fine drawing (the black outlines) on a new layer.

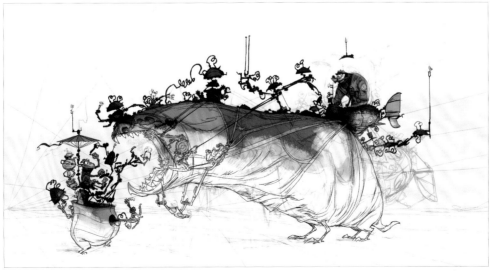

Step 4: Before I start with the coloring, I always generate a color palette, or rather a "color plan," by getting inspired by photos or things around me. In this example, I was inspired by the colors of an Indiana Jones action figure.

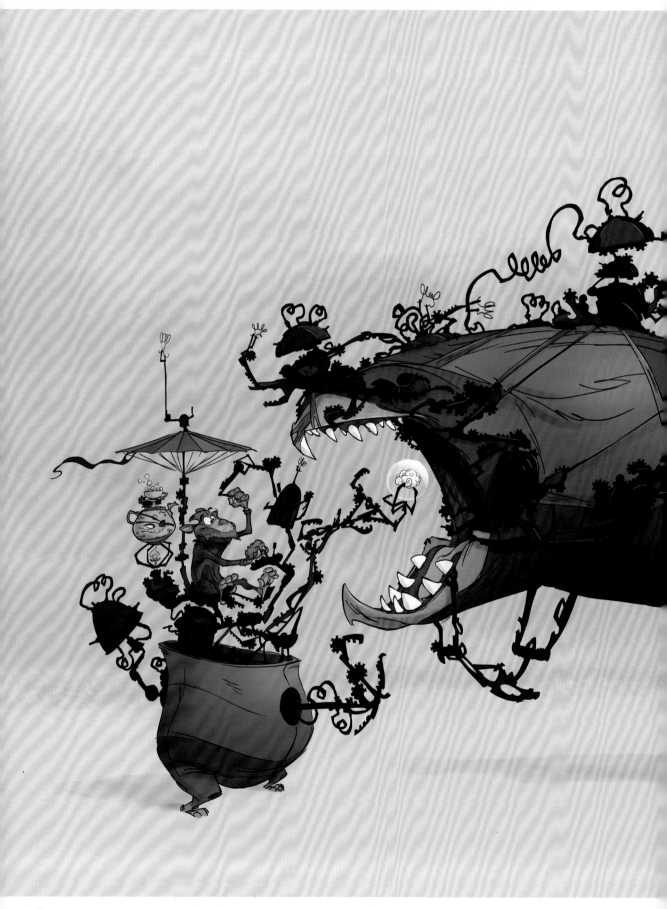

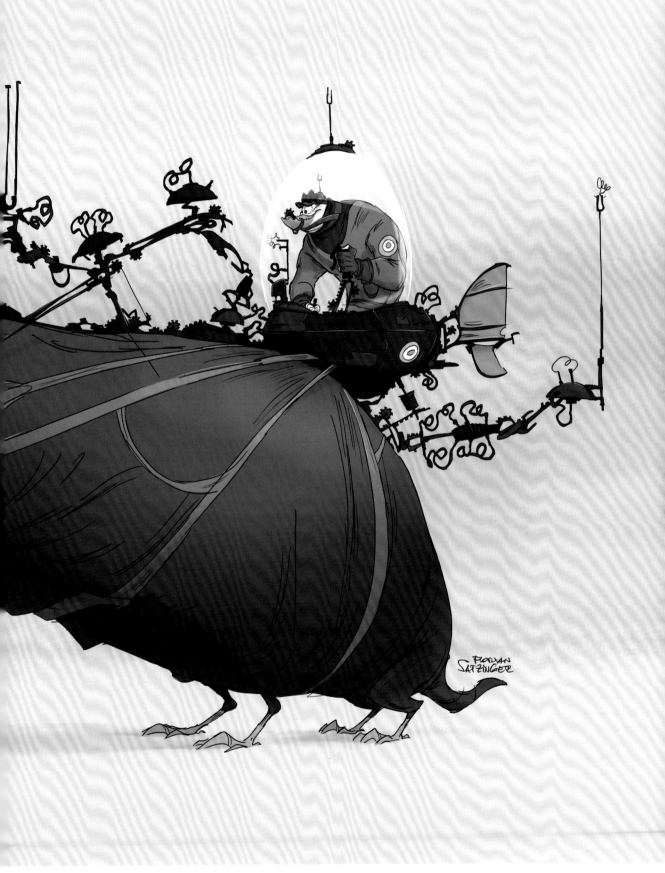

He Wei

Screen Name_**Blue Box** Profession_**photographer**

He Wei is a photographer and a commissioning editor for art books who likes to explore how photography overlaps with reality.

http://www.hewei-art.com ✉ hw.iphoto@gmail.com

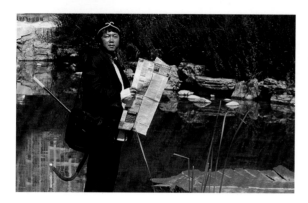

Monkey King in My Eyes

The Monkey King is undoubtedly the most distinctive figure in the history of Chinese classical literature. Holding the golden band in hand, he could travel on clouds; his fiery eyes and golden gaze enable him to identify the evil spirits of all kinds. With the seventy-two transformations, the Monkey King is invincible. However, all those who have read the original fiction of *Journey to the West* by the Ming novelist Wu Cheng'en will find that the Monkey King has encountered countless hardships and hazards, which not only produces suspense and changes of rhythm in the development of the story, but also creates a Monkey King of interesting personalities. His undisciplined and unrestrained nature has marveled us, while his loyalty to the Tang Monk, the Pigsy, and Sandy moves us deeply. Despite his prowess, sometimes he also got lost and even shed tears when painstakingly wrestling with the hardships. All these make us believe that he is so real. Actually, he represents how the novelist challenged the world and how helpless a man at loss is.

Monkey King in My Work

Real life is the source of any artistic creation. *Journey to the West* is no exception. The Heavenly Palace, netherworld, and demons are based more on the novelist's metaphor and parody of the real world than the ancient folklore. As a photographer, I wanted to exploit the descriptive and realistic features of this particular artistic form to construct a stage for *Journey to the West* in reality to interpret this image in a new way.

In this modern version of the Monkey King, having experienced a lot in this mortal world, the Monkey King hopes to seek solidarity in the city in the most unnoticed way. Therefore, he transformed himself into a slightly overweight white-collar man who cares little about his dress. However, not a moment of tranquility can he find in this world, which takes on a new look every second. In the story *Havoc in Heaven*, having seen through the enticing lies of the real estate agents who disguised themselves as deities, the Monkey King prepared himself for a fierce battle with his golden band. However, how can the consumers without the fiery eyes and golden gaze battle with these artless businessmen? In another work named *The Five-finger Mountain*, the Monkey King with a city map in hand turned stupid in the city. Like most urban strugglers, he believes that he has already reached the top of the world, not knowing that he is now trapped in the closing palm. We can totally understand this sense of disorientation in urban life that is undergoing rapid development. We all aim high and strive to reach our goals but can never get ourselves out of the mountain.

My works were finished by shooting a model in a predetermined scene. Since my inspirations were drawn from reality, I made enormous efforts in selecting the scene. I like to witness the moment when my works are interacting with the real world in an intimate way. Both photos were taken with a 4×5 camera, and the films were revised in Photoshop after being processed by an electronic color scanner.

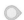

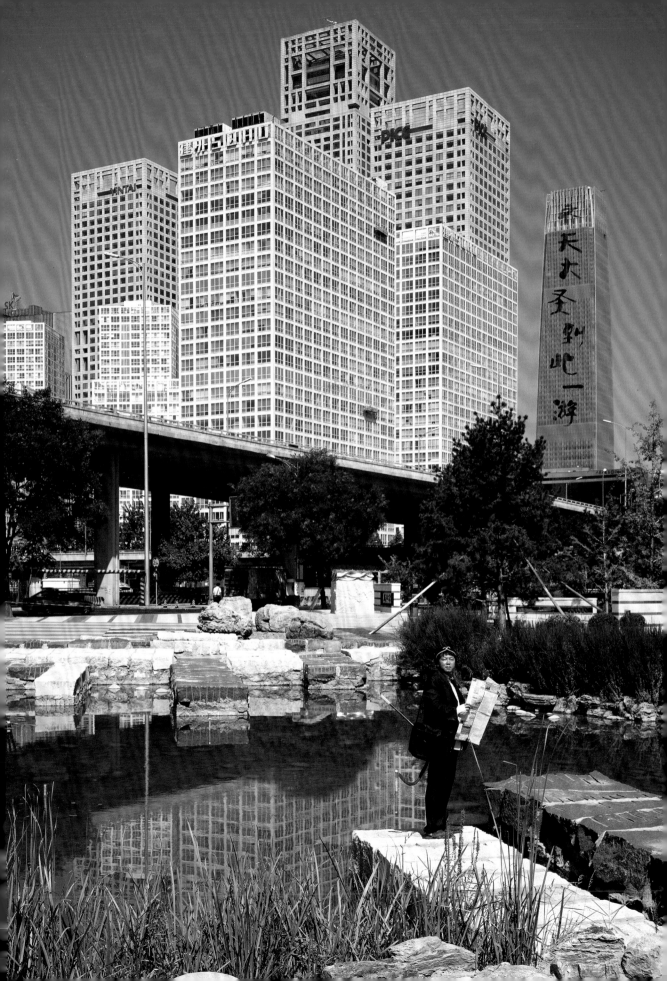

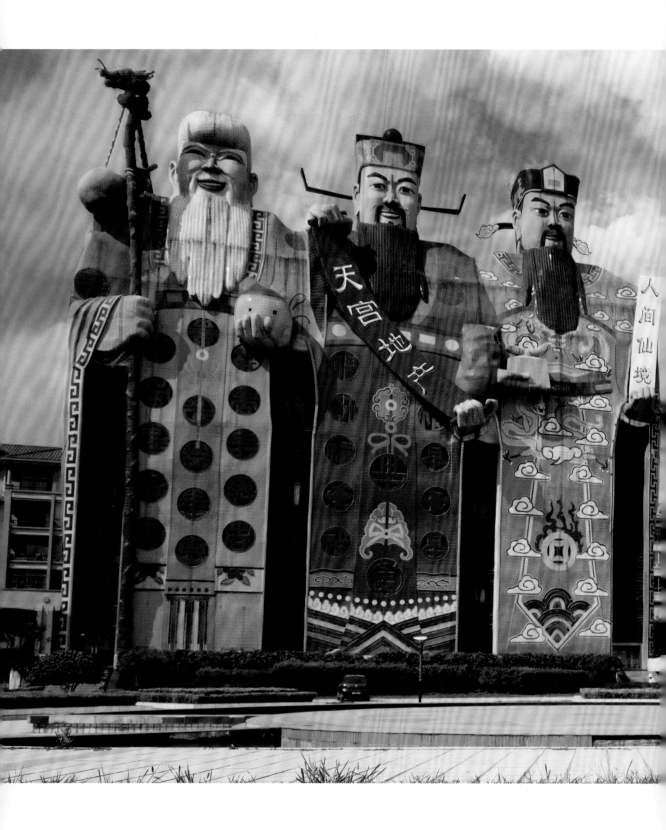

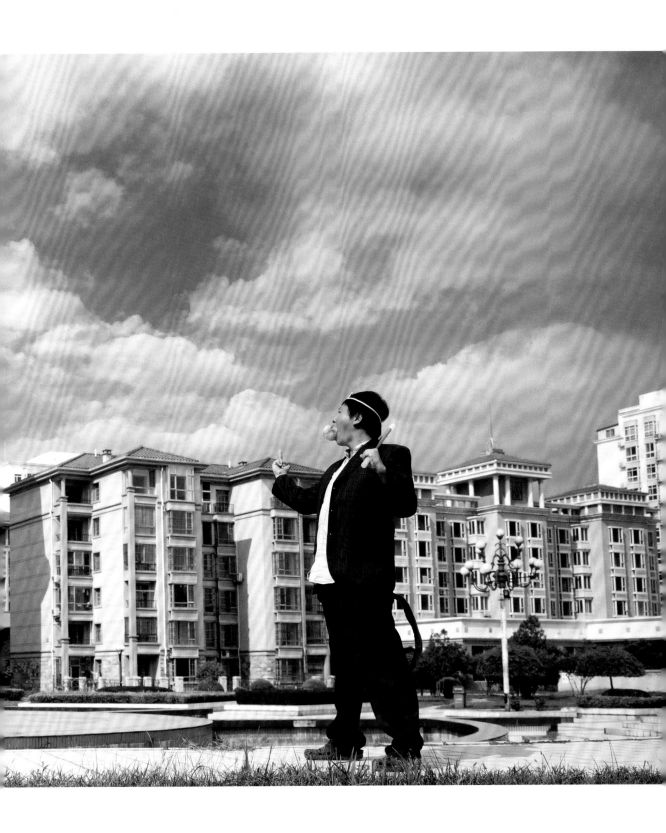

He Wenxin

Screen Name_**Wen Xi** Profession_**game designer**

Gender: Male; Loves: Females, money, and fancy cars; strongly supports self-reliance, no history of theft or robbery; looks forward to a one-*mu* farm (measuring 0.00066 km²) with two head of cattle, wife, children, and warmed bed; sincerity is his trademark; and peace of mind is his long-standing pursuit.

hx5879@163.com

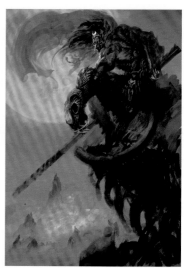

Character's draft: The character's draft revealed his back, lonely and relaxed. He sat there at rest after eliminating a devil. Later, I repositioned him on a cloud, which would better illustrate my idea.

Monkey King in My Eyes

The Monkey King is my icon. *Journey to the West* accompanied me growing up, and my favorite character is none other than the Monkey King. I love him for his dispositions: he has an inherent ruffianism, ignorant of the established conventions; he is not afraid to accept responsibilities, while remaining rebellious and unruly; he is arrogant and confident, immune to any form of evil. All these properties are no more than a combination of what every commoner longs for, whether an ancient Chinese or someone living today. Everyone says to themselves, "If I were as powerful as the Monkey King, I would…" The answers usually refer to something concerning bringing justice to the evil, corrupt, and greedy; the list can go forever.

The Monkey King is illusionary but eternal at the same time. Or we may say that his eternality is a result of his being an illusion. There is no doubt that the monkey is cooler than any American who wears his underwear on the outside. The Monkey King's spirit drives all his fans crazy—they strive for this spirit, which, unfortunately, forever stays beyond their reach. Eventually, illustrators can take out their obsessions on paper by enabling the Monkey King to be true to himself in every sense and empowering him to run riot.

Monkey King in My Work

I have imagined the Monkey King in such a way due to my conceptions of him. He must be inferior to nobody in terms of martial prowess and will certainly dwarf all evil with his mightiness. Besides, he must be a loner who could find no match. The Great Sage glances back with his fiery eyes, suggesting, "Who is my match? The chivalrous is here to deliver justice." You yourself would feel intimidated in the face of the Monkey King if you were a devil. We should throw a party to celebrate our non-devil identity. We all tremble in fear at the thought of the justice deliverer. Unruly and carefree, lonely but righteous, this is what I desperately want to illustrate in my work.

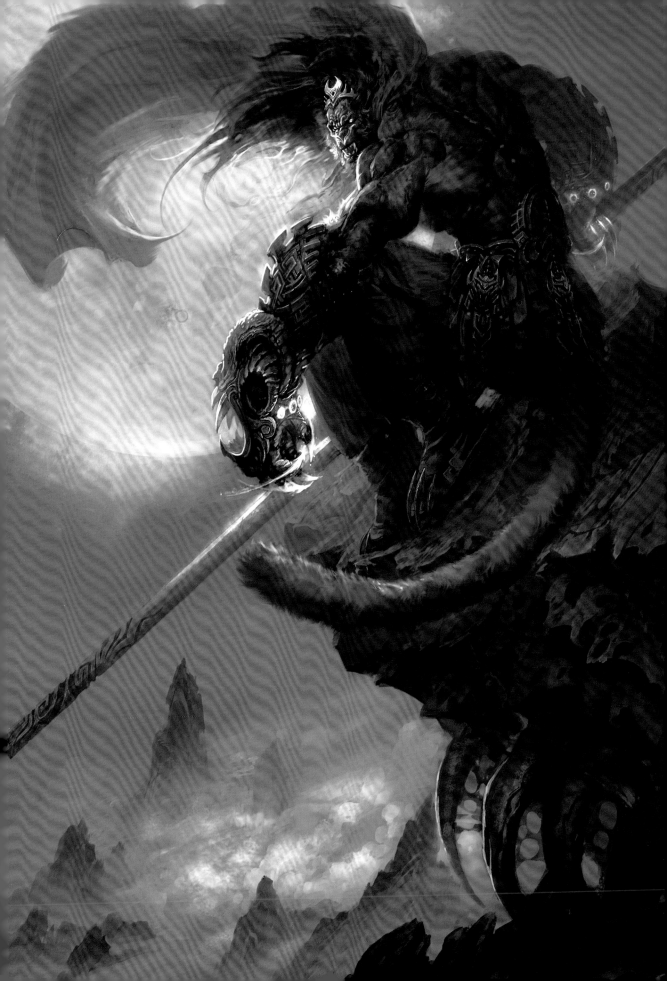

Step 1: I used rough lines to jot out my thoughts on paper. I was just brainstorming —the original intention was to create a mixture of divineness and mischievousness in the context of a lonely night lit by moonlight.

Step 2: I made adjustments to the line patterns in various directions to make the composition balanced and comfortable; I went further to add forms and objects in keeping with the overall style.

Step 3: With a general idea of composition in mind, I changed the layer properties. After sketching out the dark and light areas, I started to pave color, set up a new layer,

brushwork style in search of what feels right. In this stage, instinct came first, before connection, differentiation, contrast, and proportion between complementary areas.

Step 4: I composited all the layers and compressed it down into a single paper-like construct. This did not involve any fancy techniques. This process must be quick and straightforward. The rest of the work, including adding and adjusting color, form, texture, and lighting was supposed to be finished within this process. This habit is a product of all the years spent on game design, when I had to wrestle with a tight schedule. As to the production procedure, I

questioned by all the teachers and students back at school. But to me, this method is acceptable because it is less time-consuming. However, it should be noted that wherever you start from, you must always look at the whole picture, with a general idea of what the part you are working on will look like in mind.

Step 5: I improved lighting and dark and light contrast. I switched to the big picture to examine the contrast and perfected the details. I sacrificed the parts that looked wrong. "Sacrifice," what a cruel word! How it hurts to eliminate a visually striking detail. So, "sacrifice" here cannot be more appropriate.

He Xin

Screen Name_**NEIKO** Profession_**freelancer, illustrator, animation director, toy designer**

To He Xin, painting is an integral part of life, just like having dinner. Nobody expects to earn fame by playing tricks with dinner. It is the same with painting.

http://blog.sina.com.cn/NEIKO **neiko.lee@gmail.com**

Monkey King in My Eyes

The Monkey King is not only a legendary figure, but also an incarnation. I don't envy him for his capabilities of seventy-two transformations, or for his cloud-somersault, or for his fiery eyes and golden gaze. What interests me most is his indomitable spirit and his boldness to act in an unrestrained way. There might be things that you have not yet imagined, but there is definitely nothing that he dares not to try. He is so rebellious that he always wants to take an upper hand. He always picks up powerful rivals. He is so eager to prove himself if someone dares to question his abilities. I get excited each time I think of this. Or perhaps he is only a monkey. We might have imposed too much on him.

Monkey King in My Work

I chose a relatively fierce look. Why? Because the Monkey King has just raised a havoc in heaven. He must be arrogant and undisciplined. No matter from the psychological or physical perspectives, this is just the climax of the Monkey King. In other words, I believe that only through this configuration can the mood of the Monkey King be fully expressed when he was imprisoned at the bottom of the Five-finger Mountain.

Having decided on the image of the Monkey King, I was confronted with other problems. What would the Five-finger Mountain look like? Is it only a mountain? If this mountain has crystallized the essence of the five elements—that is, gold, wood, water, fire, and earth—then how can these elements turn into a mountain?

One day, the inspiration finally knocked on the door. It suddenly occurred to me that what could suppress the Monkey King must be something in himself.

According to the Buddhist theory, everything observes a univeral law—everything is nothing but emptiness. One cannot know something clearly unless he understands himself in the first place. Five hundred years is neither too long nor too short. However, it has taken the Monkey King five hundred years to convince himself that what he saw in that flash is real, and to think about why he held back at that time. Therefore, he has to pacify himself and gain a peaceful mind before coming out and practicing Buddhism. Actually, the Buddha said nothing to him except asking him to take a clear look at himself. At these words, the Monkey King started to question himself. With this inner transformation, it is easier to deal with the exterior troubles. At this thought, I finally got a Monkey King I wanted from my perspective

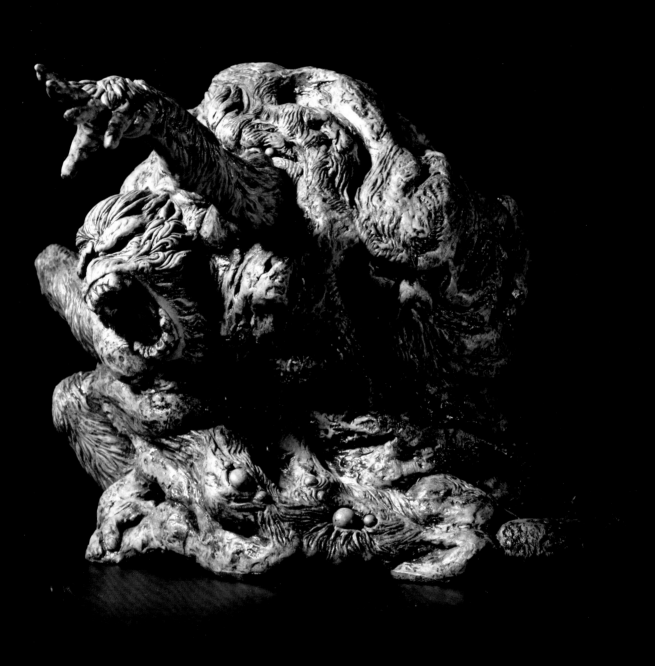

Step 1: I got a rough idea. I have a bad habit, that is, I don't make drafts. I'm afraid that drafts will restrain my thoughts. Therefore, after drawing some sketches of the monkey and searching for some materials, I started with my work.

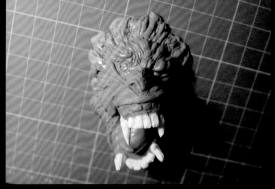

Step 2: I made the head in a rapid way.

Step 3: I assembled different parts together to get an overall impression. After determining the positions of arms and legs, I began tearing them down and elaborating on them.

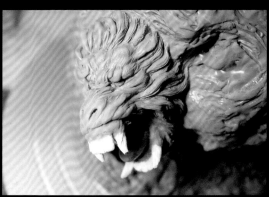

Step 4: I made the first round of overall elaboration, identified the problems, and then drew the draft.

Step 5: I focused on the facial expressions and attached nails made of rice to the claws.

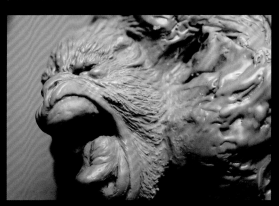

Step 6: I elaborated on the head and then the muscle.

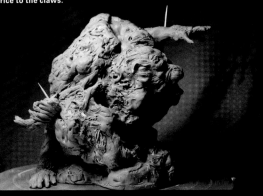

Step 7: I enhanced the fierce looks, added muscles, and revised the left hand. The other one? I made revisions to it as well.

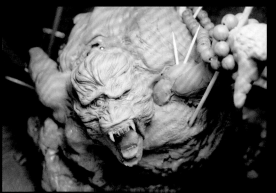

Step 8: I spent a lot of time revising the facial expression, which was almost completely different from my original concept. I used American clay to make teeth and elaborated on the arms. And I finally put different parts together for a review.

Step 9: I worked on the details, tore down the arms for elaboration, and used small stones to produce textures.

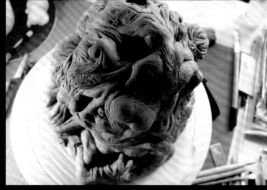

Step 10: I made bold and creative revisions.

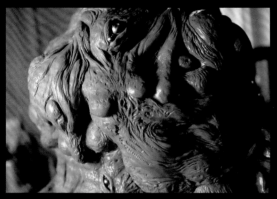

Step 11: I added more details.

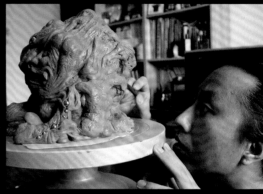

Step 12: I made final amendments before rolling it over.

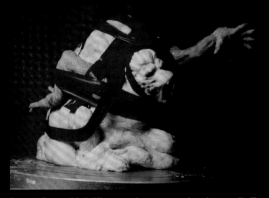

Step 13: I assembled different resin parts to review the overall effect.

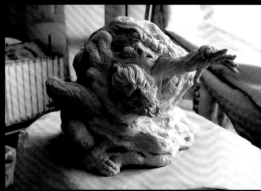

Step 14: Based on the resin model, I enhanced what should be enhanced. I remedied some flaws such as the bubbles and sprayed the reinforcing earth.

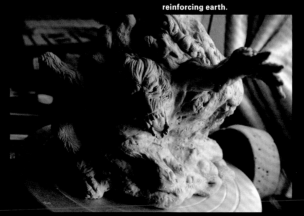

Step 15: The model was finished, ready to be put on the production line.

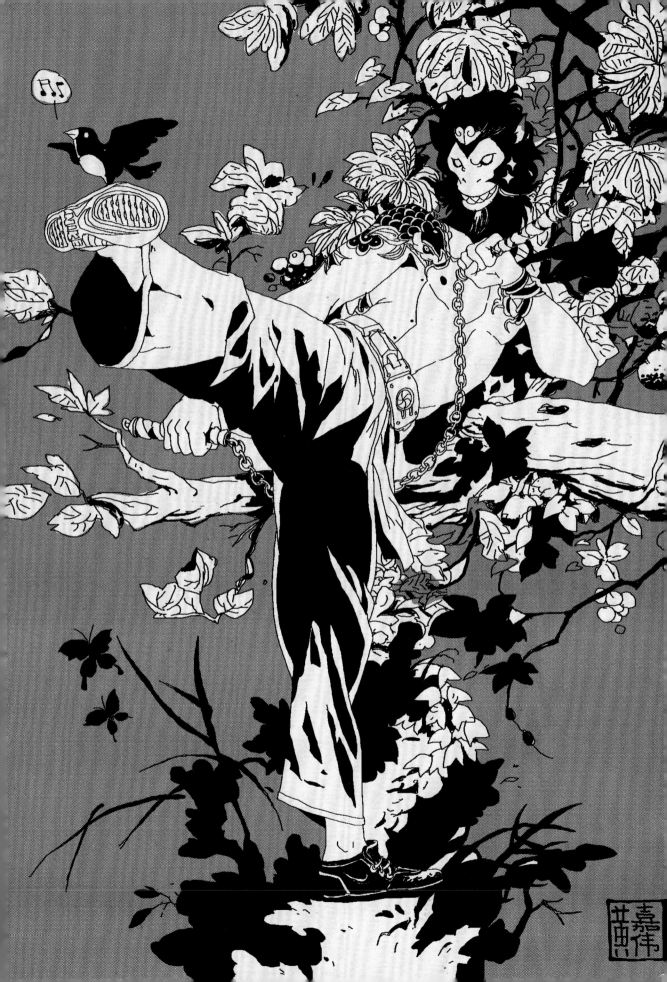

 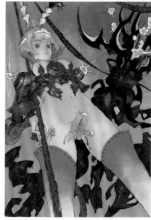

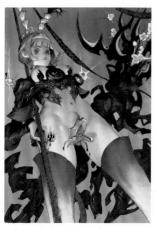 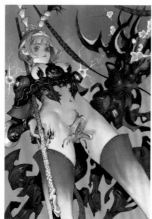 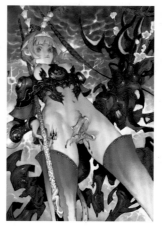

Step 1: When drafting, to determine the size of the character within the frame is the first step. I myself tend to pay attention to the emptiness around the figure, trying to work out a proper way to arrange other forms in a rhythmic way. After all these were fixed, I started to work on the legs and torso as the frame and added all the elements my mind.

Step 2: I built on the draft by adding the helmet, distortion in the left hand, and some other special effects. I erased the unneeded lines and darkened the remaining lines.

Step 3: I scanned the draft into the computer and produced another layer. I selected the right contrast ratio and did the cleanup.

Step 4: I paved the color. First, I tilted the paint bucket to produce an accent color and then allocated various colors to individual parts. I added some light sources of considerable sizes to determine where the light would come from.

Step 5: I further elaborated on the picture, which was the most time-consuming step. Having filled in the accent color and found a color that is more striking but still matches as a foil, I can start from wherever I prefer.

Step 6: I added shadows to the objects within the picture based on the lighting sources.

Step 7: I started to work on the environment after the character was roughly finished. In depicting the environment, I referenced some photos for the dark clouds, drawing them in an unhurried and unrestrained way to create a sense of space. Later, I used the blur tool to adjust the depth of field.

Step 8: I added more details and made more adjustments. I darkened the details.

Step 9: I deepened the color tone after finishing all the details.

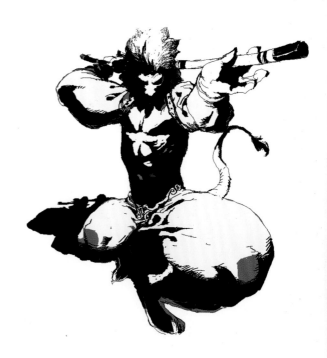

Huang Guixing

Screen Name_**Iya-star** Profession_**graffiti artist, concept designer**

Huang is a cartoon designer, animation director, and game concept designer. His representative works include *Iya-star* animation series, *Minimo* animation series, etc. His animation work received financial support from the Ministry of Culture in 2008 and 2009.

http://iya-star.com 622000457@qq.com

Monkey King in My Eyes

Journey to the West has been my favorite story since childhood. I used to mimick the Monkey King out of admiration for his almightiness. He is an optimist with an open mind. Legend has it that, wronged by the Tang Monk, the Monkey King returned to the Mountain of Flowers and Fruit, but he was still concerned with the safety of the Tang Monk. When he was informed that the Tang Monk was turned into a tiger by the Yellow Robe Demon, he put aside his grievances and rushed to his rescue. He is capable of seventy-two transformations and cloud-traveling. Sometimes, his loyalty was not rewarded by recognition and praises but engendered misunderstandings and reprimands instead. He was even deprived of his discipleship several times. Driven by his instincts, the Monkey King can do bad things or good things. He has already gained buddhahood in nature, which can subdue the instincts through self-cultivation and self-exploration. When meeting with difficulties in studies, we should face the challenge by thinking it over seriously without panicking. When confronted with difficulties in life, we should be courageous, resourceful, and optimistic. Though he is only a fictional figure, the Monkey King has exemplified the pursuit of benevolence and justice of the ancient Chinese. We should learn from him.

Monkey King in My Work

I have done several illustrations on the Monkey King, all of which featured Q-style. However, in this illustration, the Monkey King looks evil and wretched. Since I am used to the amiable image of him, I wanted to make a change this time. The Buddha, who is respectable and awe-inspiring in the original fiction, is also approached in the same way. I guess nobody has ever imagined that he would do something like pick his nose. It is just intended for a sense of humor. Even so, the courage and magical prowess of the Monkey King are also demonstrated in the illustration. Besides, some characters in my brand have also been included to display a cosplay style. It is hoped that this Monkey King might be different from the traditional image.

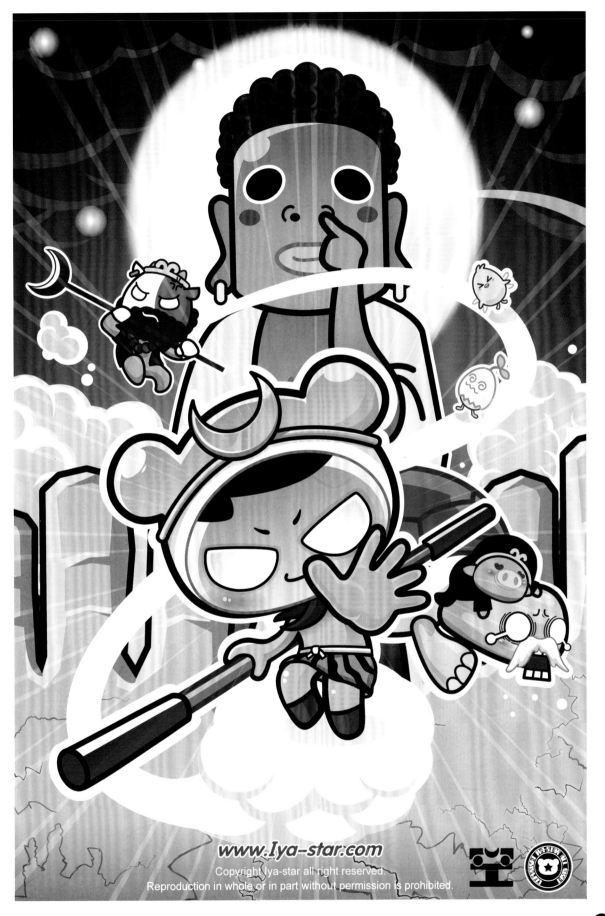

Huang Weidong

Screen Name_**Don** Profession_**freelance designer, illustrator**

Huang is a cartoonist, illustrator, and toy and graphic designer.

http://www.ox-family.com ox-family@163.com

Monkey King in My Eyes

I have been a fan of *Journey to the West* since childhood.
One of my pastimes was to mimic the Monkey King by
swinging the band and acting as if traveling on clouds.

Monkey King in My Work

I put some serious thought into this project before deciding
to make use of pixels in my work.

The resolution ratio for a pixel is 72 dpi. The
uncomplicated square matrix will produce magical effects
when integrated with creative thoughts. The Monkey
King is said to be capable of seventy-two transformations.
What a wonderful coincidence! Therefore, I decided to
make use of the pixel in my creative work.

In this work, the Monkey King is configured as a
mechanism made of pixel armor. He possesses the ability to
perform seventy-two transformations.

The process to create "The Warrior Buddha" is like
assembling the Gundam models. I have to select different
components, assemble them, grind, and paint until it is
completely finished. Generally speaking, I have to paint
a series of components in the preproduction stage. Then,
I have to base them on my inspiration to assemble them.
In the creative process, I have frequently experimented.
Some of the processes are not presented here, which is a
great pity. I have included two illustrations of the Monkey
King featuring varied effects. I hope that I can find different
inspirations from them.

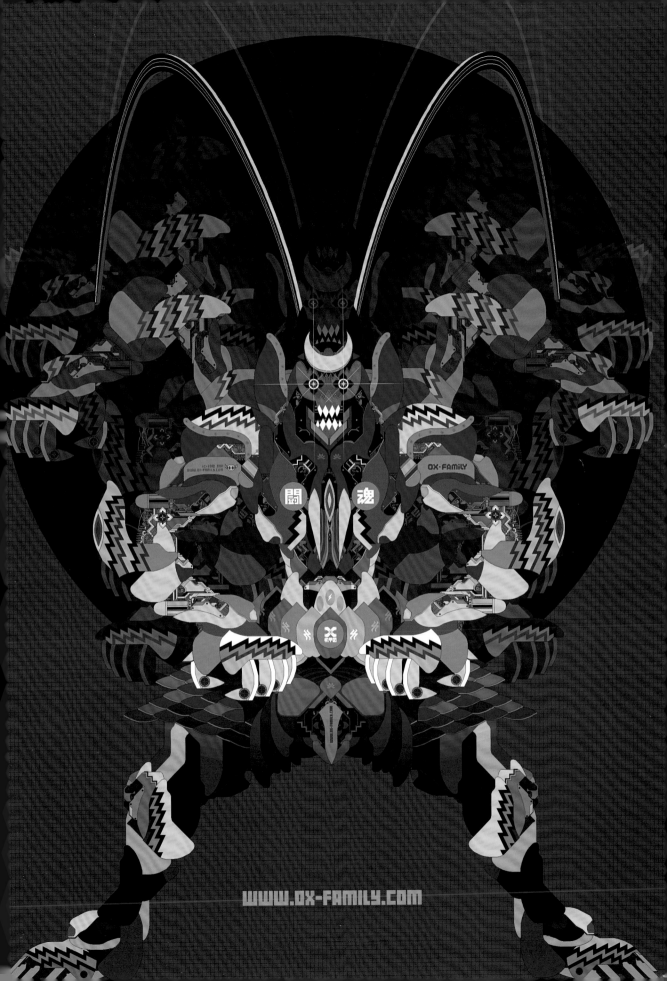

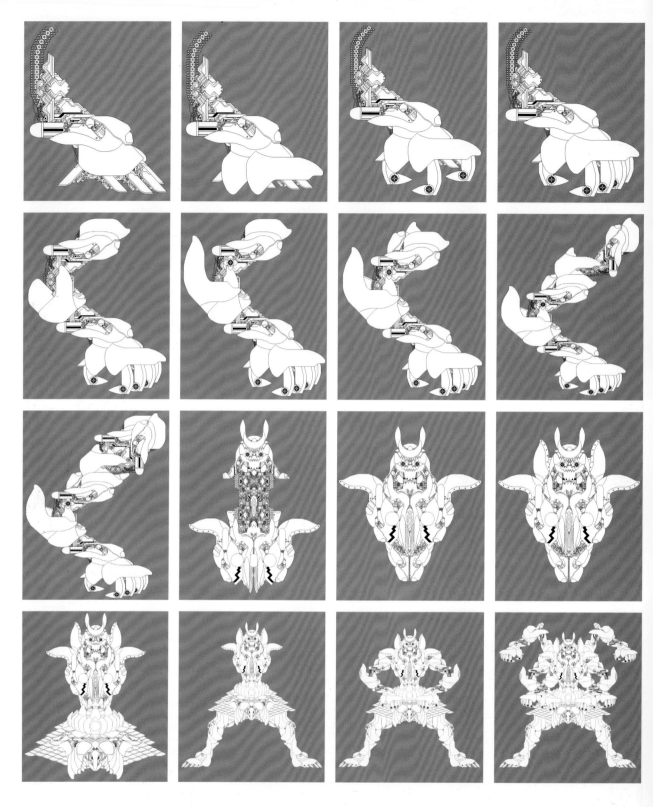

Step 1–Step 9: I have used some preproduced componets to assemble the arms.

Step 10: The head was made in the same way. As an essential part of the character, the head is very important for the entire body. This process was demanding but equally rewarding. The Monkey King had epitomized both virtues and viciousness, which just fit how he impressed me.

Step 11–Step 15: After finishing different parts, I assembled them and made adjustments. It was relatively time-consuming. As the pixel elements were used, I had to make local adjustments one by one until there was no dissatisfaction. I integrated all the layers when it was roughly finished, or else the revision would last forever.

Step 16–Step 18: I set up a new layer under the mechanism and added arms to make a Monkey King with three heads and six arms. I had colored the arms at the back gray in a habitual way to distinguish different layers.

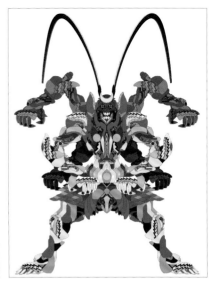
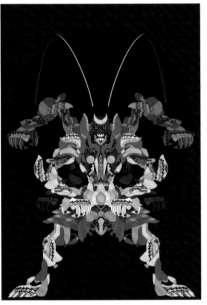
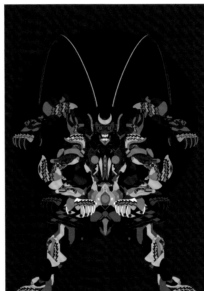
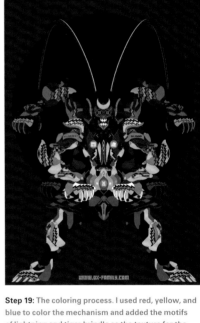
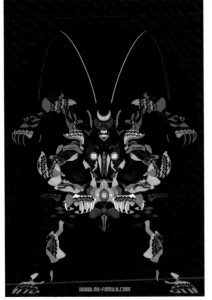
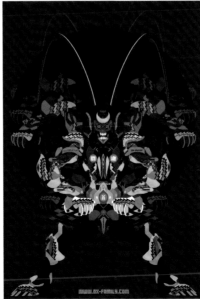

Step 19: The coloring process. I used red, yellow, and blue to color the mechanism and added the motifs of lightning and tiger brindle as the texture for the armor. I had to adjust the color palette in a constant way without observing any determined rules, having totally followed my instincts.

Step 20–Step 21: I added the background color. It seemed that the color of the mechanism was still a little obscure. Therefore, I reproduced the color layer, overlaid the positive layer, and adjusted the percentage of the layer. The color became more solid and concrete, representing a more evident contrast.

Step 22–Step 23: I added the logo to the mechanism and added glints to the eyes. I enjoyed this process, because the work was roughly finished. I had adjusted the color in the lower body to make him stand in a more stable way.

Step 24: All the layers concerning the mechanism had been integrated. I reproduced a layer and moved it. I then adjusted the transparency to enhance the dynamism. Finished!

Huang Yitao

17

Screen Name_**SHALA-H** Profession_**illustrator, street artist**

As one of the earliest street artists in China, Huang is also a member of NGC CREW. He favors simple, straightforward, brisk, and smooth lines. His work is primarily based on abstract images.

www.shala-h.cn shalahuang@hotmail.com

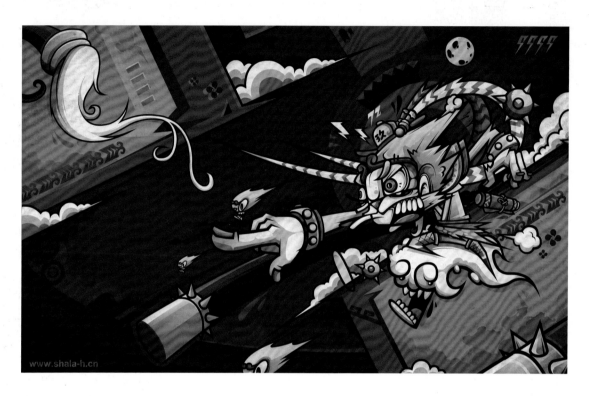

www.shala-h.cn

Monkey King in My Eyes

The Monkey King, to the generation born in the 1980s, presents a familiarity that cannot be translated into words. Why? Because I believe millions have watched the TV Series *Journey to the West*. Our favorite character was the Monkey King, whose power of seventy-two transformations and eccentrically brilliant properties make him very appealing. One of the most popular games in our childhood was to mimic the Monkey King, through which we were exposed to the cultural essence of our country. Besides, the Monkey King had enlightened us in life and in creation by posing a profound influence.

Monkey King in My Work

As my maiden work of the Monkey King, this picture integrates my graphic design styles. Is this monkey recognizable! I haha! This subject is so appealing that I have already decided to work on another piece. Certain design elements will be evident in this piece, which depicts the Monkey King in combat. Finally, here comes a chance for him to talk with his fists.

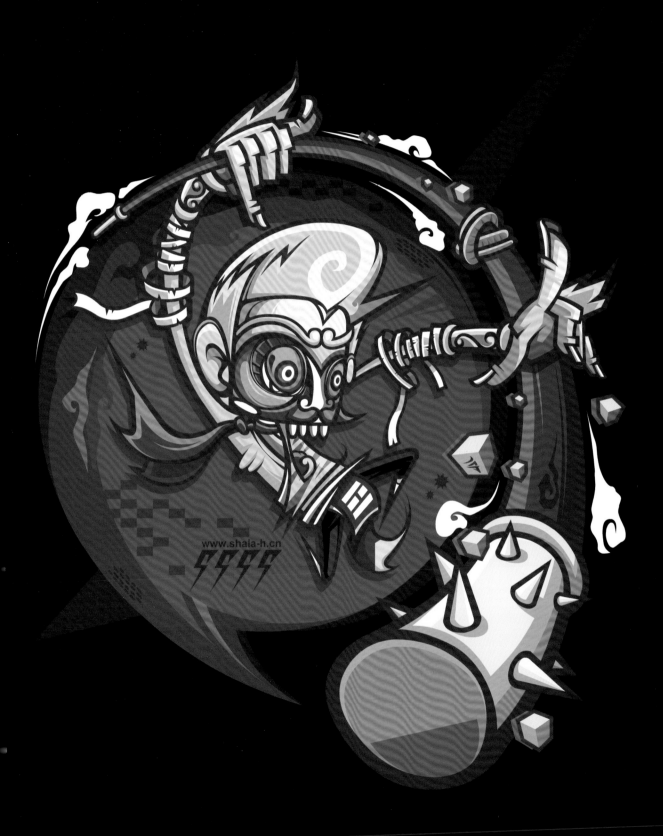

18

Jessada Sutthi

Screen Name_**Jessada-Nuy** Profession_**concept artist**

Sutthi is a concept artist and matte painting freelancer from Thailand.

 http://www.jessada-nuy.deviantart.com ✉ **generationseed@hotmail.com**

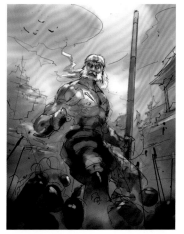

Step 1: After I got an idea I just sketched and checked the composition.

Step 2: I added black and white to control the value.

Step 3: At this step I used earth tones to overlay the top. Then I just added the details. After this I would depict the image of the Monkey King.

Step 4: I alway check the composition because the value can be deceptive if you flip the image. I tweaked them all up and refined. Finally I added more details by using textures and refining the lighting to finish.

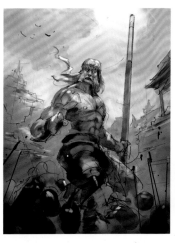

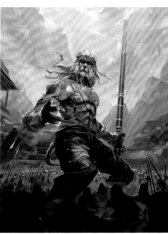

Monkey King in My Eyes

When I was young I used to watch the Chinese Monkey King TV Series. That story was so interesting to me that after school I would rush back home to watch it. My friends and family also loved the series. In *Journey to the West*, I enjoyed watching monsters who are making trouble all the time and the new events.

Personally I think the Monkey King is a symbol of strength and honesty. Although he is very mischievous, he always helps the friends and people he cares about.

Monkey King in My Work

For this piece I wanted to draw the Monkey King fighting against the army and show the different scale between king and soldiers. I needed the feeling of the Asian culture.

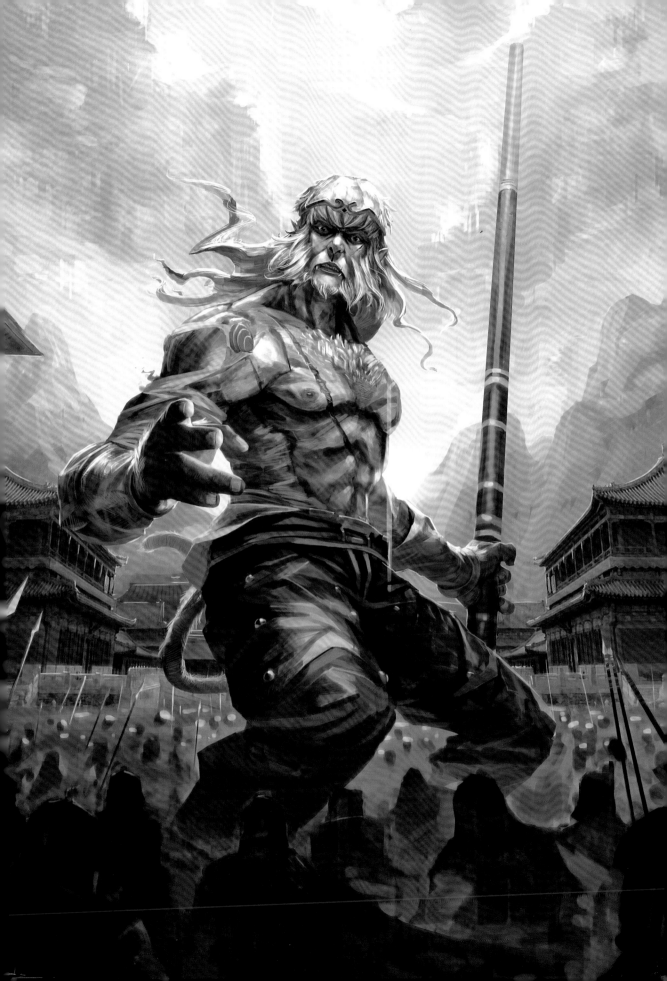

Jiang Sha

Screen Name_**Jangsa** Profession_**concept artist**

Jiang started to learn drawing at an early age under the ferocious coercion of his parents. However, it seems that he is capable of nothing except drawing today. Currently, he works in a small game-development company in Shanghai. His former dream was to become a director. Wow, what an embarrassment! Now, his dream is the arrival of 2012.

http://blog.sina.com/jangsaart jangsa@126.com

Monkey King in My Eyes

The river water had been clear for five centuries, followed by another five centuries when it turned muddy / cracked riverbed used to house whose home or country / who has etched the enormous tear in the golden pillar to pacify the seas / and plant the veins into my skeleton and soul / who was hiding behind the magical headband / looking down at us with benevolent eyes?

Today or whenever, we practice divination to tell whether wind comes from the southeast and rain sweeps from the northwest / demons kowtowed to the copper vessel / demons glare at the Holy Monk in anger and greed / who are you / who are we / vultures storming into the plateau / monsters haunting the forests / White Skeleton Demon feeding on souls / or the orc thirsty for blood

Who is hunting along the river / huge secrets are deeply concealed under the West Heaven / the holy is cloud-traveling / etching on the tortoise shell and beast bones / at repose behind the Southern Heaven Gate / silent

I want to fight! I hold my burning urge in hand / flames of battles scorching me to the utmost / boundary is only in my heart / I feel the surge in my veins

Come! Let this battle survive in the legend / Come! Let my fighting spirits flaming between earth and heaven for thousands of years

Gods and Buddhas, please accept my challenge

Whatever emotions you are holding toward me, please battle with me

I want to FIGHT!

Monkey King in My Work

This time, I want to set the Monkey King up in peaceful times. The former savior could take a walk in the street at twilight. Of course, he would look at his past glories now and then. The Golden Band ridden with odd etches / have you gone afar / Eighty-one adversities, the five hundred years flashed by, time snapped to a stop / all the past blurred with thriving wild grass

The rusted Golden Band / reminds him of the Mountain of Flowers and Fruit / Are you leaving, Hero?

A sigh / using cloud-somersault to cover dozens of miles could never happen again

It is said / he is gone

 68

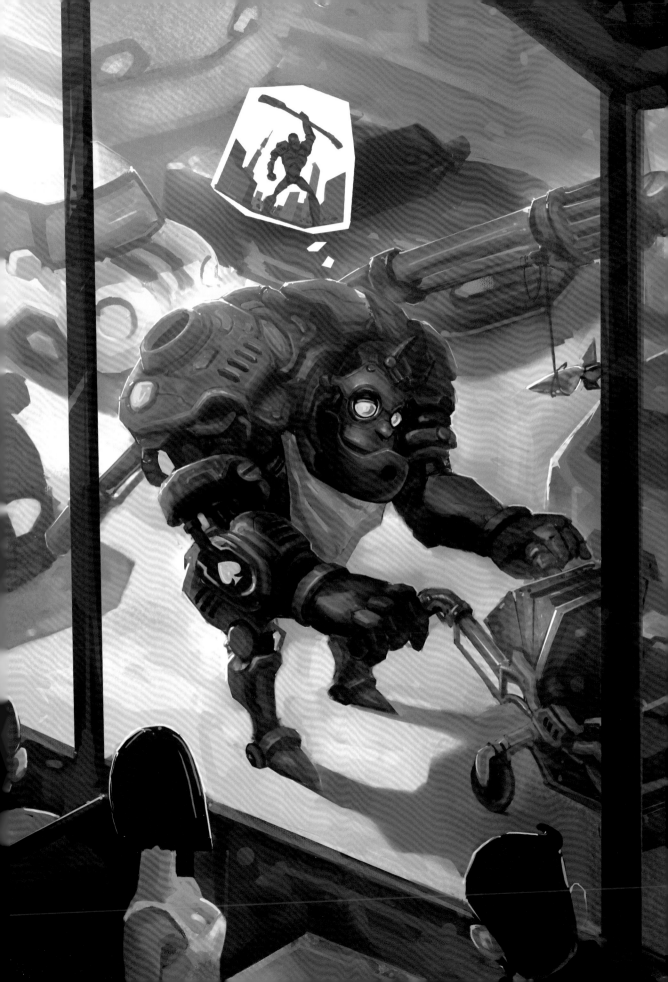

Kan Shimeng

Screen Name_Iceberg

Kan is a concept designer and character designer who loves illustration and toy design. His CG works were awarded the Cover Design Award of "Computer Arts." Now, he works as one of the concept artists for PENGTOYZ, fully engaged in GK creation.

http://blog.sina.com.cn/sywdxx wmefgh@hotmail.com

Monkey King in My Eyes

I first got acquainted with the Monkey King through *Havoc in Heaven*, an animated film directed by Wan Laiming. I was amazed by this hero who holds the "pillar that pacifies the oceans" and is capable of the cloud-somersault and seventy-two transformations. He is so cool!

Later, I used all the means to collect materials on the Monkey King. As for who this character was based on, opinions varied.

Some people believe that his prototype was a prestigious Tang Monk named "Aware of Emptiness," or a miraculous rock, or a god commanding water, or an Indian miraculous monkey named Hanuman. Actually, none of these theories matters to me. What I'm concerned about is what has happened to this character. All these materials have provided me with a lot of inspiration.

Monkey King in My Work

I have already produced two versions of GK works on the Monkey King. The first version is largely based on the illusions in my mind, without referring to any traditional images, which turned out to be a great pity for me. Therefore, I started to work on the second version of the Monkey King. The entire production process takes two and a half months. Fortunately, the final effect of this illustration is quite satisfactory to me.

In the preproduction stage, I referred to many materials, mainly about ancient Chinese armor. A perfect Monkey King deserves a set of imposing armor. Looking through armor of dynastic China, the glittering armor in Sui and Tang dynasties looks the most handsome. Besides, Tang dynasty is just when the story of the Monkey King took place. After determining the dominant features of the armor, I started to work on the details. Only the left shoulder features the motif of beast head, which is intended to produce asymmetry. Besides, the coverings for the left

and right arms have been removed so that the originally complicated glittering armor has been simplified. The knee-length skirt has been changed into a fitting armor, which has reserved the resistance function and highlighted the outline of the legs.

The dominant elements of the illustration have been finished. Now I finally get a break to introduce the concept of the work. This work is intended to capture the scene when the Monkey King has turned into a "Victorious Fighting Buddha" after he has practiced Buddhism and discarded all the evil thoughts. Afterward, the Monkey King is even superior to the Shakyamuni. All those evil thoughts that the Monkey King has discarded flew from the mouth of the Buddha, transforming into the evil looks of the Monkey King in the initial version.

At last, I want to express my sincere thanks to all the friends who have lent support to the PENGTOYZ. Their inspirations have spurred us to make constant progress.

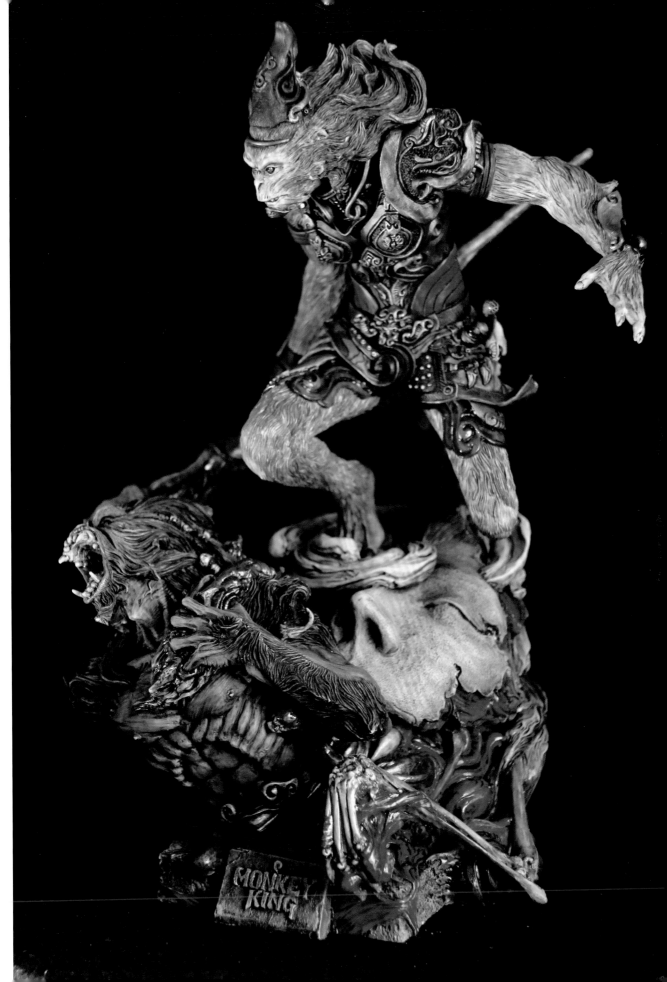

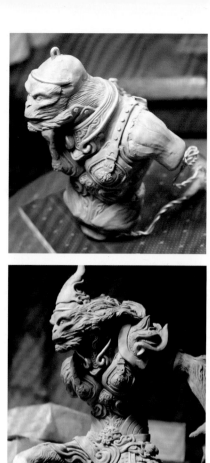
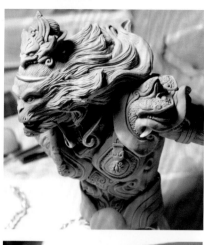

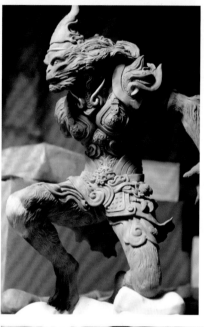
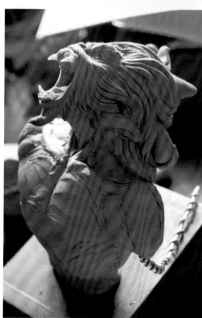

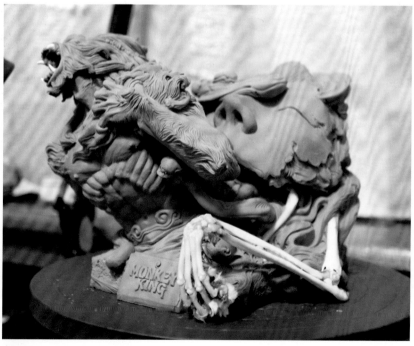
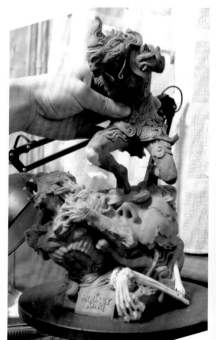

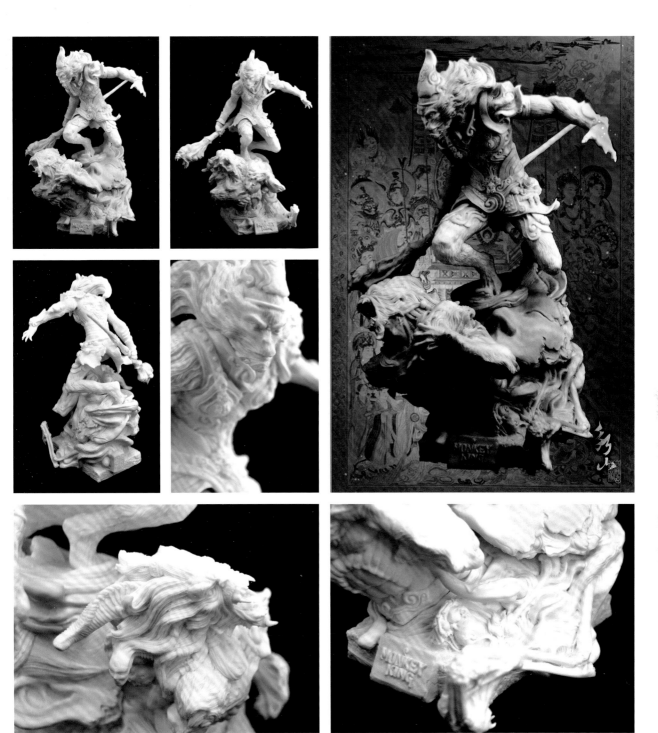

Step 1: After determining the size and ratio, I used Super Sculpey Firm (a good choice for sculpting clay) to make a rough statue. Afterward, I started to tear apart the body and deal with its parts one by one. I prefer to start with the head and body.

Step 2: After the head and body were generally finished, I started to make the golden coronet. However, I was not satisfied with it. Along with the flowing hair, it looked extremely awkward. Therefore, I had to remove it and start all over again.

Step 3: The motion of the legs was quite important, because it would determine the dynamics of the entire body. Therefore, I had to make good adjustments. Some accidents happened when the finished legs were baked in the oven—the knees were burnt. I could do nothing but remove the burnt parts and make amendments with AB clay.

Step 4: I had already done the Monkey King before. Therefore, it did not take much time because I had been familiar with the process.

Step 5: After integrating the Monkey King, his ferocious expressions, and the Buddha's head, I stopped to review the overall effect so that I could make corresponding adjustments if there was any problem.

Step 6: I used some organic materials during the production process—the animal skeleton. Using such materials would make the production process easier. No artist is more outstanding than nature.

Step 7: Only some small parts were not done. OK! Basically finished!

Li Guanzhen

Screen Name_**zguan** Profession_**art director in the game industry**

Li has been working in game design since 2006.

✉ guanzhenk3@163.com

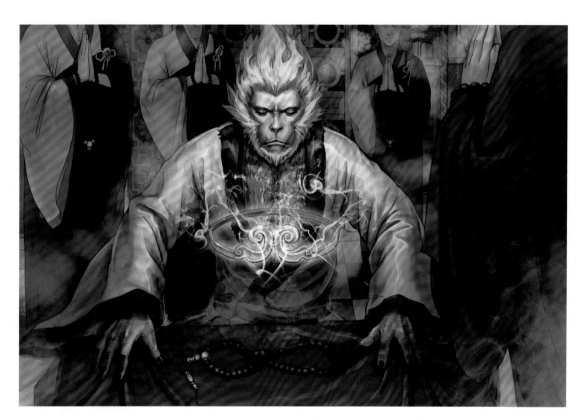

Monkey King in My Eyes

In my childhood, I enshrined the Monkey King as a hero, an incarnation of justice. He always came to the rescue of the Tang Monk, Pigsy, and Sandy when they landed in danger, and he gave a hand to those who were in desperate need. When I grew up, I came to the understanding that he used to behave according to his whims by claiming the mountains, commanding wind and clouds, and exuding an air of overlord. Later, he was imprisoned at the bottom of the mountain for five hundred years for having violated the heavenly rules. Afterward, he put on the magical headband and protected the Tang Monk on his pilgrimage to the west. Maybe he has finally understood something after five hundred years of loneliness and pondering. I still remember how he transformed into a demon servant and knelt down to the Demon Grandma in the cave in order to save the Tang Monk. Before doing so, the Monkey King shed tears outside the stone cave. After all, he used to be the Great Sage who dared to challenge the Heaven Emperor. My personal understanding of this episode is that it could be viewed as a story about personal growth.

Monkey King in My Work

I decided to draw a Monkey King wearing the magical headband, which can demonstrate my understanding of him in this stage. In my opinion, the Monkey King has experienced three stages—demon-human-Buddha. The moment that he put on the headband indicates his transformation from demon to human. He must be calm in appearance but struggle intensely at heart. The scene when the Monkey King put on the headband in the film *A Chinese Odyssey* has always lingered in my mind. I decided that this static shot would be a good idea for this work. With this concept in mind, I started to look for reference materials. At this stage, I don't feel competent enough to illustrate the picture conceived in my mind. Anyway, I was expecting a challenge.

Step 1: In the drafting process, I made the composition and configuration clear.

Step 2: I overlaid the solo color. This process is essential to color match.

Step 3: I elaborated on the solo color; I created a sense of space.

Step 4: I added the mist, divided the space to enrich the picture, and further enhanced the sense of space.

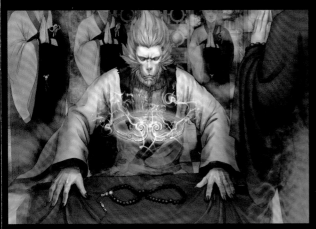

Step 5: After making the overall adjustments, I started to elaborate on the details in the foreground and background, focusing on the Monkey King and his magical headband.

Step 6: I made further adjustments. At this stage, I revised the facial expressions of the Monkey King to illuminate his face.

Li Hao

Screen Name_**HAO, C9** Profession_**toy designer, product designer**

Li is a creature aiming at creating interesting designs.

 http://hao.lab.blog.163.com ✉ exs01@tom.com

Monkey King in My Eyes

My first impressions of the Monkey King come from a classical TV series starred by Liu Xiao Ling Tong, which I saw in elementary school. In that TV series, the Monkey King is always thrilled with joy, no matter in facial expressions and actions. I used to buy this overexaggerated approach. But when looking back now, it always occurs to me that this approach is indeed a little biased—the TV series has been focused on highlighting some positive properties of the character and overstating his almightiness. When working on this project, I bought the original novel *Journey to the West* and made up my mind to reinterpret this character. However, I was not keen enough to obtain a good understanding of the character's inner world. Therefore, I put down the novel halfway through, and started to search on the Internet to see what others think of him. Actually, the *Journey to the West* has been reinterpreted by later generations so many times that it is really difficult to distinguish which interpretation sticks to the original fiction. However, this is kind of good, because we have indefinite room for imagination. Personally speaking, I prefer some unofficial and unauthentic but logical and reasonable interpretations. All these interpretations have challenged my childhood memories of this TV series. These theories concerning the interest relations and conspiracy will pose a powerful emotional impact on the conventional readers. I used to be one of them.

Monkey King in My Work

After turning down my original ideas based on the golden band, I focused my eyes on the curves on the monkey's tail, which reminded me of the stripes on the jail uniform in other countries. At this moment, a fiction suddenly occured to me as follows: the Monkey King was sentenced to five hundred years of imprisonment for conspiracy in the Nirvana, which had violated the heavenly laws. His golden band was sent to the Ministry of Penalty for weapon research. However, I was concerned whether such a concept would compromise the glorious images of the characters in *Journey to the West*, and finally gave it up. I didn't know why I couldn't decide on the looks of the Monkey King this time, but as long as I could capture what he stood for, I did not need a concrete image. Besides, I started to think about what the Monkey King would do in the future, when the Captain Black Cat popped out in my mind, along with an obscure image of the police wagon featuring white and black motifs. Therefore, I decided to work with this instinctive impression to invent another story and create a Monkey King Robot coming from the future.

I assumed that I would produce an animated film on a future Monkey King featuring fantasy style. I didn't intend to create an invincible Monkey King. I might give him a powerful weapon—a robot guard controlled by the nerves of the Monkey King. This robot is good at close-distance combats, based on existing technologies and featuring somewhat realistic functions.

Step 1: I sketched a draft illustrating how the Monkey King and the robot would throw themselves into a battle. Later, I changed the perspective and incorporated atmospheric elements. Though the picture seemed more visually striking, I still preferred the original draft. This Monkey King featured a somewhat distorted gesture and a flat sense of perspective, which was a trademark for traditional Chinese story books. This approach was classcial and traditionally Chinese. However, I would not add too many Chinese elements. I was looking for a simple look and a sense of curved plane.

Step 2: In order to reinterpret the classical image of the Monkey King, I did not give his rival too much space throughout the drafting process. After all, he was only a supportive role who was only intended to enrich the picture. There was no point in spending too much time on him. However, it dawned on me that as long as I had referred to the F-117 stealth fighter, I had transformed the robot into a stealth-invasion machine, who would be even more advanced than the Monkey King. In addition, I tried to add a few more arms and bodies to create an imposing air, when it suddenly occurred to me that this robot shared a lot in common with the three-body-and-six-arm Prince Nezha. Though this character was not to my liking, I still searched for some references and elaborated on some details. At least, I had to ensure that the character looked striking at first sight.

Step 3: After finishing all these drafts, I started to draw the final. The drafts had captured the most intuitive and original ideas. I focused on the concept development and drafting of the character. The messages I wanted to deliver had already shown on the paper in the former stages. Therefore, it was really a bore to work on the final. This time, I just intended to draw a toy design sketch, thus little consideration was given to the textures. The black-and-white effect was used, and the coloring process did not involve too many techniques. As usual, I made two logos, and added some textual titles. Finished!

Step 4: Actually, I had not gotten all that I was looking for in the final, because it was not simple and abstract enough. However, considering the looming deadline, I picked up one of the drafts that was relatively satisfactory and worked further on it. Afterward, I realized that there was still some time left so I added the golden band and made another experiment of mechanical design.

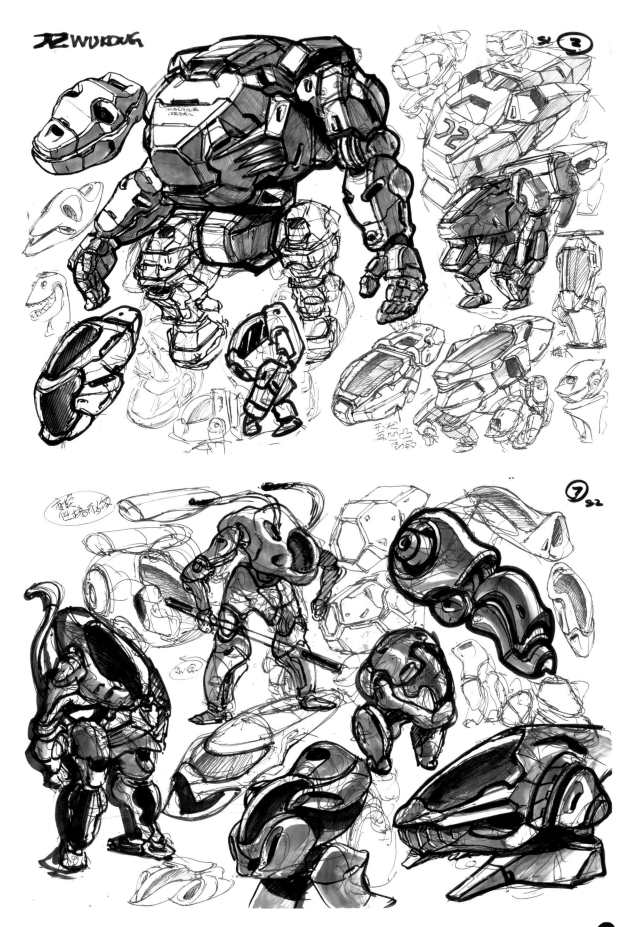

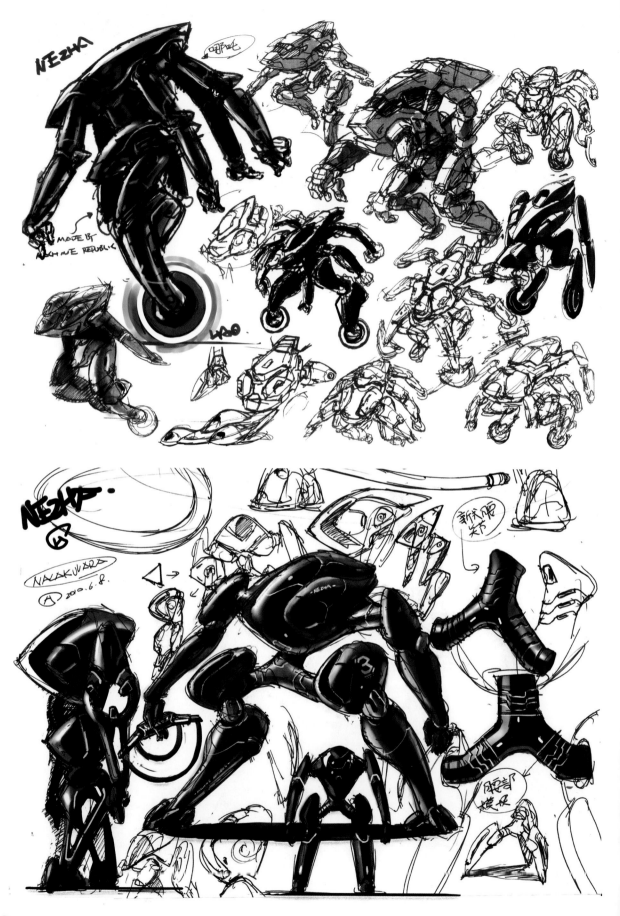

WOKONG
WEKPONE.

OPEN

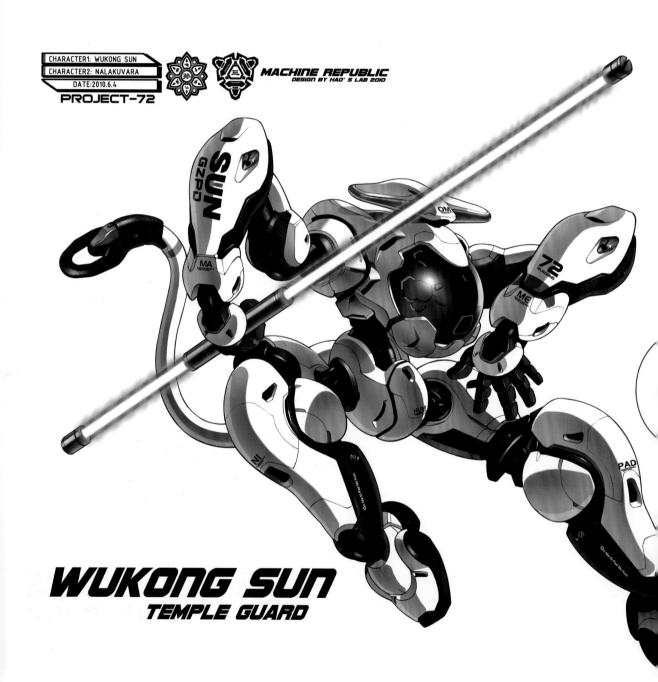

CHARACTER1: WUKONG SUN
CHARACTER2: NALAKUVARA
DATE:2010.6.4
PROJECT-72

MACHINE REPUBLIC
DESIGN BY HAO'S LAB 2010

WUKONG SUN
TEMPLE GUARD

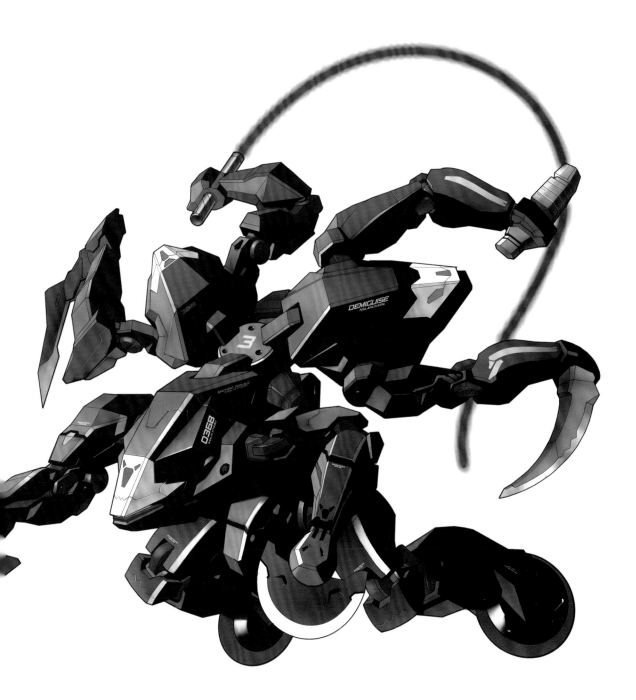

NALAKUVARA
STEALTH ATTACBOT

Li Kai

Screen Name_Dry Orange Profession_**concept artist in the game industry**

Li is a drawing lover.

23

http://blog.sina.com.cn/fuckorange 63627169@qq.com

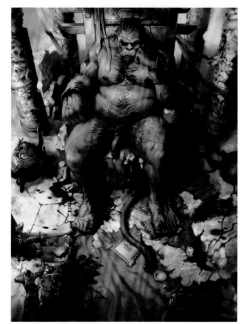

Monkey King in My Eyes

The Monkey King is a hero who has influenced me the most since I could remember anything. I first got the notion of "rebellious" through this hero.

I don't know why I always feel that the Monkey King seems to exude a sense of tragedy. I'm not sure whether gaining the Buddhahood at last really means "fulfillment" for him. I loved drawing the Monkey King since my childhood. Maybe it was out of sympathy. I always drew a Monkey King who was under punishment. In one of my most impressive illustrations, balls of different sizes were piled up to make a pyramid, while the one at the very center of the last row was a monkey's head, intended to illustrate how the Monkey King has been imprisoned at the bottom of the Five-finger Mountain. Back then, I was not old enough to go to kindergarten. Such a composition is considerably bold. At least, I would not dare to try such a composition now… I always prefer the Monkey King who has not embarked on the pilgrimage to the West. Rebellious, ignorant, undisciplined, and free… I love him for who he really is. It might be said that it was the most glorious stage in his life. However, it is by practicing Buddhism and through the restraints in the later stages that he finally turned into a complicated character who has finally gained human nature, in which lies the greatness of the classical fiction *Journey to the West*.

Monkey King in My Work

I want to draw a Monkey King who lives a carefree and unrestrained life on the Mountain of Flowers and Fruit. Therefore, I referred to the clothes of the local gangsters when designing his costumes. I used a lot of coarse textures such as beast hides and hemp ropes, and spent a lot of time on the drafting process. The Monkey King should look undisciplined, mischievous, and a little naive. I don't want to create a Monkey King who is hardly recognizable—after all, the traditional image of the Monkey King is already well established. Therefore, I chose to make some changes in the hairstyle and accessories. As to the cloud-somersault, I want to illustrate it as a being made up of drifting clouds and mists that could communicate with the character. I believe the illustration will become more lively by doing so.

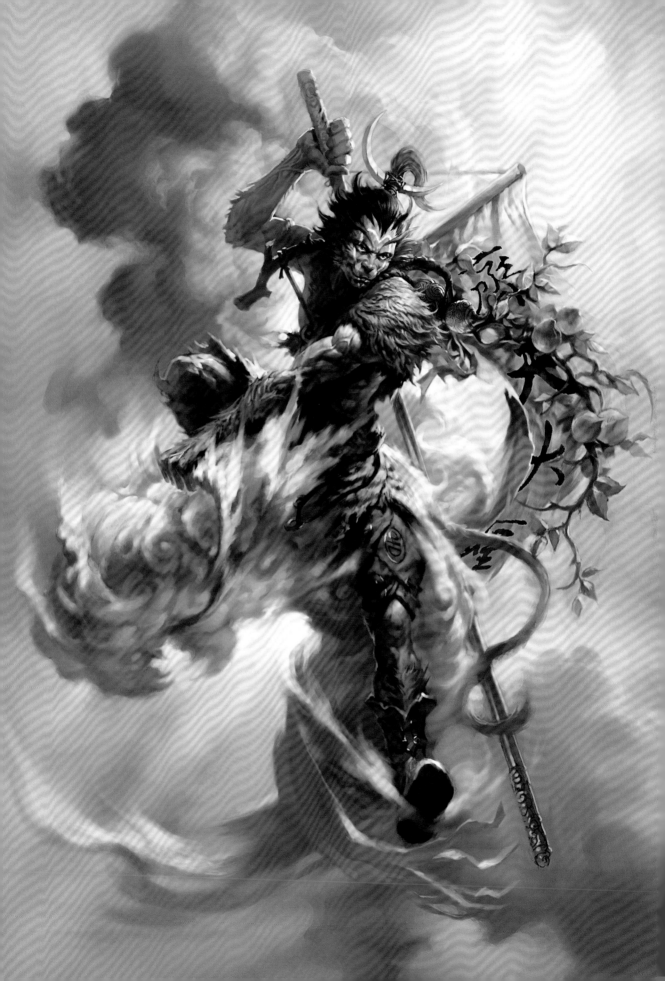

I determined the base color after the draft was scanned. There is nothing wrong with noisy colors at this stage, because I can still make adjustments in the later phases. For an extended gesture, I made some adjustments in the head, arms, and legs.

I started with the dominant elements and then moved to other parts. The facial expression was no doubt the highlight of the illustration. When working on the expression, I always thought of myself as the Monkey King who was traveling on the cloud, imagining what was in his mind in such a situation.

It would save a lot of effort to select a proper brush, especially when drawing clouds. The clouds always featured rich details and constant changes. By using the brush for clouds and mists, everything would become a lot easier.

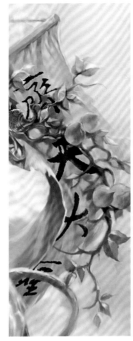

It is important to choose suitable materials. The strong sense of existence can only be found in real objects. Of course, materials identical with the illusions in our mind are difficult to locate. Therefore, in most cases, we only focus on what is required.

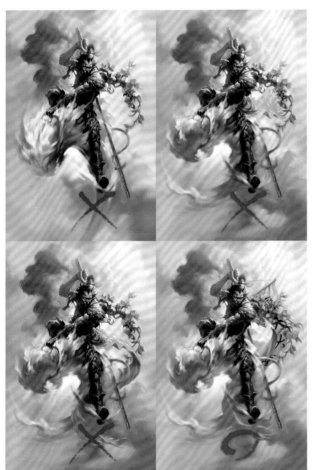

When working on the cloud-somersault and banner, I experimented with many compositions so that the motions of the character and the surrounding environment as well as the components would go in accordance. Besides, I also had to ensure the integration of strokes.

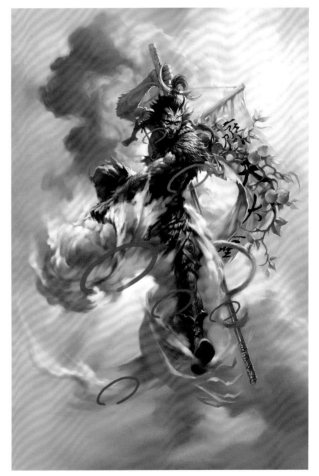

At this stage, I determined two secondary lighting sources in addition to the dominant lighting source (daylight): Light II was the reflective light in the space (the part in the red circles), and Light III was the reflective light emitted by the character (the part in the blue circles).

24

Li Ming

Screen Name_**Daybreak** Profession_**visual designer, illustrator**

Li is a designer for the fashion brand FIREPANDA. He is the manager of the HI brand based in Guangzhou and also works as a column writer, advertising illustrator, and visual designer. He has also worked in graphic design, photography, illustration, comics, as well as toy and fashion brand design.

http://daybreakswork.blog.163.com/　896075990@qq.com

I experimented with various styles of monkeys, which were later made into stickers.

I experimented with stickers featuring different styles of monkeys.

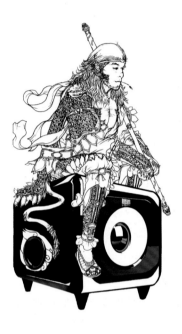

The American-style monkey is also made into stickers.

The sticker made for the first anniversary of YOHO Magazine.

The images of Monkey King designed for a sound box brand, which have observed the traditional Chinese approach.

Monkey King in My Eyes

The first cartoon image I ever knew about was the Monkey King. My father worked in the printing industry. Therefore, I had access to a lot of storybooks in my childhood. As for the *Journey to the West*, I still remember that there were five editions by five different authors, each of which boasted a distinctive style. Among them, the works of Liu Jiyou were my favorite. As an adult, I still have a lot of opportunities to draw the Monkey King. He is no doubt one of the best-known legendary figures in China. Among all the anecdotes in *Journey to the West*, I like *Subduing the White Skeleton Demon Three Times* most. I have learned from it that insistence on the right things will be rewarded by the recognition of others. I love this figure because he is naughty, unyielding to difficulties.

Monkey King in My Work

After serious consideration, I tried to draw several drafts to illustrate the Handsome Monkey King; all ended up in the trash can. Suddenly, it occurred to me that the Monkey King is a monkey in the first place. Therefore, I decided to capture his primitive nature. This illustration is basically based on how the Monkey King and the Heavenly Dog fought with each other for bananas. In my story, the Monkey King has gained Buddhahood after his pilgrimage to the west. Later, he returned to the Mountain of Flowers and Fruit. By exploiting his intimate relationship with the Thunder God and his seventy-two transformation capacities, he cast a spell on the bananas in the mountain and transformed them into incomparable delicacy. All the evil spirits have turned into vegetarians through a conversion process. Therefore, the bananas in the Mountain of Flowers and Fruit are mostly wanted—the Monkey King has to throw himself into the battles again… As the Monkey King never holds back from expressing his love and hatred, I used the flaming red and bristling hair. Plunder is a recurring theme when we talk about the Law of Nature. For metaphorical meanings, I used the pythons to stand for greed and anger; white skeleton for hatred, love, and stupidity; the dog for evil; bananas for people's goals. On our life journey, we always feel as if we can never arrive at our destinations on time. This is because we have been possessed by all these aforementioned negative feelings. The golden band stands for introspection and redemption. Generally speaking, I would like to incorporate some life lessons into my works. I enjoy the creative process a lot!

Step 1: I started drawing on the computer. After deciding on the concept, I started with large color lumps. Fountain pens were used to trace the gesture of the character.

Step 2: I like to do the drafts with a red sharp-pointed brush. Further adjustments to the details were made in the outlining process. I kept the overall effect in mind.

Step 3: I transformed the lines into deep brown and added the details. The draft was largely finished.

Step 4: I filled the lumps with color.

Step 5: I added light and shade and motifs to the cloth. I colored the tattoo, which is based on the Supreme Heavenly God, on the dog's arms.

Step 6: After the coloring was basically finished, I added something interesting, such as the sticker and incantations to drive away the evil spirits. I added the paper textures in the background later.

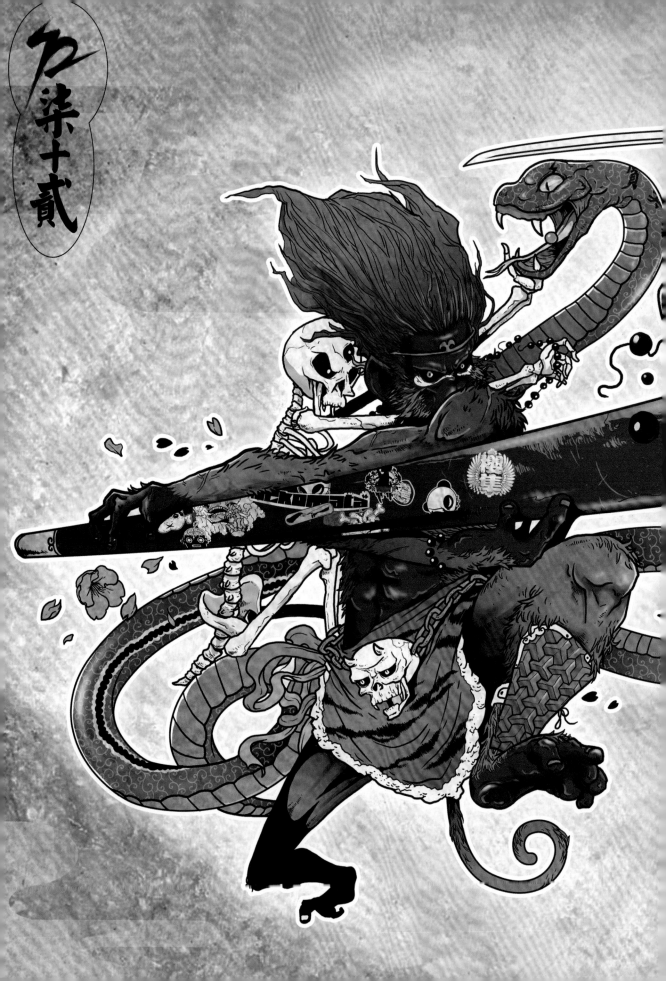

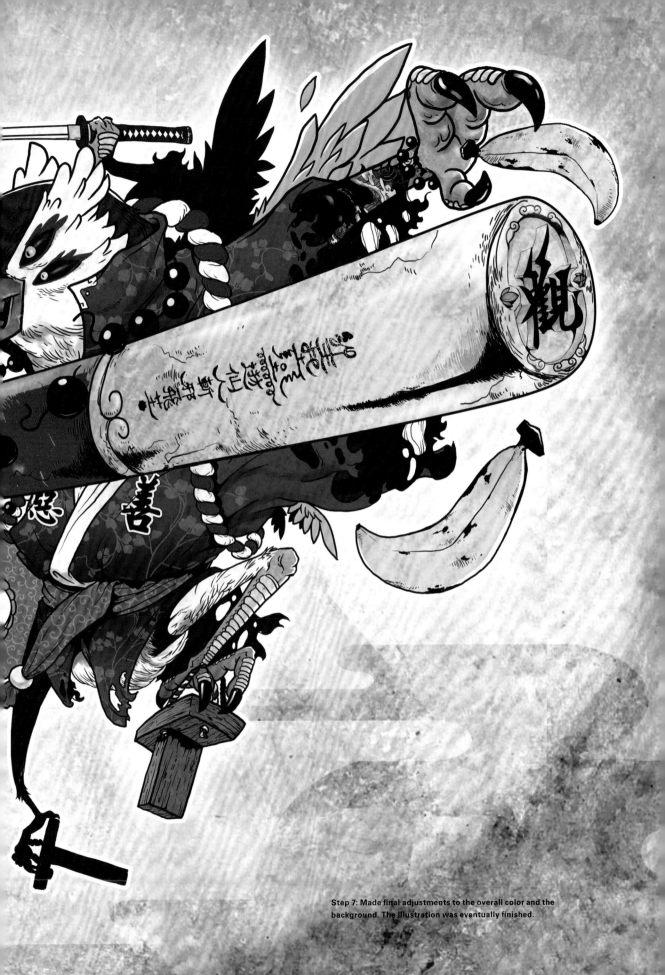

Step 7: Made final adjustments to the overall color and the background. The illustration was eventually finished.

Li Xiongbin

Screen Name_**MILK** Profession_**game designer, illustrator**

Li works in game design and re-creation painting.

http://milk0504.qzone.qq.com milk0504@vip.qq.com

Monkey King in My Eyes

All those born in the 1980s must have been deeply influenced by *Journey to the West*. This TV series was a common choice for many local TV stations every summer vacation. It is believed that many of us had dreamed of obtaining the fiery eyes and golden gaze, being capable of various transformations, and having supernatural power, just like the Monkey King (also called Sun Wukong). The Japanese manga *Dragon Ball* is another collective memory for us. The protagonist of this manga is also called Sun Wukong. Those born in the 1980s have obtained a

remarkable knowledge of Sun Wukong through both works. Actually, the Monkey King has posed a profound influence throughout the world, especially in Japan. Female versions of the Monkey King appear occasionally in many Japanese games and cartoons. It is relatively easy to capture the Monkey King. The headband or the golden band is enough to make clear his identity. As long as the artists can distill these defining elements, we can come up with various versions.

Monkey King in My Work

I prefer teams to individuals. Therefore, I have taken consideration of his company on his journey to the west. According to the original novel, all four pilgrims are males, but I want to make a twist this time. Except for the Tang Monk, all the other characters have been transformed into females.

This illustration is very challenging to me. I attempted to integrate the Japanese manga styles and the Chinese subject. Besides, I tried to add some traditional Chinese patterns (such as auspicious clouds), making it a little difficult to make an integral whole.

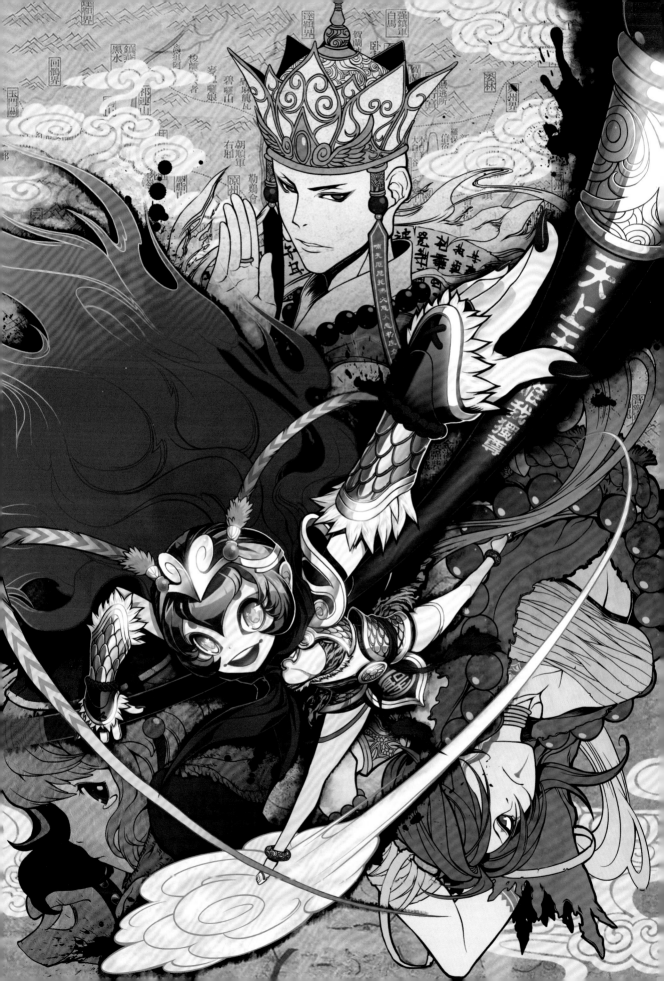

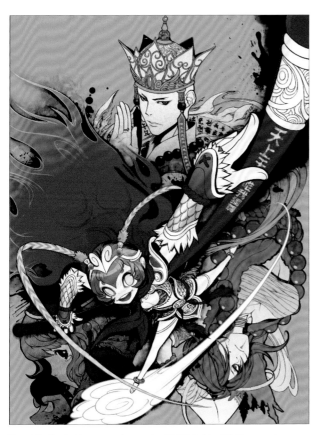

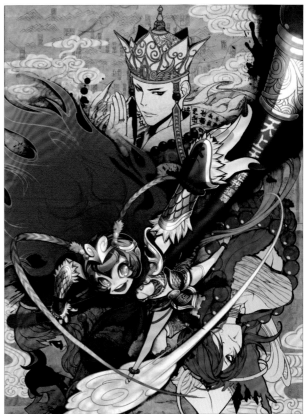

Step 1: In the drafting stage, I wanted to highlight his athletic competence and his aura. Therefore, I deliberately amplified the perspective relationship by stretching the actions. Besides, I allocated different layers for his company. I selected different colors for different characters when working on the draft, which would make it less confusing to do the outlining.

Step 2: In the outlining stage, every character had his own layer. It should be noted that we have darkened the shades to enhance the sense of depth. I could also make adjustments to prioritize the highlight for a desired effect.

Step 3: In the bedding process, I basically painted each character in the same color with the outline. Following this step, I could start with the coloring process.

Step 4: This step was a little time-consuming. When managing the color palette, I tried to give each character no more than five colors for fear of the picture appearing too garish. It took me a lot of time to work on Sandy and Pigsy. As both characters had been reinterpreted, I needed to use a gradient color on them. I adopted a typically Japanese bedding approach in this process. Each color was basically allocated to a separate layer, while different layers were integrated after the light and shade had been determined. This approach boasted a distintive merit—I could immediately adjust the color palette to make it more visually appealing after reviewing the overall bedding effects.

Step 5: As the highlight of this illustration is the Monkey King, the color palette in Step 4 threatened to cause distraction, as his company were equally eye-catching. In order to reduce the flatness and uniformity, I added some paper textures. Ink brushes were used in an extensive way. I then outlined this figure to highlight its prominence.

Step 6: In this final coloring step, I set my focus on the Monkey King. I hoped that the color palette would appear natural, bright, and velvety. As the Monkey King was known for his fiery eyes and golden gaze, I put some starry elements in his eyes to make it funny. Later, I added some ancient maps in the background to give a nostalgic touch. As last, I added the motifs of auspicious clouds to enhance the Chinese style. This illustration was finally finished. It took me around thirty hours from the draft to the finish.

Li Zhunan

Screen Name_**Biscuit / Biskit** Profession_**street graffiti artist**

Li is a Beijing-based artist and a pious graffiti fan.

http://www.biskit.cn ✉ **biskit@126.com**

Monkey King in My Eyes

Journey to the West is an integral part of my childhood memory, and the Monkey King is one of my favorites. As an epitome of traditional Chinese culture, the Monkey King has almighty prowess, which has impressed me most. His seventy-two transformations always give us one surprise after another. In my childhood, it was a common practice for little boys to mimic the Monkey King. Wearing his masks, swinging the golden band, we chased and fought each other in a maniacal manner. Many years later, when doing graffiti arts, I have thought of using the Monkey King as my subject. I have been thinking how to capture the Monkey King in my mind. Later, I find it not difficult to find solutions, because I have identified what I myself share in common with the Monkey King: Just like him, I am also dynamic and flexible. As long as I have known for sure what I want, and determined the color palette and illustration style, the Monkey King in my mind will look vivid on paper.

Monkey King in My Work

This work is done in cooperation with the French street artist Seth at the 798 Cultural Zone in Beijing. Last time Seth was in China, he ran across my sketchbook and got really excited at the sight of a draft on the Monkey King. He told me that we have a common interest in the Monkey King. Later, he showed me his draft of the Monkey King. His intensive interest in traditional Chinese culture impressed me. Therefore, we decided to collaborate to produce an illustration. To highlight the theme, we need another supportive role, the Erlang God. He is entangled with the Monkey King on many occasions, and the entanglements between them added interest to the whole story. Later, we invited our friend Nato to join us. Therefore, this illustration, using Chinese red as the dominant color and incorporating both the Eastern and Western styles, has come into being.

Julien Malland

Screen Name_**Seth** Profession_**illustrator, graffiti artist, editor, documentary producer**

Seth is an artist who likes painting characters on the wall. He likes taking trips all over the world to meet street artists of different backgrounds. His works take various artistic forms and touch upon various subjects. His earnings enable him to afford his global tours and continue with his artistic creation.

http://www.globepainter.com juinzeworld@yahoo.fr

Monkey King in My Eyes

When I came to China in 1999, I was impressed by the significance of the Monkey King as an exemplification of the Chinese culture (to the Westerners, the Monkey King is a "God of Monkey"). He is also one of the several classical Chinese images that are popular among Chinese overseas and some foreigners. I have known him since my childhood.

I still remember the amazing story which I came across in the school library. Since then, the Monkey King has become my favorite Chinese legendary figure. Therefore, it is of great significance for me to have the opportunity to reinterprete this image during this trip.

Monkey King in My Work

As an illustrator, my real Chinese journey did not start until 2010, when I was deeply obsessed with the traditions and cultures of this country. I feel honored to have the opportunity to cooperate with Biskit and Nato, who are known for employing modern artistic approaches to create works on traditional and historical themes. On my first journey to Beijing, I was introduced to them and then began our collaboration.

One of the most important parts of my creative process is to work with local street artists, which is a way to familiarize myself with the local cultures. Nato has invited me to paint on a bus at the 798 Cultural Zone in Beijing. This cultural

zone is a community for local and international artists, as well as a window to exhibit Chinese arts to the outside world. Therefore, this is an ideal venue to exhibit our cooperative work. Finally, we decided that I was responsible for the left part of the Monkey King, while Nato and Biskit were responsible for the central and right parts respectively.

As a traveling illustrator, I have been to many different countries including South Africa, India, and Brazil. Influenced by the local drawing styles, I incorporated the signature elements of each country and tribe into my works.

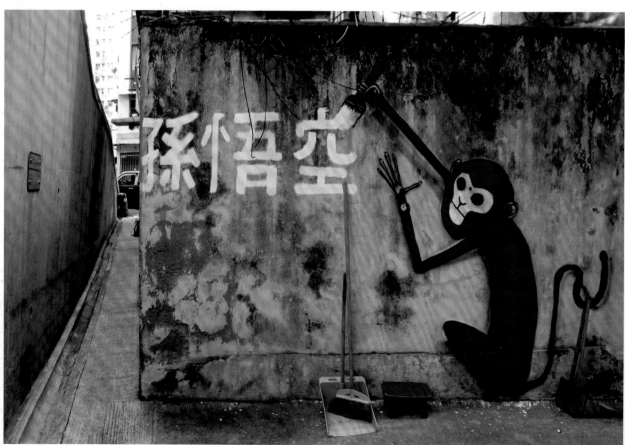

Liang Yan

Screen Name_**JO-COYAN** Profession_**game designer, art executive**

As a concept artist, Liang can be interpreted as the silence after countless dashes. In a quiet but not silent, exciting but not noisy background, he has played with different elements to produce illustrations.

http://blog.sina.com.cn/jo803 jo.803@hotmail.com

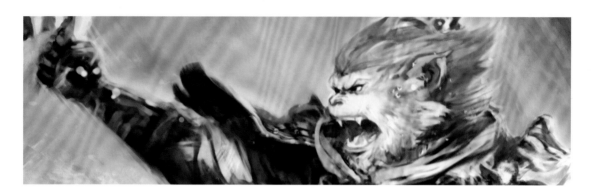

Monkey King in My Eyes

The Monkey King can be interpreted as an untamed monkey that has finally gained Buddhahood. This illustration is based on his battle with the three princes guarding the Western Sea. Though the Monkey is not good at maritime battle, he still subdued his rivals despite all the disadvantages by virtue of his perseverance as a warrior. The armor and golden band have given full expressions to the undisciplined and unrestrained nature of the Monkey King.

The Monkey King is someone we have admired and imitated since our childhood. I also have a concrete understanding of this figure. I hope that I can produce a perfect image with my techniques.

Faced with the blank drawing board, I am really hesitant to draw. Maybe I am a little confused how this Monkey King is different from the real one. I just hope that he will be flawless. Another picture of Monkey King flashed by in my mind. He is also armored, his eyes glittering with arrogance and the skull looming in the darkness. This image is different from the original one in terms of scene and atmosphere. Due to time limits, I have decided to focus on the first image.

Monkey King in My Work

"The combat was unexpected, and the enemy is at a stone's throw distance. The Monkey King felt an enormous strength surging from the edge of his palms and spreading up the arms. He kicked the rock under his foot…" This illustration is inspired by a scene depicted in the original novel, enhancing a sense of tension. Such a visual effect incorporating both stillness and dynamics will trigger boundless imagination.

Firstly, I decide on the color palette and finish the character design. At this stage, I have referred to my collections of works featuring the Monkey King. The Monkey King can be cartoon-styled, muscular, gentle, or fierce-looking. However, I still prefer the traditional image of the Handsome Monkey King. The facial expressions of the White Dragon in the battle are also the highlight—pointed teeth, exaggerative tongue, flowing whiskers, and the giant body are colored blue to construct a vast space with stones and waves, which is a primary part in the composition.

After finishing the draft, I moved on to work on the details, especially the protrayal of the Monkey King. In my memory, the Monkey King is always dressed in rugged cloth or tiger hide, but I like the armor most. It took a long time to elaborate on the armor and hair. It is also interesting to deal with stones and waves. Generally speaking, I took great pleasure in drawing the picture, because the entire process was controlled. The drawing of the fins and scales of the dragon was easier. As for the dragon head and the dragon tongue, I have adopted an exaggerative approach. The sky and the sea in the distance were done in one shot.

This is the entire creative process for this illustration. Though it does not involve bold experiments, the dominant and secondary elements are integrated in a flawless way, facilitating a perfect presentation of the Monkey King.

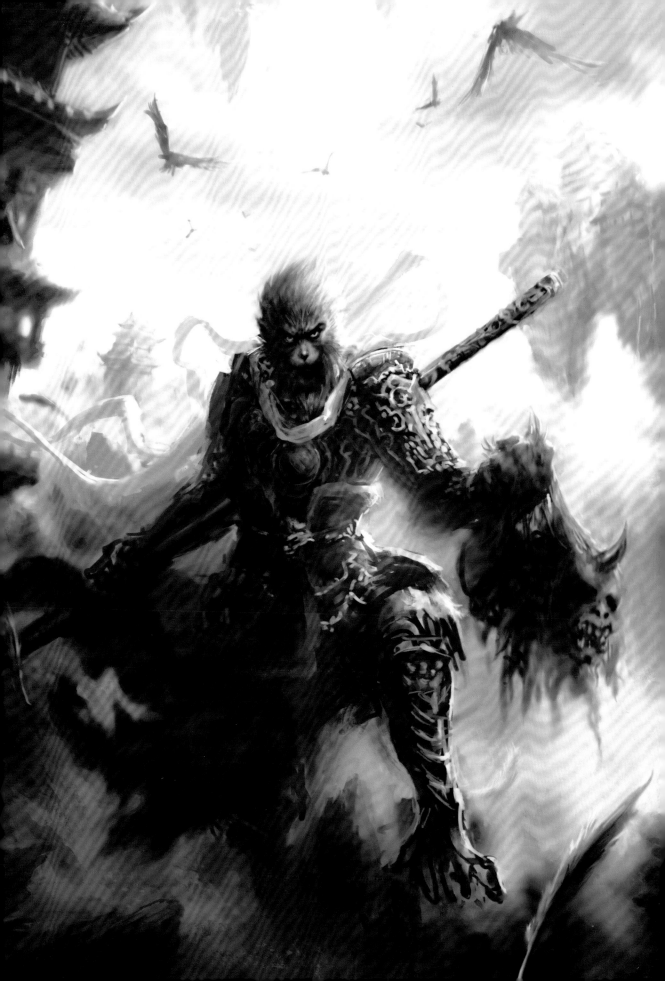

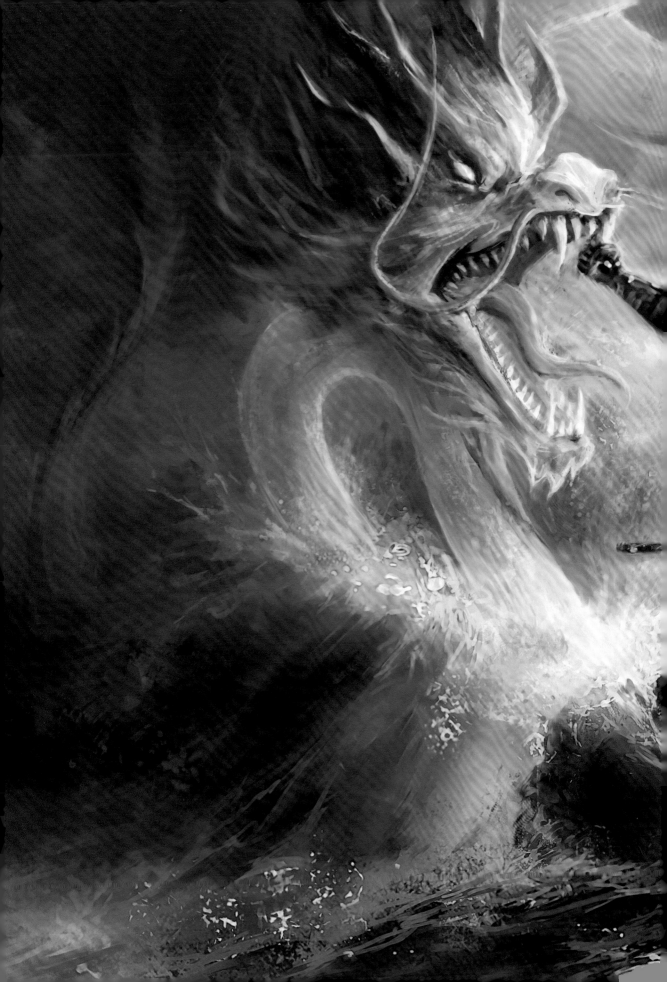

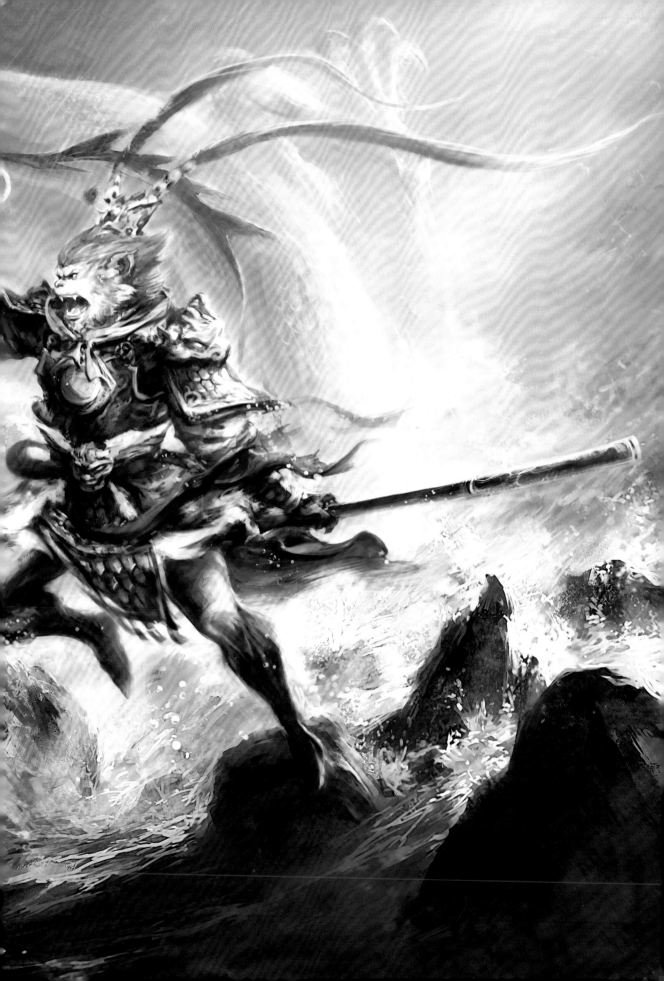

Step 1: I drew a rough draft when the concept had been basically determined.

Step 2: After the draft was finished, I found it quite neat. And then I started the bedding process for the sea and the dragon.

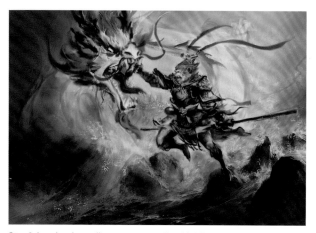

Step 3: I made minor adjustments to produce highlights, especially in the dragon body. Later, I focused on depicting the water and the shadow on the stones.

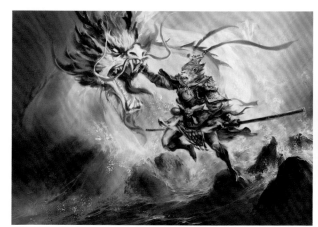

Step 4: I started to depict the White Dragon.

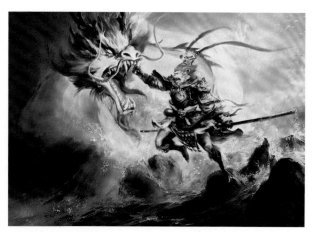

Step 5: Having decided on the overall color palette, I started to work on the details of the Monkey King, including the light and shadow.

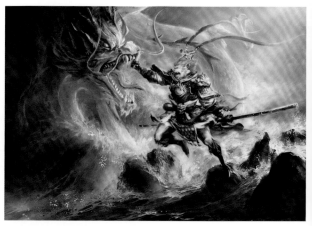

Step 6: The white body of the dragon produced exposure. Therefore, I adjusted its color to make it fit into the sea.

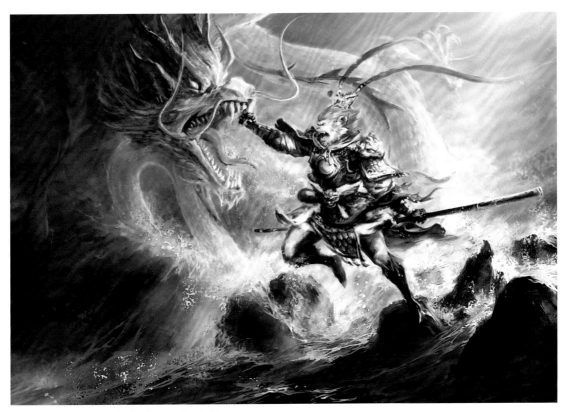

Step 7: I further worked on the details of the illustration.

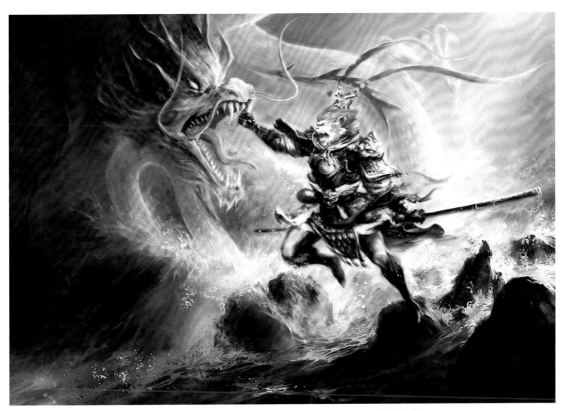

Step 8: I made minor adjustments to the visibility in order to come up with a more lively picture. Finished!

Liang Yi

Screen Name_**Invisible Man** Profession_**concept designer in the game industry**

Liang was drawn by comics and games into a world brimming with crazy ideas at a young age. He had dreamed of working in his favorite animated movies as a top-grade concept designer or becoming a distinctive cartoonist. He also thought of taking a trip in the mysterious universe.

 http://blog.sina.com.cn/hellbb2007 liangyia@linekong.com

Monkey King in My Eyes

In my opinion, the Monkey King is undisciplined, subjected to no restraint. He is keen to deliver justice, protect the good people, and suppress evil; besides, he is always loyal to the Tang Monk and kind to other disciples of his. The Monkey King is always a supreme hero in my mind.

Monkey King in My Work

Recent years have witnessed a surging interest in the *Journey to the West* in the design industry. TV directors, game designers, animation producers, and toy makers are all considering projects themed on *Journey to the West*, and I'm no exception. I myself have been working on the company's project *Journey to the West*. I have been asked by Vincent to illustrate the "Great Sage, Equal of Heaven" in my mind. Though there already exist various configurations of the Monkey King in the market, I still feel excited at the thought of designing the Monkey King.

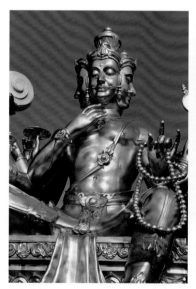

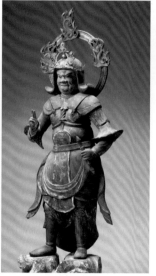

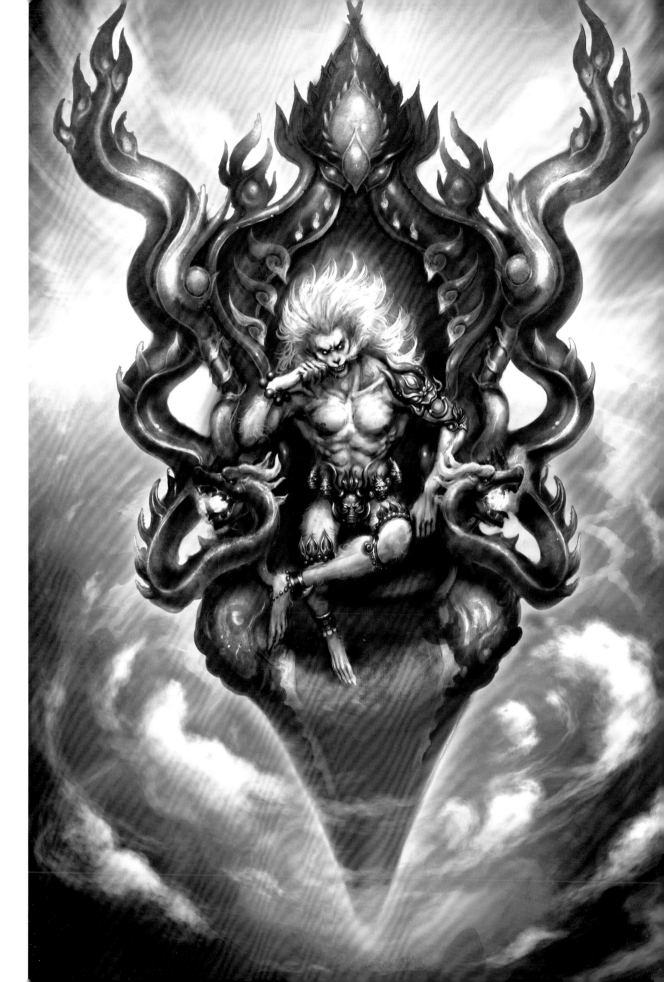

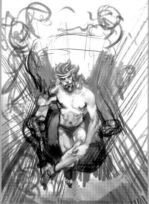
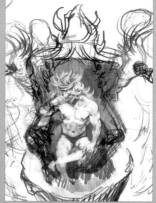

Step 1: I put all these references in my mind to produce a story of the Monkey King. After finding the inspirations, I started to put down my ideas on paper.

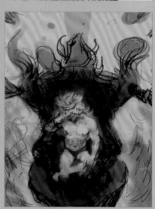

Step 2: I tried to achieve a desired effect through draft composition and quick coloring so I could have a rough idea of the final atmosphere sketch.

Step 3: I referred to a photo of high-altitude clouds to illustrate the effects of overlaid layers.

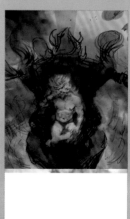

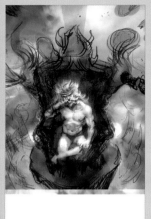
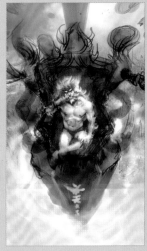
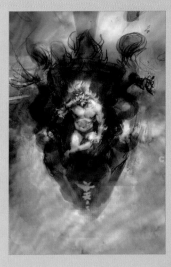

Step 4: I determined the color palette and light and shadow effect of the illustration, and then made a quick adjustment. After that I got what I have been looking for.

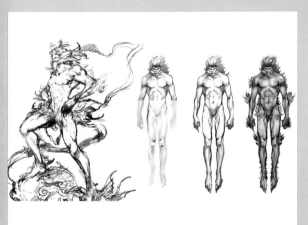

Step 5: I have drawn a series of design sketches for this character, hoping that more and more people can understand what the Monkey King in my mind is like. He is always wild with anger and cares little about daily concerns.

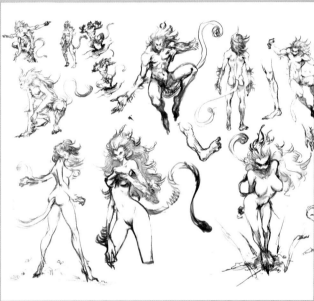

Step 6: With these drafting exercises, I could better demonstrate the distinctive characteristics of the Monkey King. Therefore, it was not long before I could start revising the drafts.

Step 7: At this stage, what I needed to do was to keep the overall effect in mind instead of being obsessed with details and certain parts. After determining the characteristics, composition, sense of space, color palette, and light and shadow effects, I started to deal with layers. I integrated all the layers and then allocated them to the character and background.

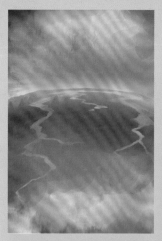
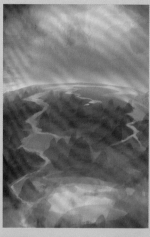
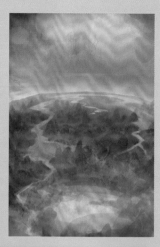

Step 8: This time, I separated the background into another file. I can speed up. I started with allocating the space for the river and determining the perspective direction. It should be remembered that this is high altitude. Then, I moved on to the mountains by determining the height contrast. Following this, I rapidly looked for a photo texture, and integrated it with the layer featuring subdued light effects. The most evident merit with computerized painting is that overlaying different textures and pictures can produce diversified texture effects.

Step 9: Background illustration has been roughly finished. I then started to put the character in the illustration and make adjustments to the character in the foreground and the color palette in the background.

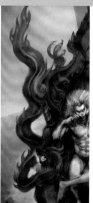
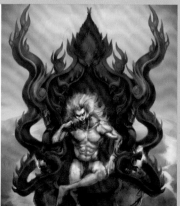

Step 10: After achieving satisfactory preproduction effects, I elaborated on the draft with ease. I started with the details in the Dragon Throne by referring to the materials and searching for inspirations. If you are painting a symmetrical object, you can start with one half, and then reproduce the other half to get a whole.

Step 11: After finishing the details in the Dragon Throne, I set up a texture to integrate different layers to get a richer effect. Then, I tried to produce the light and shadow effects to highlight the splendor of the throne.

Step 12: After finishing the Dragon Throne, I went further to illustrate the effects of high-altitude clouds. I selected a brush featuring clouds and fog effects, which could be downloaded from the Internet.

Step 13: After finishing these supportive elements, I started to focus on the monkey by making adjustments of his muscle. Then, I moved on to the accessories by putting more Buddhism-related elements on him.

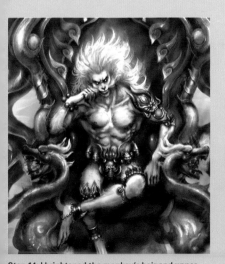

Step 14: I brightened the monkey's hair and upper body to highlight his image.

Step 15: It seemed that this picture was not striking enough. After showing it to several colleagues, I obtained valuable suggestions. I have used a strong sense of perspective for the entire picture but neglected that the character and Dragon Throne featured a weaker and relativley regular perspective. Therefore, I experimented with distorting tools to make proper adjustments.

Liu Dongzi

Screen Name_**Monkey King** Profession_**concept designer, cartoonist**

Liu likes drawing, fighting, and photos of hot girls.

http://blog.sina.com.cn/u/1683650195 82dongzi@163.com

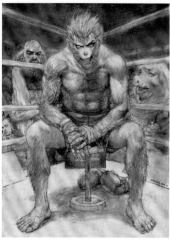

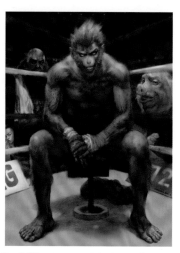

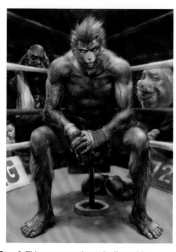

Step 1: I took the Multiply format to make the picture more energetic by maintaining the freshness of pencil lines. I paved the color in a simplistic way under this format.

Step 2: This step was mainly given to the highlighted or light parts of the illustration. Generally speaking, my drawing techniques mainly observed those employed in watercolor paintings. There was much to take note of in drawing the light part or the highlight.

Step 3: This step was about dealing with the last layer, primarily intended to adjust the general relationship between different elements in the illustration, which was why the Multiply format worked.

Monkey King in My Eyes

Not a single Chinese person is unfamiliar with the Monkey King. As a time-honored country, China is endowed with a heritage of mythologies and legends that have fascinated generations of Chinese. In some sense, the Monkey King is no more than an impressive legendary character. I have illustrated the Monkey King millions of times but failed to capture his true image in my work. There is no need to talk more about my attachment to this character: I started to draw illustrations of *Journey to the West* at school; after graduation, I spent two years participating in the production of *Journey to the West* directed by Zhang Jizhong, during which I finished many concept designs and character images. However, I am still unable to come up with one definitive image—something that might haunt me the rest of my life.

Monkey King in My Work

I have illustrated the Monkey King for *Journey to the West* many times. However, I don't want to base my work on the stories in the novel this time. It's not because I don't like the novel anymore. It's just that I am not capable of giving full expression to the profundity of the original fiction. Driven by my ardent love for physical confrontations, I follow various types of fighting tournament everts around the world. Thus, I want to portray a warrior in the arena. With this in mind, only a warrior Monkey King could trigger my inspiration and morale. A general concept had already formed in my mind even before I started to put it on paper. In this illustration, the Pigsy character was supposed to work as the partner or agent of the Monkey King; Sandy would be one of his teammates, while the Monk will serve as his coach or the referee. Based on such a concept, I made some drafts. At last, I chose one of them in which I illustrated a monkey warming up before the game, because this moment is the best to capture a warrior Monkey King who is unruly and undisciplined, full of confidence in himself and with a spurring desire to fight.

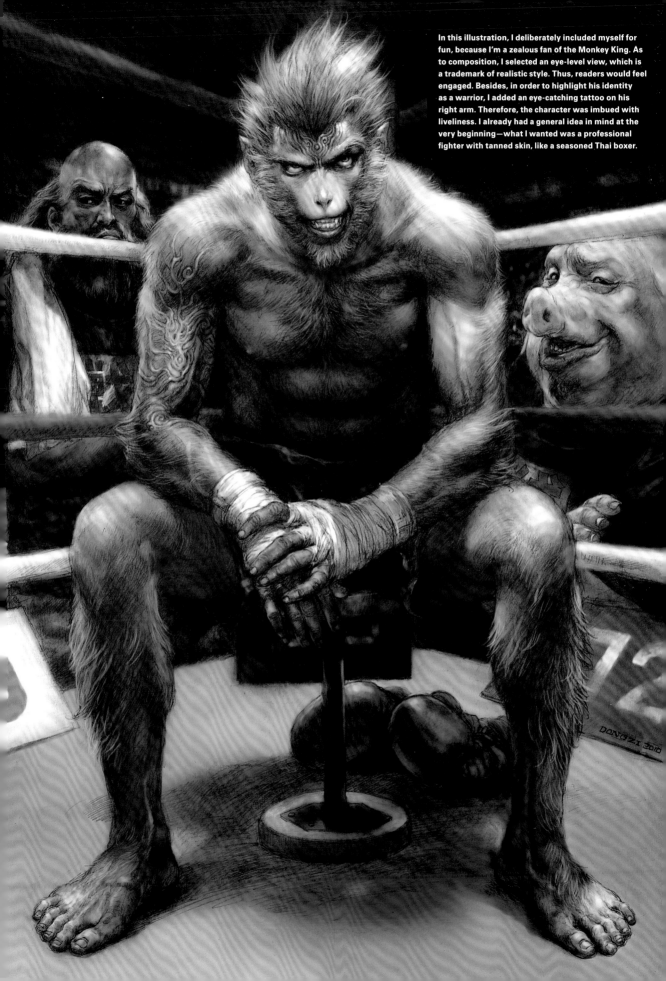

In this illustration, I deliberately included myself for fun, because I'm a zealous fan of the Monkey King. As to composition, I selected an eye-level view, which is a trademark of realistic style. Thus, readers would feel engaged. Besides, in order to highlight his identity as a warrior, I added an eye-catching tattoo on his right arm. Therefore, the character was imbued with liveliness. I already had a general idea in mind at the very beginning—what I wanted was a professional fighter with tanned skin, like a seasoned Thai boxer.

I have also kept other drafts of conventional images of the Monkey King. Here is one of his side-view portraits. I chose this one because the character looks like a monkey, which is consistent with the traditional aesthetics.

Liu Yong

Screen Name_**YOHN** Profession_**art director in the game industry**

Liu has worked in art direction in the game industry since 2003.

http: yohn.blogbus.com http: blog.sina.com/mumudad yoo_0717@hotmail.com

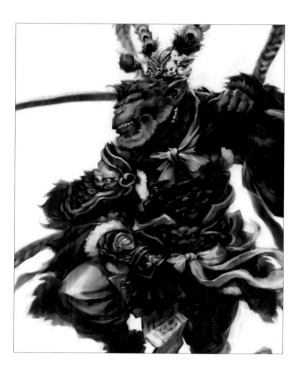

Monkey King in My Eyes

I prefer to call him "Handsome Monkey King," and he has been a companion of mine since childhood. I loved him so much that I felt uncomfortable if my eyes were not fixed on him. Little by little, I could see him everywhere, in storybooks, stickers, schoolbags, and pencil boxes. I would mimic him occasionally. Thinking of how naughty he is in the daytime, I would play with some toys of Monkey King in bed until falling asleep.

Later, with the development in the animation industry, more versions of "Handsome Monkey King" have been introduced into China. Though some versions are as cute and interesting as the earlier ones, I still love the "Handsome Monkey King," who is brilliant and brave enough to raise havoc in heaven. Nothing about him fades in my memory. As to the "Handsome Monkey King," maybe different people have approached him from different perspectives and produced profound theories concerning him. However, I'm not one of them. I just want to befriend him in the most direct and simple way. Whenever thinking of him, a naughty and brave "Handsome Monkey King" will come to my mind. The old friend of mine will provide me with constant inspirations both in work and in studies.

Monkey King in My Work

I feel honored at the invitation to participate in this creative project, because this character is really irresistably attractive to me. According to the project proposal, the reinterpretation of this character is subjected to no restriction. After serious thinking and image reconstruction, I still decided to stick to the traditional interpretation of the Monkey King. As the concept is not changed, I will focus on the expressive approaches. Based on the illusions in mind, I drew a rough draft on paper and started to collect reference materials.

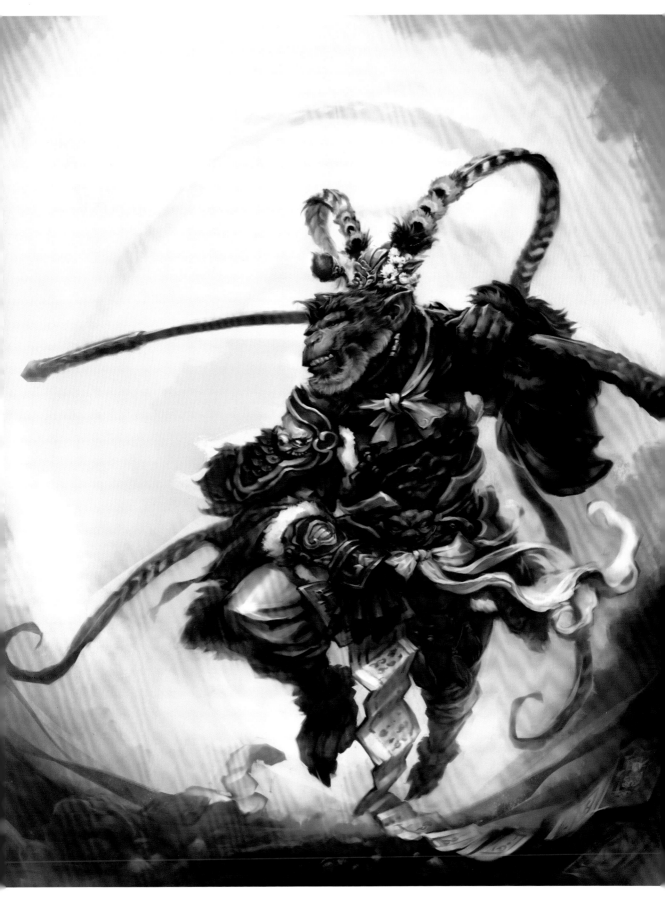

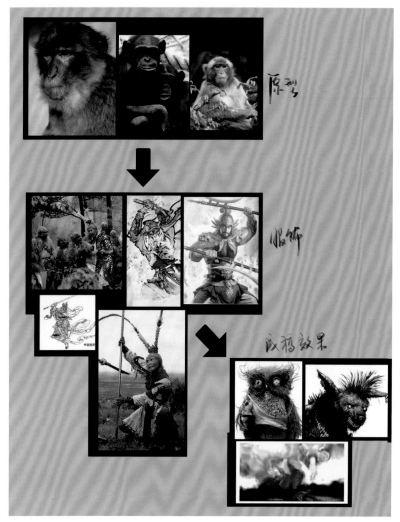

原型

临饰

成稿效果

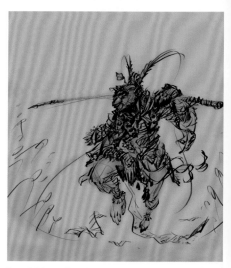

Step 2: I determined the composition of the draft. After determining the position of the character in the illustration, I tried to make it more natural and coordinated.

Step 1: I collected the materials concerning the original concept. There was no doubt I would do concrete research on monkeys, especially different parts of the monkey. The next step was to search for materials on costumes. The more detailed, the better. Besides, I would keep in mind what the final would look like and find more references. Generally speaking, the first step was to translate the abstract illusions in my mind into concrete images. With these images in mind, the production process would become more clearly oriented and more efficient.

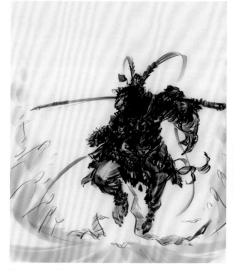

Step 3: I applied some base color in order to create a sense of volume and spatial layers in the illustration.

Step 4: I determined the background color, which would directly affect the color palette of the character.

Step 5: I made proper adjustments to the entire illustration. The distorting effect featuring a long-shot view was applied to reduce the sense of vacancy.

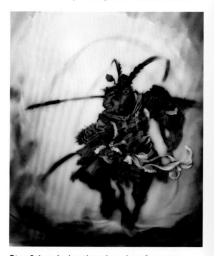

Step 6: I worked on the color palette for costume and accessories.

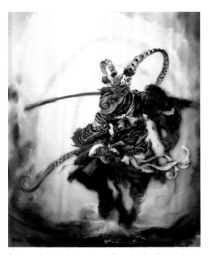

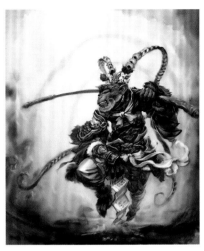

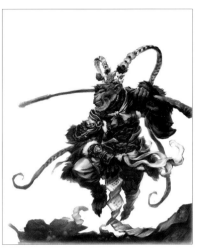

Step 7: I focused on the highlight in the illustration and moved to the surrounding parts. The well-illuminated parts in the close shot were supposed to be clearer, while the secondary and distant parts should be depicted by using fading strokes and generalized lumps.

Step 8: I elaborated on the configuration until all the parts were finished. There should be a difference between the dominant and secondary elements, with the highlights more distinct. Blurring and sharpening effects might be replied to make adjustments.

Step 9: I made preparations for illustrating the background so that it would look integral and clear-cut. It is also advised to dig out the dominant figure and separate the layers for configuration.

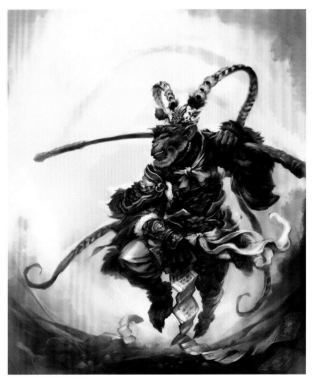

Step 10: I concealed the character and items in the layer. I smoothed the background in a flowing and integral way.

Step 11: I revealed the foreground character. Mission accomplished!

Fabrice Nzinzi

Screen Name_**Ntamak** Profession_**chief designer of Ankama**

For over a decade, Nzinzi has worked in advertising and design industry. At first, he worked in a small advertising agency as the printing and internet graphic designer. In the last three and a half years, he has worked in Ankama.

🌐 **http://ntamak.free.fr** ✉ **E-mail : ntamak@free.fr**

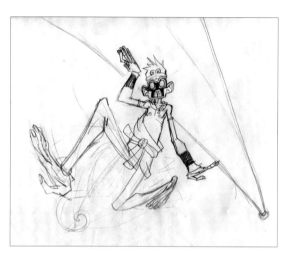

Monkey King in My Eyes

Months ago, I received an email from one of my friends, inviting me to participate in the "Seventy-two Transformations" project. I have to admit that I was thrilled at the invitation. As a freelancer, I had loads of work to do. However, I still squeezed out some time for this project, because I was blown away by this idea. I have never read the original novel of *Journey to the West*. However, many film directors and illustrators have told the stories in their ways. I think all of them are masters of

our age, especially Katsuya Terada, who has produced the comic books, and Akira Toryama, the author of *Dragon Ball*. In my childhood, I was greatly influenced by their versions of the Monkey King. I hope that my insignificant contributions will evidence my passions about this story. The story itself features lasting charisma, inspiring the most talented artists to get engaged. Sincere thanks to my friend who invited me to take part in this project.

Monkey King in My Work

At first, I painted in a random way in search for a concept that I liked. My aim was not to produce an exquisite painting but to clarify what's in my mind, determine the overall style and design concept, and then decide on the overall composition. I worked from the requirements of the commission as well as my own preferences in visual image to change the illustration style. Therefore, the illustration design was always not clear enough.

When I finally found a certain approach for visual expression, the overall style would be determined. My

illustrations used to be imposing and disturbing. Therefore, I finally chose a practical approach. In terms of composition, I had adopted the low-angle shot, which was commonly used in shooting movies to make the Monkey King more impressive. The Monkey King was supposed to hold an enormous golden band and jump out of the ground.

In terms of color palette, I had applied both green and red to enhance the dominant hue and highlight the Monkey King.

Luo Chenyang

Screen Name_**Jing** Profession_**game TLD design agency principal and designer**

Born in the 1980s, Luo currently focuses on managing his own fashion brands and design products while working in creation and design in many areas.

🔗 **http://www.dropkick.com.cn** ✉ **jing_10200317@hotmail.com**

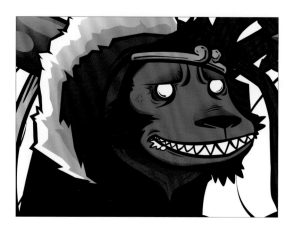

Monkey King in My Eyes

I still remember that in my childhood a mask of the Monkey King along with an inflated golden band was a must for every child. Back then, wearing a mask and wielding the band was one of the most popular street games after school.

When looking back, I have found that I used to love the Monkey King in a religious way, even though I had little understanding of the interior connotations of the character, which has not changed until now. Nowadays, I have come across some critics, which tend to challenge my "religion." According to these critics, the so-called Monkey King actually represents certain ideologies or, "despite his uncompromising nature, he was still subject to rules and restraints." With such theories gaining ground in my eyes, the Monkey King starts to lose significance and becomes a has-been. His image is no longer meaningful. It seems that

he is nothing more than a temporary inspiration. Thus, the new edition of *Journey to the West* TV series could stir no interest in me.

Weeks ago, it suddenly occurred to me that it was time to make a change. I am not supposed to look back or act like a frog living at the bottom of a well. Only the fittest could survive. One drifts in this big world like a drop in the bucket. For the sake of survival, one should learn to evolve and grasp the skills of seventy-two transformations. This entire theory seems so logical. Thus, it finally dawned on me that the image of the Monkey King actually served as our "pillar to pacify the seas," which shrank into something tiny that can be placed in a little corner. However, it would rise to the occasion whenever needed to back us up as the strongest support.

Monkey King in My Work

Almost everyone holds that the shape-shifting power is a reward of the Monkey King's religious practice. However, in my painting, I deliberately interpreted this power as means of camouflage. In the original fiction, the shape-shifting power was utilized by the Monkey King to subdue the enemies. However, in this painting, all the masks and disguises unpeeled, revealing the original look of the Monkey King himself. Such an image seems to be contrary to the one in the original novel, but there is indeed some

consistency on second thought. Though incapable of seventy-two transformations in real life, we are still utilizing a variety of camouflages to conceal our true selves. Are we happy, or just pretending to be happy? In the fiction, the Monkey King was granted Buddhahood and became the Victorious Fighting Buddha. When looking back at the eighty-one adversities, did the Monkey King feel finally rewarded or just a bitterness that could not be put into words? Different people might have different interpretations.

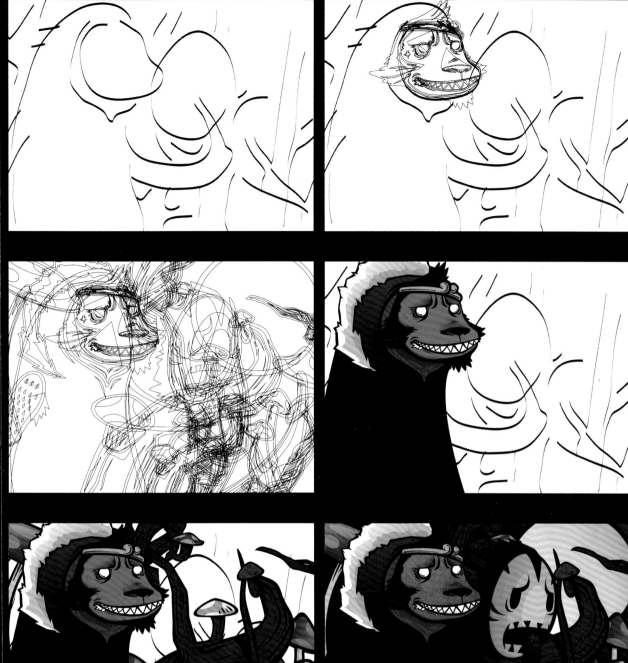

Step 1: I have no habit of drafting. Drawing several lines by moving the mouse will work (probably not a good example).

Step 2: I started with the main body. This illustration is still intended as a reflection of my trademark style, which means the facial expression would stay unchanged.

Step 3: I drew the mushroom forest in the background layer by layer to capture the thickness and greenness. I'm always sticking to a fixed color palette, striving to make some changes out of something unchanged.

Step 4: I went back to enrich and elaborate the Monkey King; I diversified within the framework of my trademark facial expression style.

Step 5: I found the color tone and gradation inadequate, so I added another tone to strengthen the gloominess of the background.

Step 6: Actually, my illustration is loaded with many contrasting metaphors. I hope that readers are able to spot all of them.

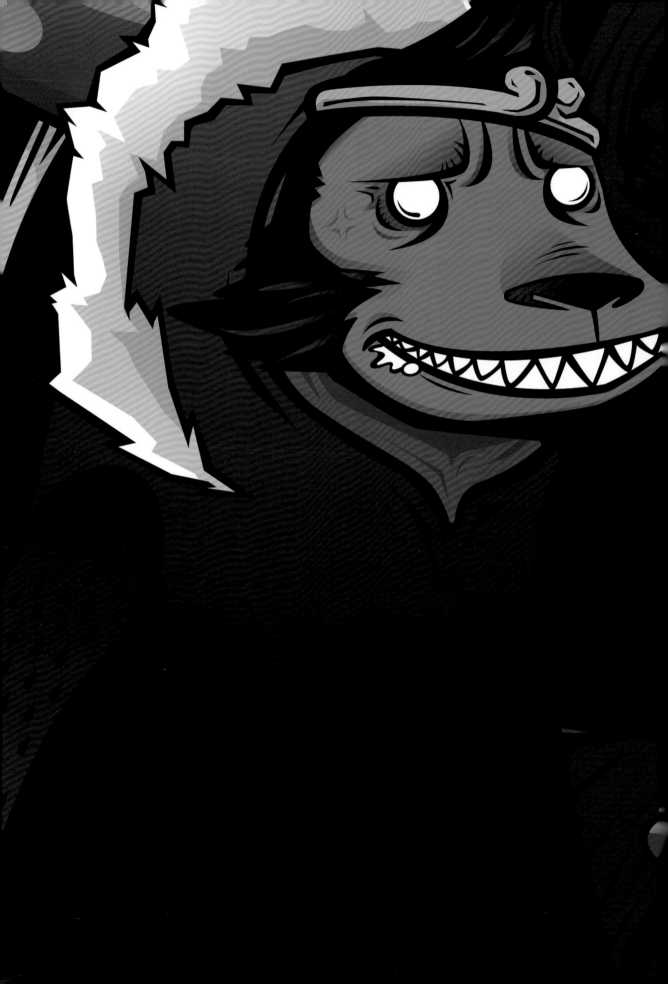

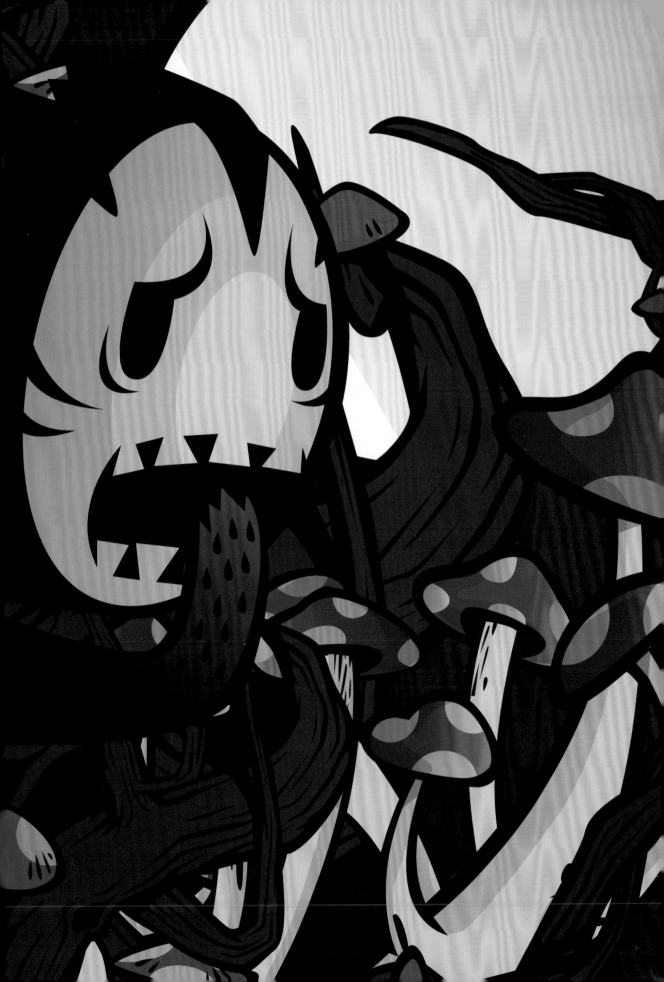

Ma Zhixiong

Screen Name_**Winson Ma** Profession_**founder of Winson Classic Creation, brand designer**

Ma loves creative activities.

http://www.winsoncreation.com/ info@winsoncreation.com

Monkey King in My Eyes

Journey to the West is enshrined as one of the Four Great Classical Novels of Chinese literature. It is known both in China and in other countries. The Monkey King is a favorite for many people. I am one of them. I have loved apes and monkeys since childhood. I still remember running into several New Year illustrations featuring the Monkey King from the *Journey to the West* in a bookstore when visiting relatives in Guangzhou. I finally bought all of them for their impressive techniques and exquisite composition.

The novel *Journey to the West* has been adapted by many renowned cartoonists and production companies. Years ago, I bought a whole collection of *Havoc in Heaven*. It was produced over forty years ago and was the first of this kind. The animation consists of two episodes, and was codirected by Wan Laiming and Tang Cheng. This heavily awarded animation is a classic in every sense, especially in terms of color palette and character design.

I founded a doll brand named Winson Classic Creation in 2006, basing different characters and stories on apes.

My first story is about a polar expedition of ape men who tried their best to save the Earth. This story attracted global attention and extensive media coverage. Personally speaking, I have always intended to write a story based on *Journey to the West* feautring Chinese style and fantasy elements. In 2006, I hosted a solo design exhibition themed on cartoon heros, showcasing works from over thirty toy designers. I designed a fantasy-style Monkey King who came from 2106. This figure is called "Ape Emptiness." This work involves incorporating fantasy elements into traditional Chinese motifs, creating an impressive effect. Fans are still eager to know whether this figurine will be produced in a large quantity. Since many doll collectors or lovers have not seen this work, it is therefore hoped that a Winson Classic Creation exhibition will be staged worldwide. Advices and critics are valued and welcomed.

Star Wars by the father of American sci-fi movies George Lucas has also got inspiration from *Journey to the West*. The discipleship of the protagonists plus utilization of Chinese martial arts and costumes impressed me most.

Monkey King in My Work

For me, the creative process starts with selection of subjects, followed by compilation of the story. The story can be of different lengths. After deciding on the characteristics for different figures, I start to draft. The process of character design usually takes several weeks.

Afterward, I will start to make models for the character along with his accessories and select fabrics to make costumes. Finally, I have to create a scene for the character, which is also one of the most important processes. It should be ensured that the background is convincing enough.

西游战记2106

猿空

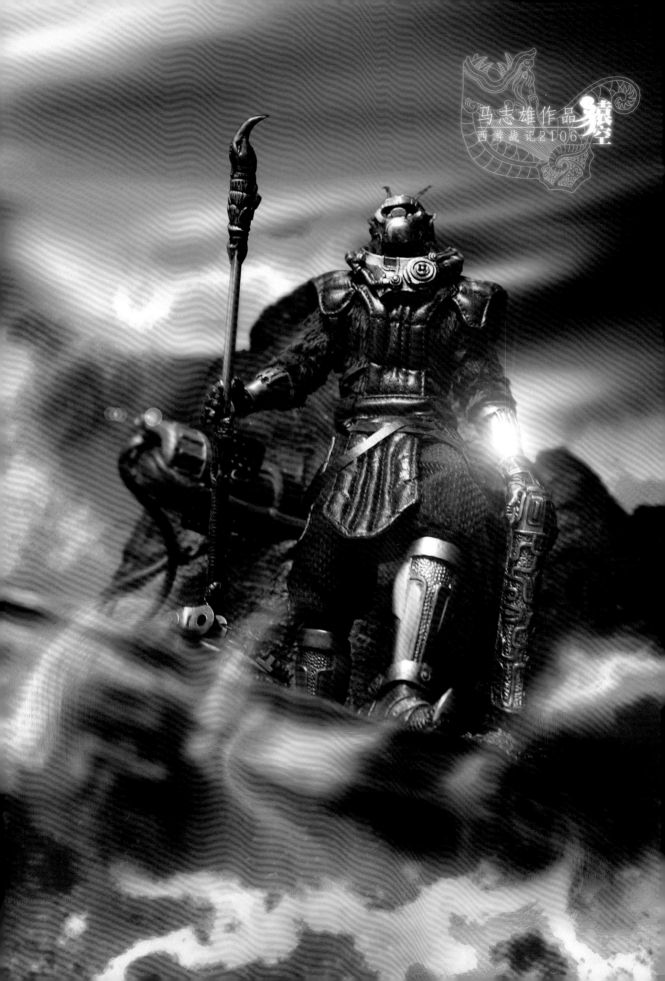

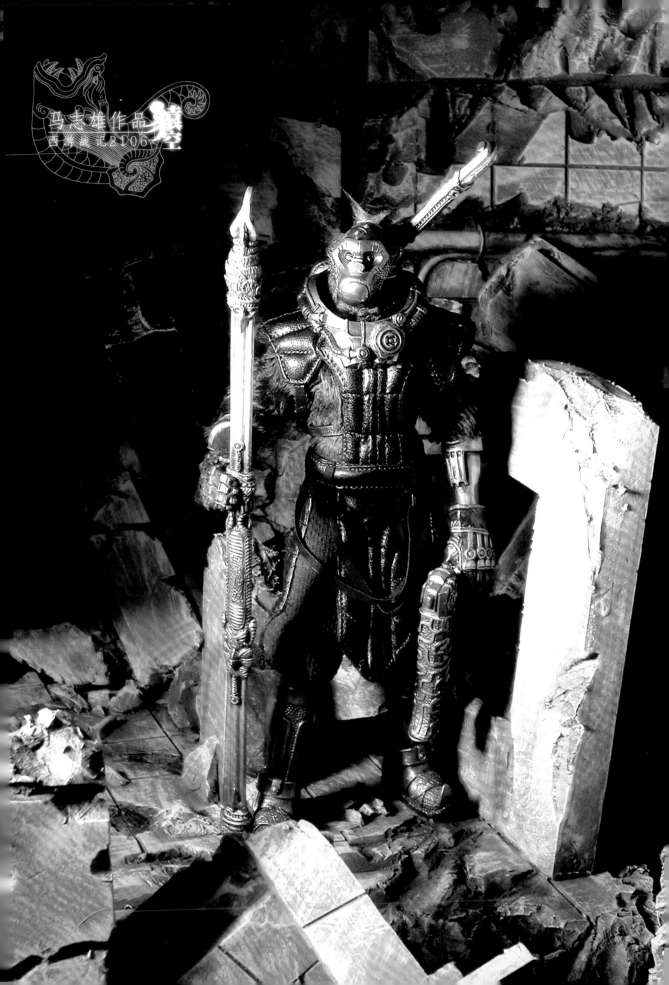

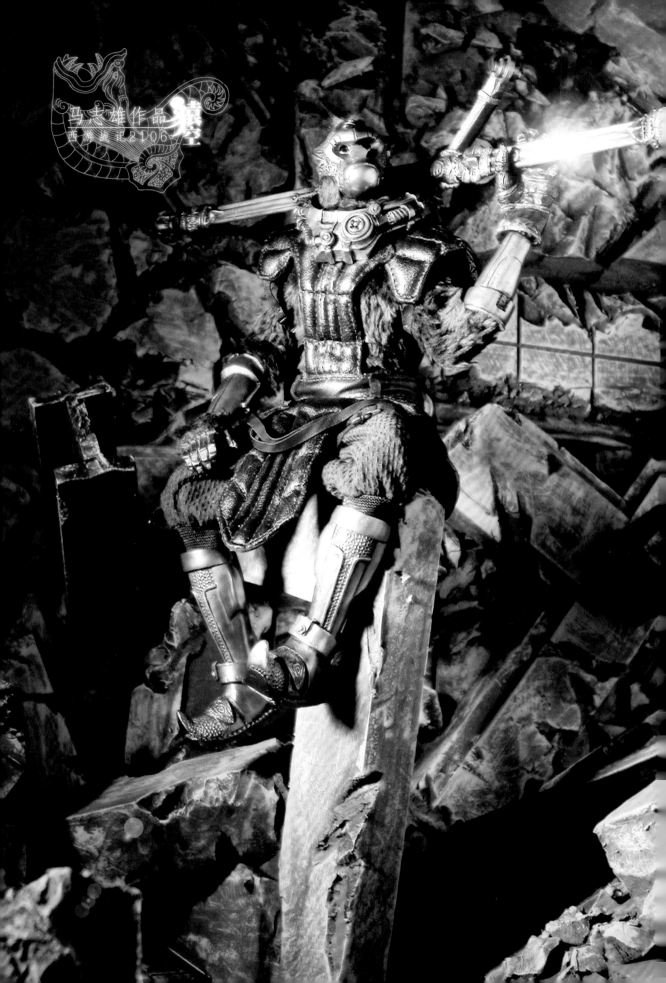

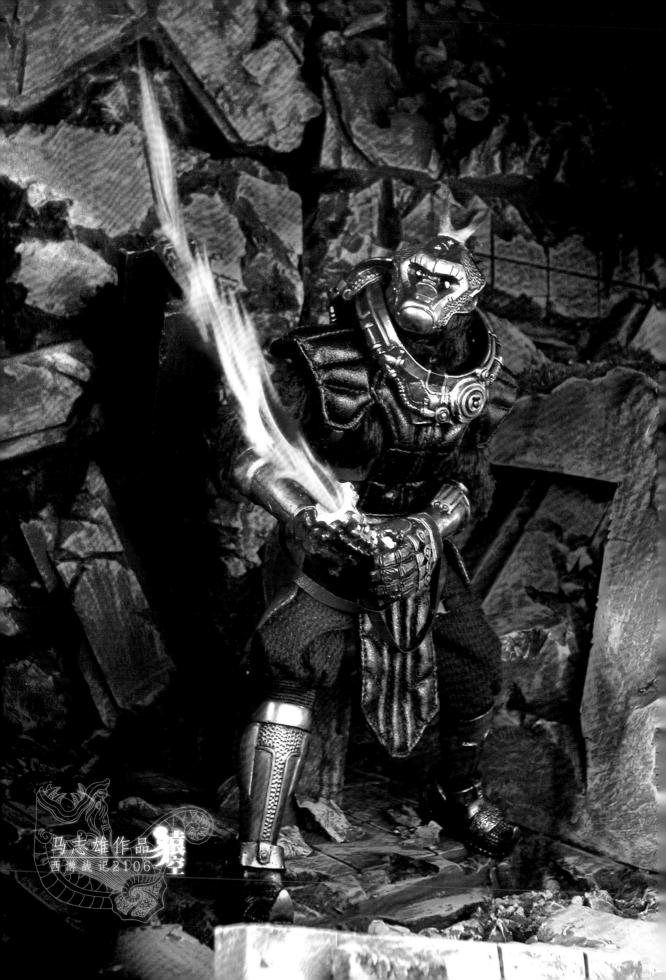

马志雄作品 猿
西游战记2106

Maria Trepalina

Screen Name_**Ketka** Profession_**professional illustrator, concept artist**

Trepalina is Russian and lives in Moscow. She works in cinema, advertising, and the game industry. She has a higher art education and degree in industrial design. In the last three years she has been working as a freelancer. She thinks it is a happier and more productive way of life.

 http://www.ketka.ru art@ketka.ru

Monkey King in My Eyes

Monkey King is a hero without a doubt, but I can't say that he is good or bad. He seems to me a complicated character. He has rather mutable moods.

I saw many old Chinese cartoons and films and they were very inspiring. I want to create a decorative illustration in the contemporary Chinese art style with many details, warm colors, and aerial forms.

Monkey King in My Work

I made a few sketches of the main character at the beginning, trying to determine his rebellious nature. After that I made several composition sketches. My goal was to find an interesting perspective. Of course I knew that this will be hard for me, but I liked this challenge. I tried many different angles of view, until I found what I liked. I must say that to draw the trees in such perspective is quite inconvenient.

I wanted to show the contrast between the Dakinis' world of beauty and the more materialistic Monkey King. I tried to do this with colors and in the texture of cloth. The light, floating Dakinis have simple dresses without much decoration. Dakinis are the creatures from the nonmaterial world and they even don't cast shadows. From the other side, the Monkey King is dressed in gold and bright ornaments. He loves bright and shiny things.

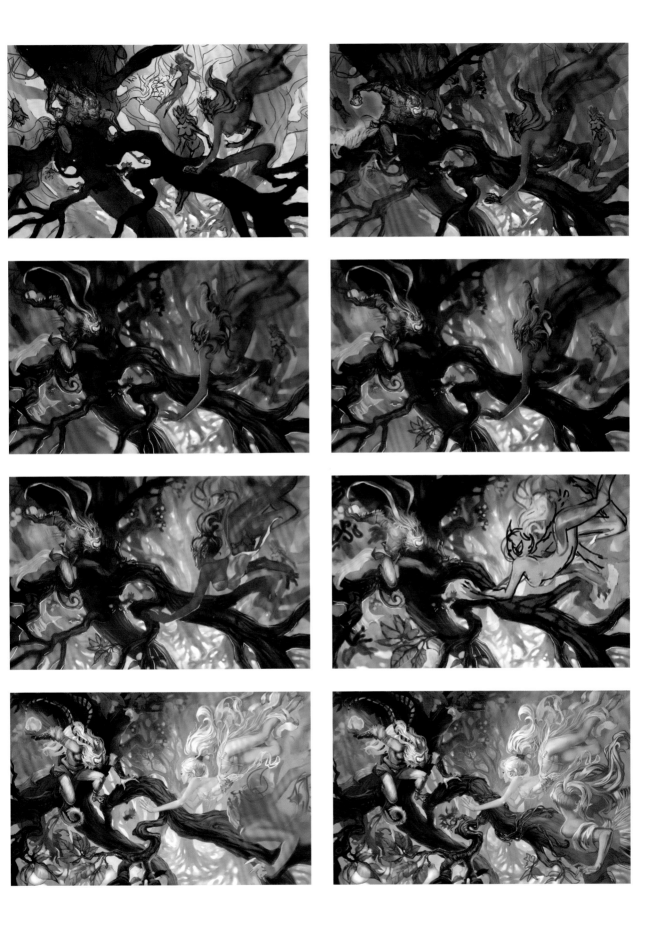

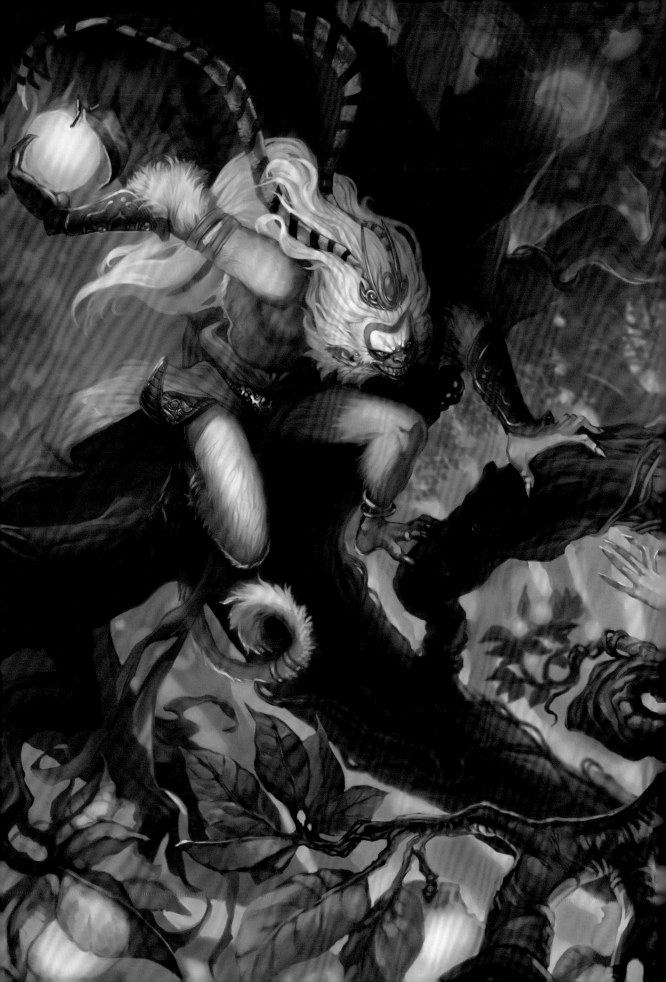

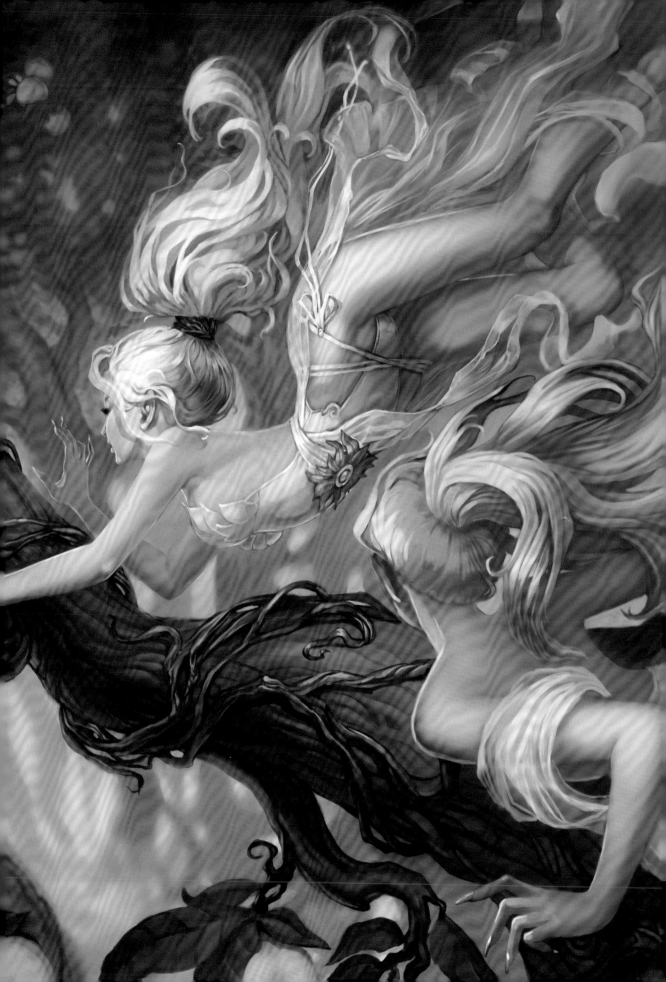

Nick Edwards

Screen Name_**GOJIRA!** Profession_**comic designer, illustrator**

Nick can be found in London reading about dinosaurs, rewatching Pixar and Ghibli movies, or listening to Neil Young.

 http://teamdynamite.livejournal.com/ goodbyemrchips@gmail.com

Monkey King in My Eyes

My first ever encounter with the Monkey King was at my friend Fred Hair's house around 2007. We watched the 1986 TV Series *Journey to the West* (hailed as the most accurate depiction of the novel), which, if you haven't seen it, is unintentionally hilarious and contains much low-grade green-screen work and amazing, yet ridiculously choreographed fight scenes. So from then on I saw the Monkey King as a bit of a dork, as a campy and awkward man in some sort of wig flying about the place. About a year later, Jamie Hewlett put the character into the animated TV spots for the 2008 Beijing Olympics. This had a positive effect on my perception of the Monkey King. Suddenly he became very cool when he was slotted next to Tank Girl and Gorillaz in Hewlett's archive of accomplishments. The animation was slick and stylized and the later inclusion of Damon Albarn and their popular stage production contributed much to the popularity of the Monkey King. Despite this, I didn't give him any more serious thought until now. I'd like to think that my naivety is somewhat refreshing in this book, as the majority of my esteemed peers and superiors are diehard fans.

Monkey King in My Work

My take on Monkey is, however, pertaining to the few incarnations I know him from. The aforementioned "diehard fans" will no doubt have already noticed that the bottom left character in my illustration is taken almost directly from the fantastic 1960s animated film *Havoc in Heaven*, which also proved to be a great inspiration for this project.

Havoc in Heaven contains some fairly lame fighting and odd altercations, but both the character design and vibrant colors are really inspiring. Monkey is portrayed more as a rebellious youth in this version. He is loveable yet somewhat an outsider to the other Gods that he mocks and agitates. I hope my illustration will express that.

Step 1: Research! It is very important to get a feel for the subject and to get to a point where your work is indirectly affected by the images and text you have been looking at.

Step 2: I started sketching. I tend to fill a few pages of my sketchbook when preparing for a larger illustration.

Step 3: I started drawing thumbnails and working on the layout and made the composition of the piece on a much smaller scale. It is important you get the balance right now rather than later.

Step 4: I didn't do much thumbnailing. About half an hour of erasing and redrawing, I finally had a layout I was happy with.

Step 5: Then I inked. This was the most therapeutic part of the drawing process. I like to listen to podcasts while inking.

Step 6: I filled in the blacks. Again this was quite therapeutic and not too taxing.

Step 7: I scanned it! If you have an A4 scanner like me, you'll have to scan an image this size in two parts. I usually scan at 300 dpi.

Step 8: I uploaded the image to Photoshop and did initial touch-ups to the line work to get those inks as black as they can be.

Step 9: Color! This is usually the longest and most distressing (yet rewarding!) part of the job. Adobe Photoshop has a feature called "Replace Color," which has given me many sleepless nights as I switch backgrounds from light beige to ever so slightly lighter beige.

Step 10: Once it was colored and saved, I might erase some line work or change certain colors, but generally the job was done by now and I could go to sleep.

Pang Fan

Screen Name_**SACK** Profession_**graffiti artist**

As a graffiti artist, Pang started working in tattoo arts in 2004.

🌐 **http://hi.baidu.com/sackids** ✉ **sackkk@hotmail.com**

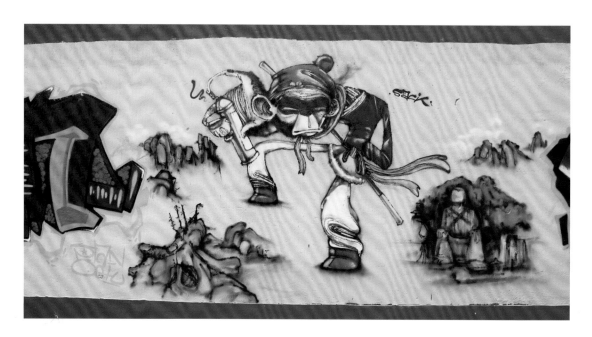

Monkey King in My Eyes

Monkey King is a figure of rich connotations. His story is imbued with inspiration and strength. Both properties are essential to the promotion of social civilization but can rarely be found today to our great regret. It was five years ago when I first did Monkey King in graffiti, which was themed on his havoc in heaven. The graffiti was indeed crude. Thus, I made up my mind to try the Monkey King theme another time after further developing my skills.

Monkey King in My Work

When working on the Monkey King project, I spent a lot of time thinking of how to construct this particular image. During my research, I found that many people had chosen to focus on his havoc in heaven when interpreting Monkey King in their work. It is true that this anecdote signifies an outburst of the so-called Monkey King spirit. But our ultimate objective is to highlight his beliefs—how he defies authority, combats dictatorship, and strives for freedom, and his somewhat childish revenge. Black humor is a trademark of my work, thus I made up a story by infusing black humor into this figure: The Monkey King had a long-standing grudge against the Buddha for keeping him imprisoned under the Five-finger Mountain for five hundred years. Even though he was made disciple of the Tang Monk later, he had never given up his quest for vengeance. However, he had learned his lesson. Instead of confronting the Buddha directly, he painted a cross on one of his statues (the Giant Stone Buddha at Leshan Mountain) to appease his anger. This concept is also in consistence with the rebellious spirits as manifested by graffiti arts.

I did research on images of monkeys and the Monkey King in particular in the stage of conceptual design. I tried every means to highlight the ruffianism of the Monkey King. Thus, I made some distortions when designing his gesture. My Monkey King had one hand in his pocket, with the other hand holding a can of paint and a cigarette between his lips, all of which were intended to exhibit his ruffianism. In selection of colors, I used many flamboyant colors to make him look more like a hippie.

Step 1: I painted the wall with the background color.

Step 2: I used light-color paint to sketch out his position and gesture.

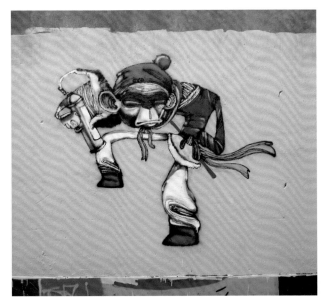

Step 3: I Employed the main colors, focused on the facial expression, and fine-tuned the background color.

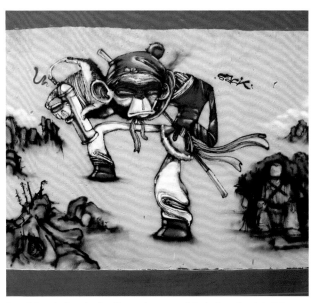

Step 4: I worked on the details on other parts of the body and enriched the color palette. I used spray paint to suggest the landscape as well as the Leshan Giant Buddha. I framed the entire work with red paint.

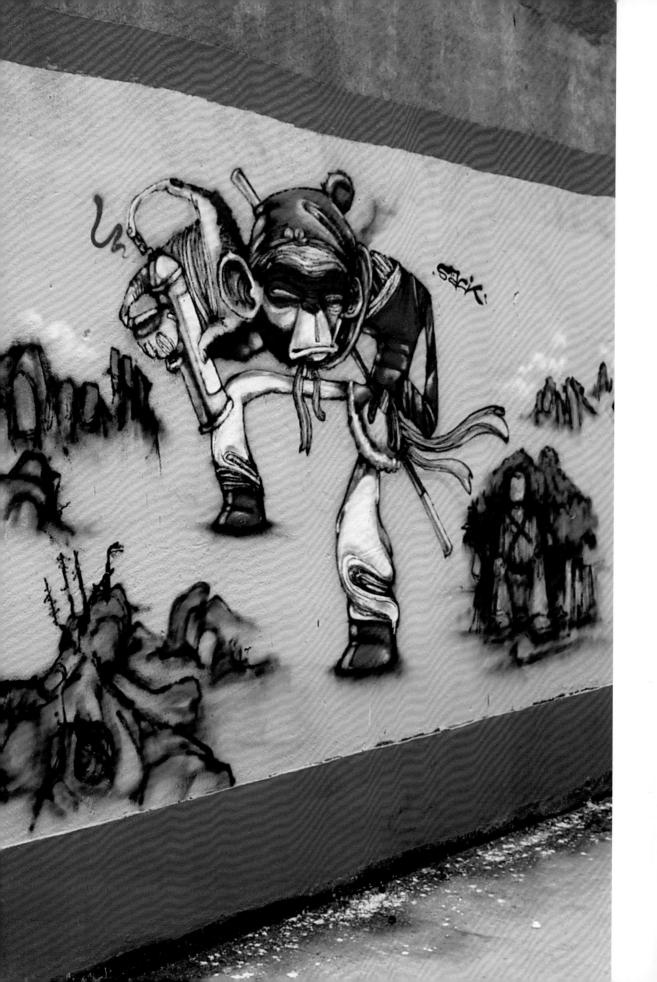

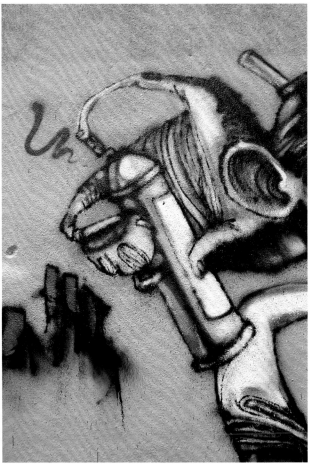

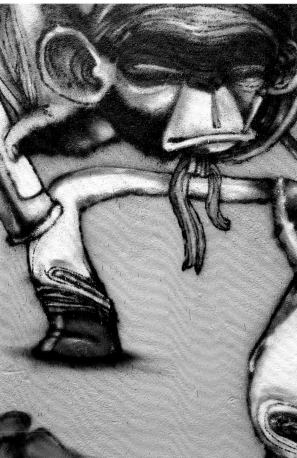

Patricio Betteo

Screen Name_**betteo** Profession_**illustrator, cartoonist**

Patricio was born in 1978 in Mexico City to a Uruguayan-Chilean family. He studied graphic design at art school but dropped out (he wanted more than that!). In 2000, he pursued a different type of career with comics, painting, and illustration. All self-taught, all with his hands and both feet on the ground, he hopes to connect with the world and dive into different cultures.

http://betteo.deviantart.com/ **patriciobetteo@gmail.com**

 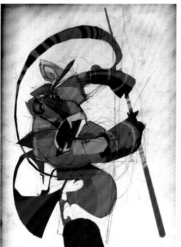 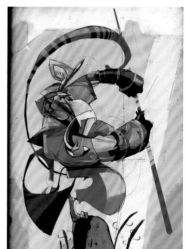

Monkey King in My Eyes

Chinese mythology, as all ancient mythologies, deserves our deepest admiration. Modern culture stands on the shoulders of those "wise inventions." Mythology provides a way to understand the universe so full of meanings, so full of lessons for mankind, and so full of deep wisdom. And fun. Myths make us smile, make us dream.

Also, myths mean color and movement. That is why I made my piece this way: color and movement, peace and war, all mixed up, all blended together, as it happens in mankind. And in animalkind, of course, in a different way.

Monkey King in My Work

I usually don't do preliminary sketches, because all possibilities excite me so much that I get distracted from the goal. So, I focus on one thing and polish it until I reach the feeling I want to reach.

I spent three hours on this piece. I start with a promising doodle. Then I put some tones on it to give some idea of light and depth. Things start to gain shape, and the excitement arises. But, I must say, not all comes from emotions. I try to keep things clean, legible. I truly believe in the beauty of "accidents"… but not all accidents are beautiful.

Any respectable work deserves strict documentation and a lot of reference work. But art is freedom and freedom makes me wake up happy in the morning. So I rendered the Monkey King as any foreign person would do. In my imagination, my inner unconscious symbols emerge, those without a nationality. This image represents the Monkey King, my concept of China, and my joy for art. We all have seen the same old symbols, the same old postures, the same old interpretations. As a Mexican, funnily enough, I always want to give a spin to the cultural *clichés*.

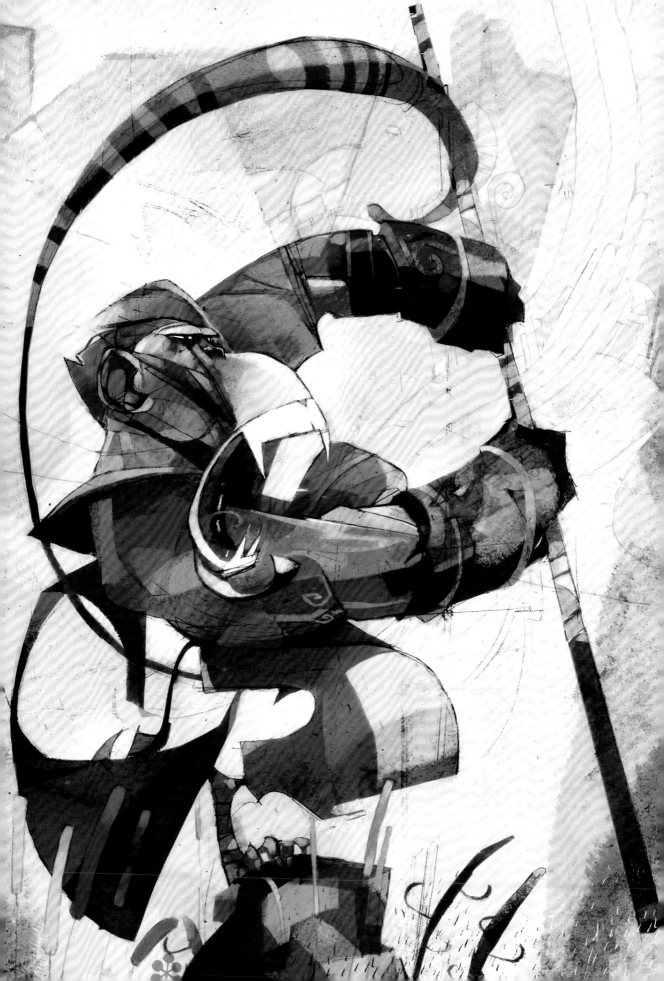

Qi Zhenxiang

Screen Name_**Jason Chyi (Jason Rabbit)** Profession_**graphic designer, character designer, illustrator**

Born in South Taiwan, Qi graduated from art college. Strongly influenced by street arts and fashion trends, his works feature distinct American styles.

http://www.jasonjumper.com **jason.chyi@gmail.com**

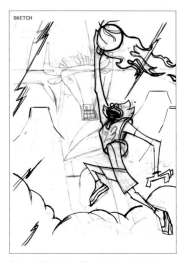

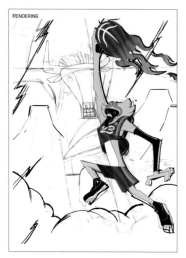

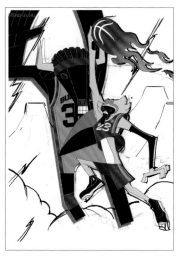

Step 1: Sketching. First I determined the background, and a relatively simple plot. I drew a simple sketch and adjusted the details, gesture, and proportion on the computer.

Step 2: Rendering. After deciding on the color palette, I started the coloring process. As this illustration originally featured a relatively American style, I intended to incorporate golden, black, and pink as the secondary color to demonstrate both fashion strategy and Chinese traditions.

Step 3: Color schema for the Bull Devil. The subordinate character Bull Devil was intended to be a villain. Therefore, black was used as the dominant color for it.

Monkey King in My Eyes

The Monkey King is one of the most representative and classical fictional characters in Chinese literature. His impressive intelligence, outstanding combating skills, loyalty to his friends, and defense of justice appealed to me most. From havoc in heaven to battles with the dragon kings, from being defiant to embarking on the journey to India to retrieve the sutras, all the episodes are familiar to the Chinese. They have been depicted in fiction, storybooks, TV series, and movies again and again, and I love them very much, all because of the Handsome Monkey King who is capable of seventy-two transformations.

Monkey King in My Work

This illustration is titled *Bull Devil vs. Monkey King* and is concerned with how the Monkey King launched a fierce battle against the Bull Devil. However, both have given up their signature weapons—golden band and iron band—and changed into cool basketball uniforms and Jordan sneakers to put on a duel between real men. The Monkey King, with short stature and swift actions, is equipped with Jordan's No. 23 basketball jersey along with a pair of classical Jordan XI Space Jams. He makes fake actions, changes hands, turns back, and makes a slam dunk despite the block of the Bull Devil.

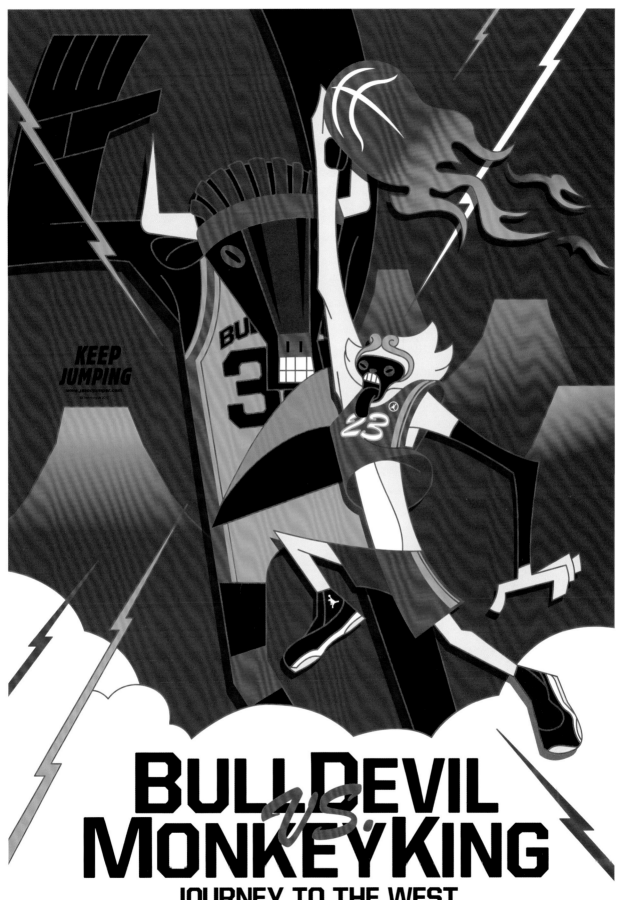

BULLDEVIL *vs.* MONKEYKING

JOURNEY TO THE WEST

Rael Lyra

Screen Name_**Distrito Papillon** Profession_**concept designer**

According to Rael, by looking through the window, you will find great things to see.

http://distritopapillon.deviantart.com/ raelyra@gmail.com

Monkey King in My Eyes

Honestly, I cannot remember exactly when I saw the Monkey King for the first time. Perhaps the references to him in *Dragon Ball*. But anyway, this character was very much alive in my mind after I saw him designed by Jamie Hewlett. When I received the invitation to draw the Monkey King, I tried to better know the character and history, and I knew it would help me to develop a more interesting picture. The monkey is extremely powerful, and some people seem attracted to his fantastic capabilities, but there are other personality traits that really catch my attention. The Monkey King does not want to be a monkey. From his birth until his battles in the Heavenly Palace, he wants to be something

bigger. He is in many aspects a creature driven by ambition and pride, and at some times, he is able to realize his desire to be something different, showing himself in another way. Of course, from a creative perspective, these are issues that enrich the character. Realizing these two faces, the massive power and the internal conflicts, I found it most interesting to elaborate on the second one. The moral questions allowed me to look at the more human and fragile side of the character. Some people wear masks with the representation of the Monkey King, and these are, in a simple observation, a reference to the internal and external masks he carries.

Monkey King in My Work

As mentioned earlier, I decided to depict the Monkey King from an inner and less megalomaniacal perspective. The entire illustration was developed with this question in mind. In addition, this version is a primitive view of the Monkey King, since I've been simplifying its image. There's a contrast between what he wanted to be and who he really was. His bat was still there, but it seemed made of bamboo. He got some

tattoos and a decorated mask in order to differentiate himself somewhat from the other apes. Pigsy, who I also included, was just a pig. There was some ambiguity in snakes, worms, and caterpillars. Were they attacking or guiding? When I started to develop the image, I tried to keep a certain childlike fascination.

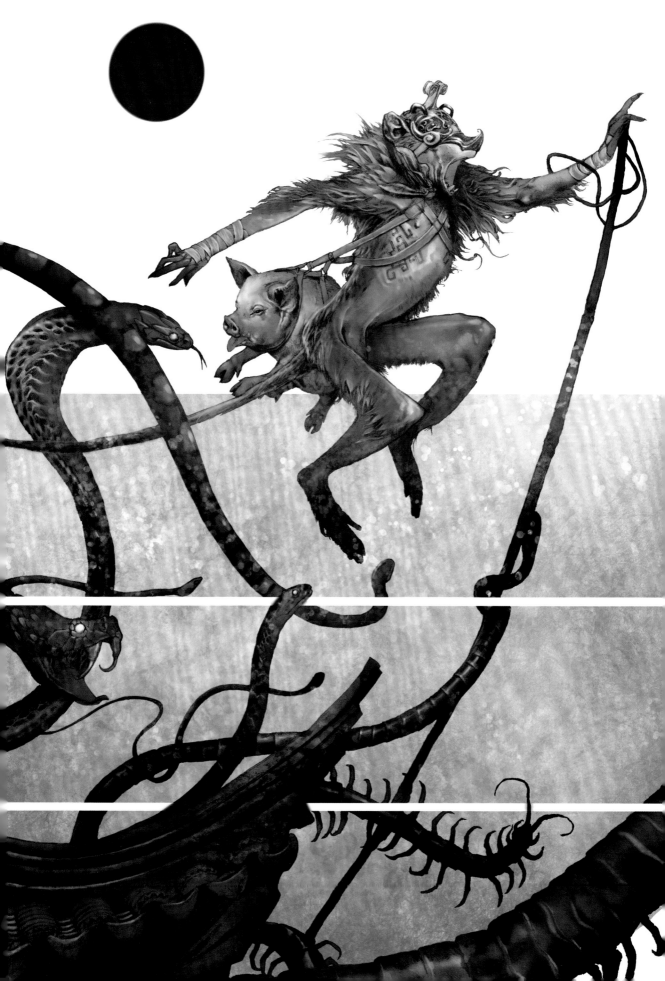

Saryth Chareonpanichkul

Screen Name_**Saryth** Profession_**illustrator, concept designer**

Chareonpanichkul is a freelance concept art from Thailand.

http://saryth.deviantart.com/ sarythcr_up@windowslive.com

 Monkey King in My Eyes

Journey to the West showcases the great fantastic adventure stories. The journey for Tripitaka (Buddhist scriptures) is like a diligent goal of living.

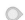 **Monkey King in My Work**

I am really happy and excited for the opportunity to create my own Monkey King. The Monkey King is a symbol of changing from badness to goodness.

I tried to keep the uniqueness of the Monkey King and made him more humanlike because he is a special monkey.

Sonny Liew

Screen Name_**Sonny** Profession_**comic artist, illustrator**

Sonny Liew is an Eisner-nominated comic artist whose works include *Wonderland* (Disney/ SLG), *My Faith in Frankie* (DC Vertigo), and *Sense and Sensibility* (Marvel Comics). He is also the creator of Malinky Robot, a Xeric Award recipient, and winner of the Best SF Album award at the Utopiales SF Festival.

http://www. sonnyliew.com **sonny@sonnyliew.com**

Monkey King in My Eyes

My earliest memory of the Monkey King was an animated version of the *Journey to the West* that we watched at my grandma's house in Malaysia. There was no way to escape him really—there were always television shows, comics, and illustrations featuring the Monkey King. He is one of those icons that will probably be around as long as the human race survives. And there have been so many visual interpretations of what he might look like; still for me, the animated character I first encountered, with his face painted red in the Chinese opera tradition, impresses me most, and I guess the piece created for the book is an homage of sorts to him.

Monkey King in My Work

It was the first time for me to draw the Monkey King. I painted his face red to pay a tribute to the Peking opera. In order to make it more interesting, I also added another toy monkey as well as some black humor elements. In terms of composition, I had referred to a photo featuring monkeys playing together.

These two images inspired me.

Su Haitao

Screen Name_**Casper** Profession_**freelancer**

Inspired by a passion for artistic creation, Su heads a studio of his own and commits himself to cartoon character design commissions from clients all over the world.

http://www.suhaitao.com casper_163@163.com

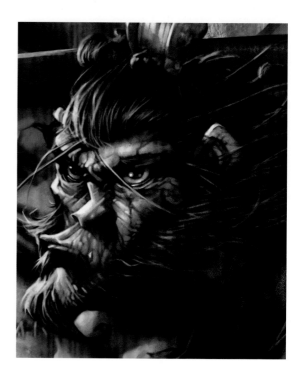

Monkey King in My Eyes

It was at the age of six or seven when I was first exposed to the Monkey King, when I saw *Havoc in Heaven* on a neighbor's nine-inch black-and-white TV set, which he assembled. The monkey was so capable and even dared to defy the Heaven Emperor. Even through the tiny figure on the black-and-white screen, I could still feel how fresh and striking this character was. Since then, the Monkey King has become one of the most established images in my mind, who has no fear of hardship, bears no prejudice, and has the courage to defy the divine and challenge authority. The Monkey King is such an impressive character that I would feel excitement surging in my veins whenever talking about him.

In my adolescent years, I read the original novel *Journey to the West* and became acquainted with all his anecdotes. Though he was still the Monkey King while protecting the Tang Monk to the west, unyielding to authority and determined to battle demons, he was no longer as dashing as he was when creating a tremendous uproar in the Heavenly Palace, which had been etched in my mind. Thus, I was hoping that I could successfully capture the primitive Monkey King, who is courageous enough to defy authority and committed to freedom and justice. He is the Monkey King with no stain; he is the "Great Sage, Equal of Heaven" who had inspired me in my childhood.

Monkey King in My Work

Generally speaking, this Monkey King is relatively less muscular, because I intended to accent on how dashing and astute he was. Besides, I gave him thick shoulders and strong arms so that he was endowed with the power and confidence to subdue the demons. I chose shorter hind legs, which is a defining feature to distinguish monkeys from apes. Also, it suggests that the Monkey King would not be easily defeated when facing difficulties. This character is largely bathed in the rays of the rising sun, indicating that he has a promising future. One of his feet is enveloped by darkness, to betoken that he has to wrestle with hazards and difficulty looming ahead.

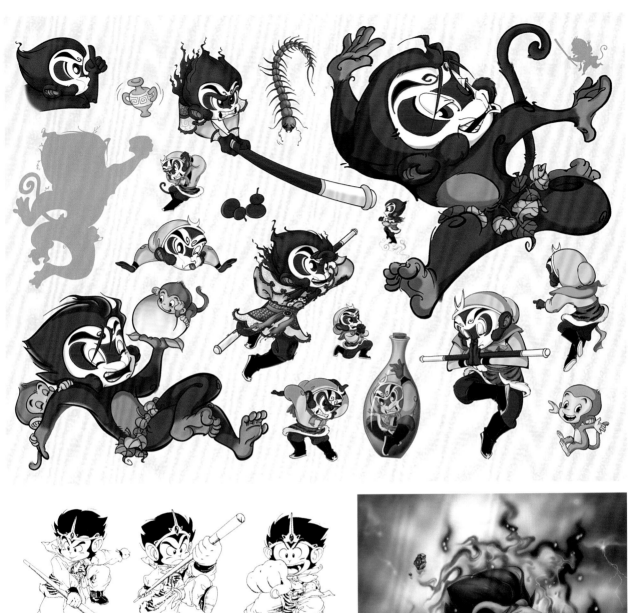

Top: This image was adopted in Jimei's *Journey to the West for Children*. Professional concept designers could not work without three-way drawing.

Lower left: In my early work about the Monkey King, I was influenced by Arika Toriyama.

Lower right: *The Stone Monkey Was Born* was illustrated in 1993 by using paints and airbrush.

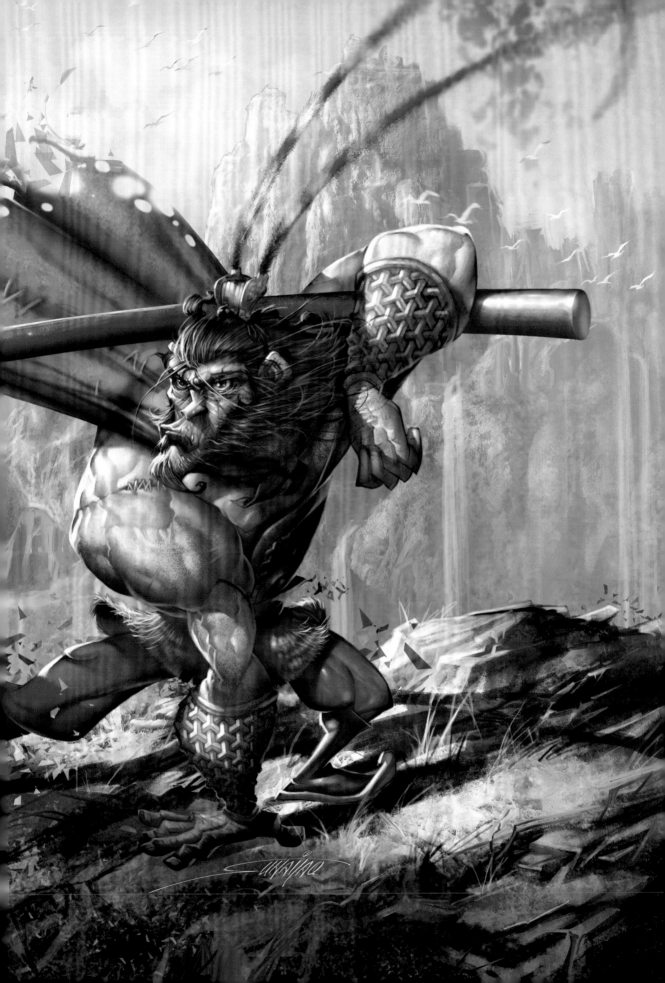

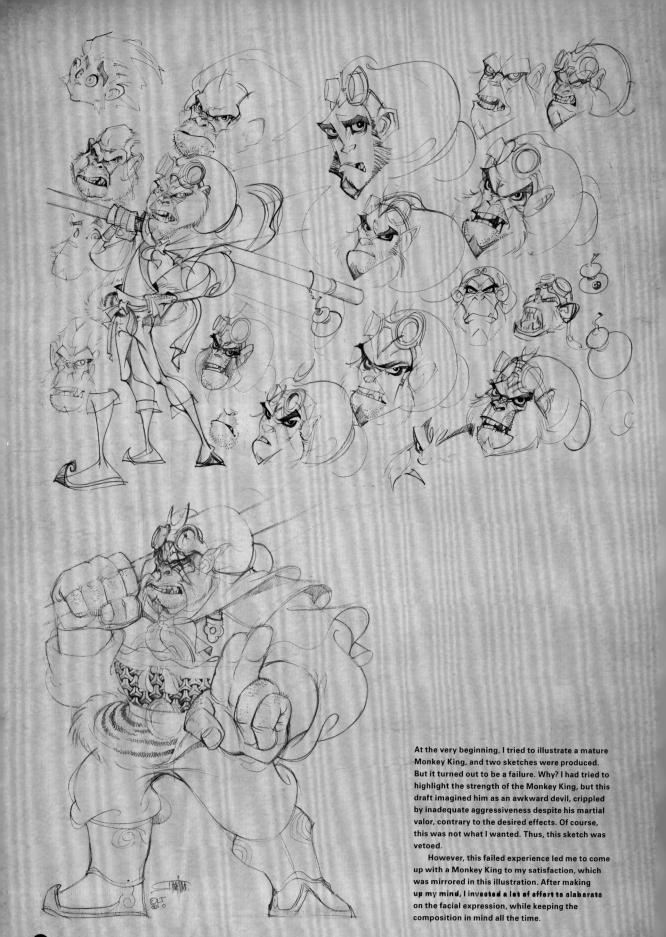

At the very beginning, I tried to illustrate a mature Monkey King, and two sketches were produced. But it turned out to be a failure. Why? I had tried to highlight the strength of the Monkey King, but this draft imagined him as an awkward devil, crippled by inadequate aggressiveness despite his martial valor, contrary to the desired effects. Of course, this was not what I wanted. Thus, this sketch was vetoed.

However, this failed experience led me to come up with a Monkey King to my satisfaction, which was mirrored in this illustration. After making up my mind, I invested a lot of effort to elaborate on the facial expression, while keeping the composition in mind all the time.

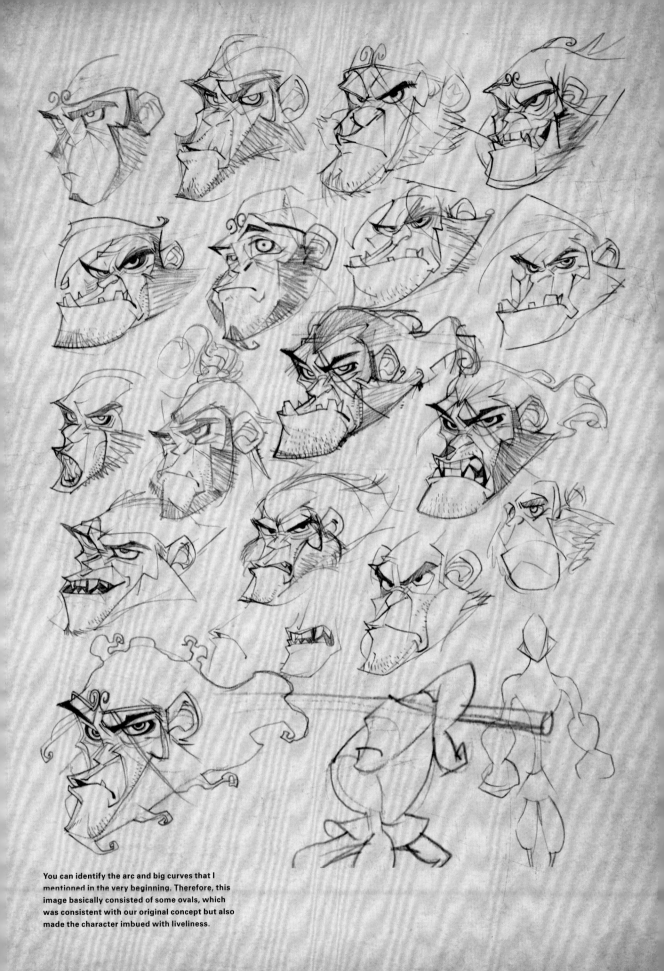

You can identify the arc and big curves that I mentioned in the very beginning. Therefore, this image basically consisted of some ovals, which was consistent with our original concept but also made the character imbued with liveliness.

43

Sun Guoliang

Screen Name_**Dalian New Concept** Profession_**concept artist**

Sun did not go to college and therefore did not receive higher education. He is dashing, liberal, and handsome. He loves nature and animals. He is neither sophisticated nor sporty and likes drawing and listening to the music, when any interruption would be taken as an offense. He wants to focus on the present without thinking too much about the future. Anyway, 2012 is looming.

http://www.banhatin.blogspot.com **futuregl2080@hotmail.com**

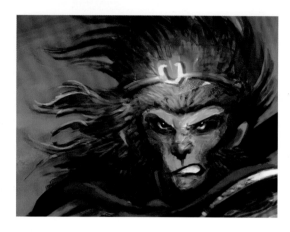

◎ Monkey King in My Eyes

I came across the storybooks of *Journey to the West* back in my childhood. The refined lines and amusing stories exposed me to the Oriental arts for the first time. During the summer or winter vacations, my favorite entertainment was to watch the TV series *Journey to the West* after finishing my homework. Liu Xiao Ling Tong infused so much vitality into this character that his version is still the closest to what the Monkey King is in my opinion. This series is often rerun on different channels, and I like to relive its scenes again and again. Whenever I hear its original soundtrack or see a monkey jumping out of the stone crack, I will rush to the TV set to watch it attentively no matter what I am doing.

In recent years, many versions of the Monkey King have been produced, in Flash, Japanese Manga, or some very cute books, even some TV programs and cartoon series. One of the Japanese cartoons even imagines the characters in the original fiction as "modern, trendy men," which is a natural product in response to the age defined by information technologies. However, I could not help feeling sorry for the Monkey King, as his images have been distorted too much. In my mind, the Monkey King is always the furry monkey in the original fiction of Wu Cheng'en: magical, amazing, and fantastically shrewd.

◎ Monkey King in My Work

This time, I selected two styles to portray the Monkey King. This realistic illustration is intended to portray how the Monkey King gets ready to combat the Dragon King of the Eastern Seas. Thus, I chose to use a vertical composition to reveal his entire body. Influenced by Jon Foster to some extent in color palette and depicting techniques, I incorporated the dramatic contrast between warm and cold colors to capture the moment when his eyes started to glitter with determination. As to the second piece, I took a casual approach, integrating both my distinctive style and features of characters in European and North American cartoons. This illustration is themed on the Monkey King along with the Monk and his other disciples. I have a unique understanding of such styles and thus like to construct a colorful and humorous image underneath simple silhouettes. I have no idea which illustration will appeal to the readers, but for myself, I'm fascinated by both. That's why I have presented both of them here (Haha! Don't be mad at me!).

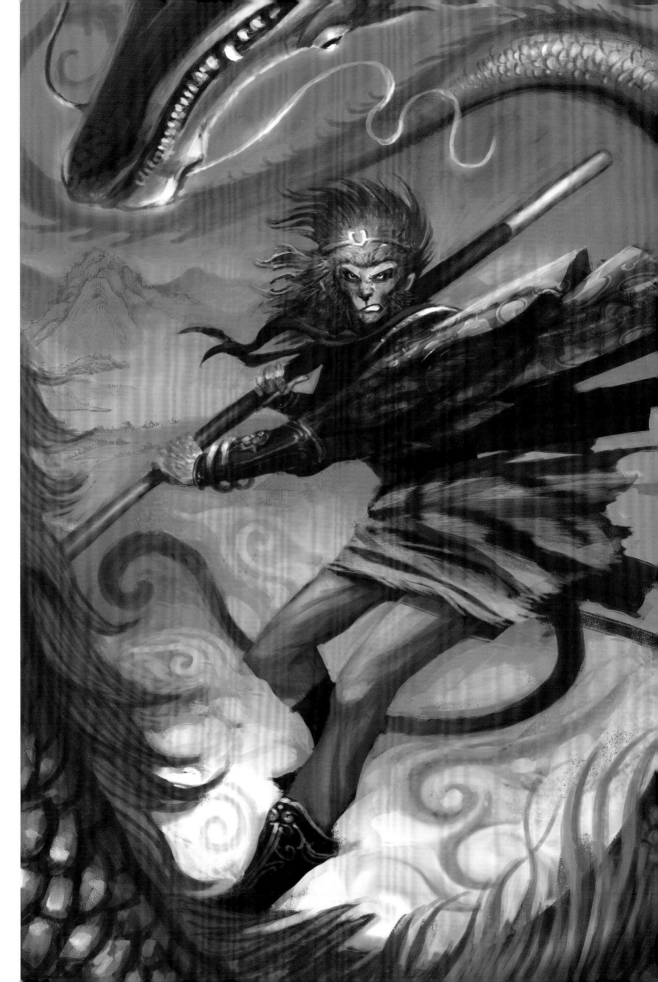

Sun Yong

Screen Name_**Qian You** Profession_**graphic designer, product designer, illustrator**

Currently, Sun is focused on design and development of household products in Beijing.

http://www.brainempty.com ✉ **sunxingzhe@gmail.com**

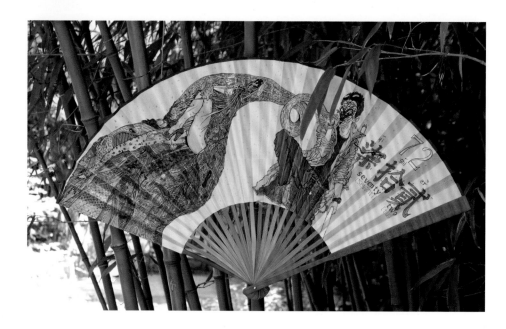

◉ Monkey King in My Eyes

I feel extremely honored at the invitation to participate in the "Seventy-two Transformations" project. I know that it will be challenging. Firstly, the Monkey King has been repetitively and intensively interpreted by people from different ages, which makes the reinterpretation considerably difficult. Secondly, I had never come up with a definite concept concerning what to put on the folding fan; neither was I subject to a fixed schedule. In fear of wasting the raw materials and failing the expectations of the project initiator, I did not start right away; instead, I waited for inspiration to knock on the door. Fortunately, the inspiration finally came when I ran across a passage of Buddhist inscriptions: "Without the awareness, the Buddha is no different from the ordinary people: with the awareness, the ordinary people will turn into a Buddha. Therefore, Buddhahood is a product of inner exploration. Why not start exploring the inner self right away for the purest human nature?" The Monkey King is admired by his skills for countless transformations, while real life also consists of countless changes and the unchanged. The character in my illustration is actually someone ordinary around us.

◉ Monkey King in My Work

The folding fan is one of the most important media in traditional Chinese culture. I started to use this medium in 2005 and have finished over thirty projects in total. I have chosen this medium because, firstly, this ancient item can still function as a modern medium for the artists to express themselves. Secondly, I want to pay a tribute to the traditional Chinese culture. Folding fan design can give me an opportunity to learn Chinese culture and traditions. Of course, it is also a means to challenge and entertain oneself.

Many other materials have been used in the creative process in addition to Chinese brush and ink, such as watercolor, propylene, marker pen, mapping pen, ball pen, correction fluid, oil paint, spray paint, and even nail polish, lipstick, and eyebrow pencil. At the same time, sculpting, piercing, stitching, collage, printing, reproducing, and other techniques have also been employed.

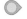
164

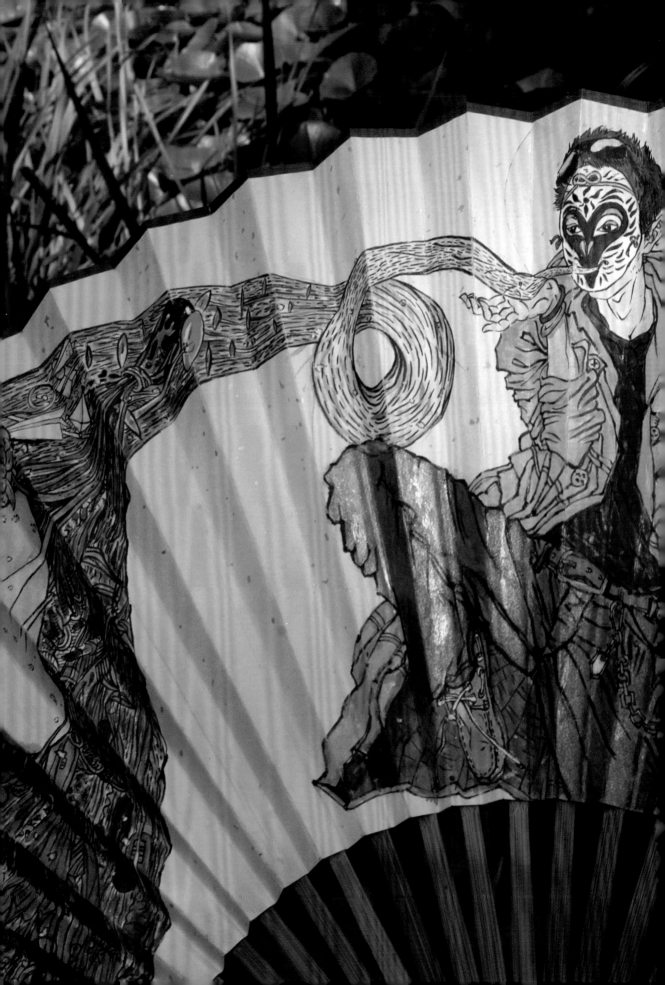

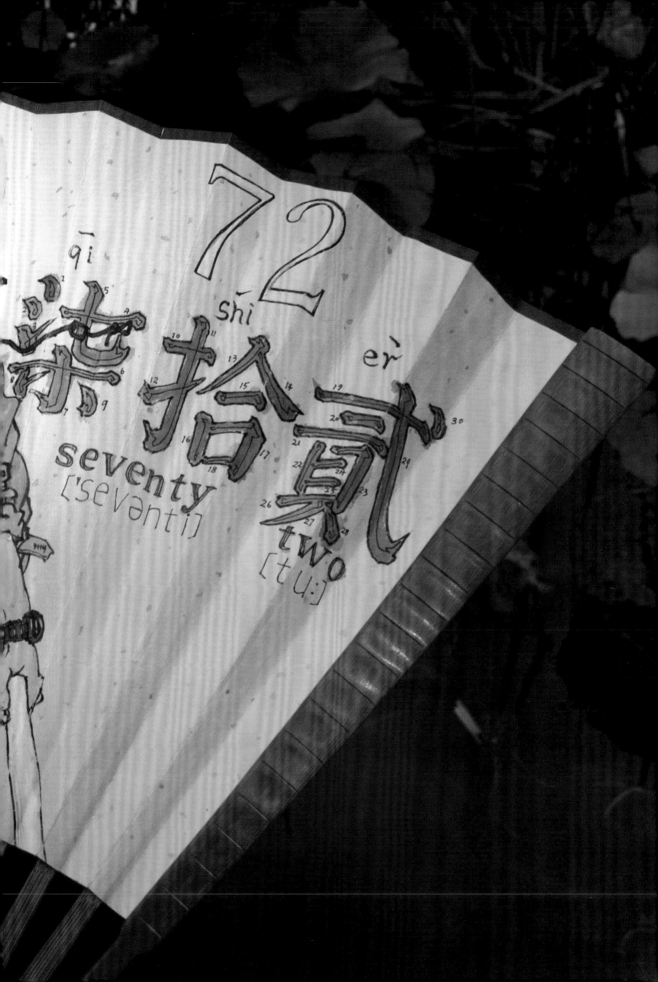

Sun Zhenhua

Screen Name_**A. Wing** Profession_**freelance designer, brand founder**

Sun has been engaged in advertising, media, design, and brand management for over ten years.

http://www.a-wing.cn a.wing09@gmail.com

Monkey King in My Eyes

I still remember that one of my favorites in my childhood was the TV series *Journey to the West*, as well as the animated films *Havoc in Heaven* and *Subduing the White Skeleton Demon Three Times*. This almighty character who fears nothing was a supreme hero in my childhood. He is impartial and rebellious at the same time. He has almighty powers, loves freedom, but sometimes submits to the restraints of the magical headband. On his journey to the west, he is never intimidated by hardships and uses his fiery eyes and golden gaze as well as seventy-two transformations to subdue all the evil spirits in heaven and hell. As the coolest character in *Journey to the West*, the Monkey King is not merely a fictive figure. Instead, he is a totem that represents strength and certain spirits.

Monkey King in My Work

I believe that every one has a Monkey King in his mind. I am no exception. I have seen many photos and materials on him. However, I still want to put down what the Monkey King in my mind is like on paper. In my opinion, the Monkey King is a cool rocker. There are too many classical elements on this Monkey King. He wears the magical headband, possesses the fiery eyes and golden gaze, swings the golden band, covers 108,000 *li* in a single flip, and is capable of seventy-two transformations. What will happen if the Monkey King lives in the modern world? The headband will be signified into his eyebrows. Without the restraint, he will feel more carefree. His fiery eyes and golden gaze are still glittering, but the golden band which he used to suppress the evil spirits will be transformed into an eye-catching electric guitar. His seventy-two transformations are only expressed in changes of costumes, while the cloud-somersault will be changed into a pair of sneakers. However, he can still use his strength and spirits to move the world and shock the universe.

WUKO is specifically designed for my own brand. I chose some simple letters of catchy pronunciation for the brand in hope that it will sell well in the international market. The mascot is evidently based on Chinese elements. A modern Monkey King is also likely to wear ear studs, a sweater, jeans, and sneakers. By doing so, he will turn into one of us.

I have also created a Q-style version of the WUKO mascot and would match it with various accessories to produce different styles.

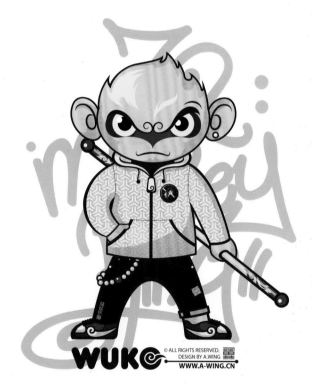

WUKO

Birth of WUKO

Long long ago, there was a scenic mountain called the Mountain of Flowers and Fruit.

One day, a meteor hit the highest peak of the mountain, causing a quake to the entire mountain.

The next morning, an enormous peach stone was found.

This peach stone perched stably on the summit. Weathered in the sunshine and moonlight, this stone has turned into a solid rock, and stayed there for five thousand years.

In a night of thunderstorm, the thunder crashed and the lightning flashed, when a thunderbolt hit the peach stone on the summit.

In a split second, the stone cracked open, and a dark shadow soared from the flames and flashes.

Legend has it that the Monkey King could cover 108,000 *li* (longer than the circumference of the Earth) in a single flip. This speed has surpassed any airplane and rocket! Cool!

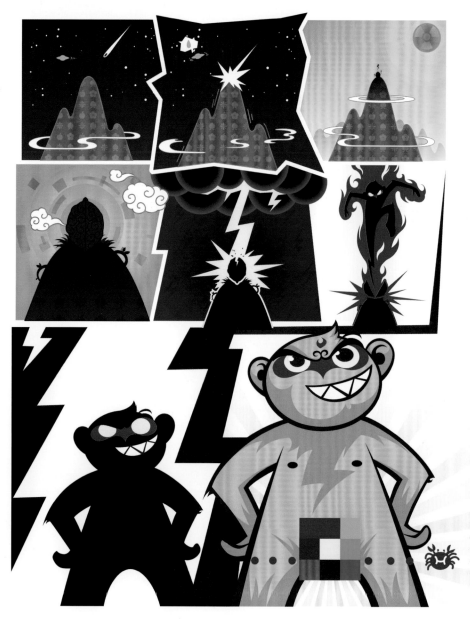

I incorporated the WUKO mascot when designing clothing for the new season.

The sweater featuring the WUKO mascot has integrated the Chinese elements and design techniques. The gilding motifs on the hood look like the Monkey King's magical headband when the wearer puts it on and like two lumps of cloud on the back when the wearer takes it off. A golden Chinese character "monkey" is stitched on the chest, while the figure "72" can be seen in the character. This is an emblem for the Monkey King. A totem featuring the Monkey King is printed on the back, and the seal meaning "suppressing the evil spirits" is stitched in a corner, incorporating the traditional design elements into modern clothing.

T-shirts of the WUKO collections use yellow and white as the base color. The facial motifs as a signature of the WUKO mascot is printed on the chest. The eyes are gilded to make his fiery eyes and golden glaze glittering with brilliance. The naughty Monkey King also uses the golden band to write a graffiti "72: Monkey King." The wearers will exude a sense of vitality and youth. At the same time, traditional Chinese techniques have also been employed, while the stitched golden auspicious clouds are a signature emblem of the Monkey King by highlighting the traditional Chinese style.

Based on the WUKO mascot, I have extended the production line, producing stickers and key chains, etc. I will continue to experiment with other new products. I hope that they will be well received.

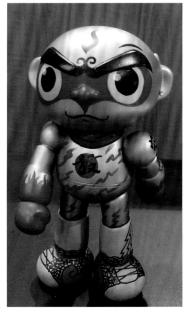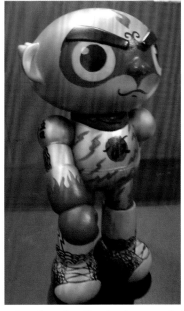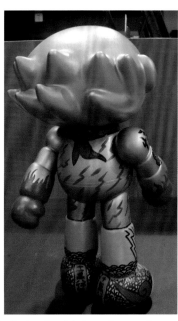

The Monkey King can perform an indefinite number of transformations. Therefore, I cooperated with other brands and designers, incorporating various versions of the WUKO mascot into other products.

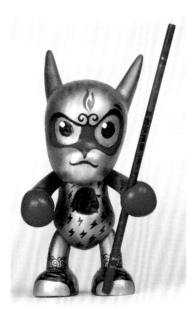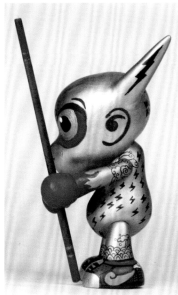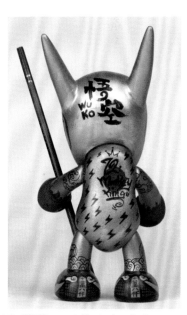

This is a work by JUDASZ, a Spanish toy designer. Its artistic style is an ideal medium to present the WUKO mascot. The toy has also been exhibited in San Sebastian, Spain.

In 2010, the second WEAkid Toy Exhibition was hosted, which offered a platform for the WUKO mascot.

Thierry Doizon

Screen Name_**BARONTiERi** Profession_**concept designer**

When he is not at his desk working on some artworks and ideas, Thierry is trying to find a balance between his love for extreme sports and environment protection activities!

🌐 **http://www.barontieri.com/**　✉ **barontieri@gmail.com**

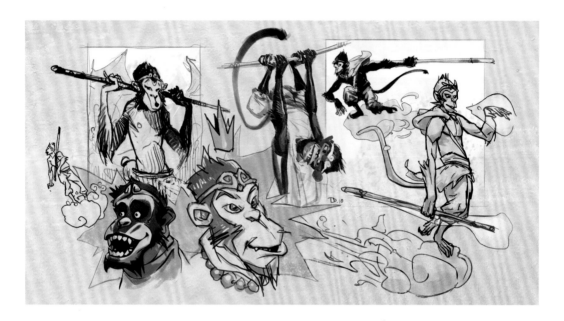

I've started with a montage of selected digital sketches of the Monkey King, knowing that the different poses would eventually be connected to the same cloud. Then I refined those sketchy lines before experimenting on the background, the volumes, and the basic colors. In the end, I spent more time on polishing the details as well as tweaking the contrast, color balance, and overall saturation.

Monkey King in My Eyes

A few months ago, I gladly received an invitation from Vincent, asking me if I wanted to be part of a new exciting book that would be focusing entirely on the Monkey King. It is a surprising but also challenging proposal, in many ways, first because I have always wanted to illustrate the famously odd and fearless ape figure but have never had the chance to do so, and also because so many great artists have already done the job well. I haven't read *Journey to the West* yet and it's enough of a shame to join such a project without knowing what's going on exactly in the story. But I've been introduced to the Monkey King by people such as Akira Toriyama, Katsuya Terada, and the Black Frog and through many movies, so I didn't know where to start or how to do it. When I first read *Dragon Ball*, I instantly fell in love with his magic cloud. It's just an amazing idea, imagining the endless pleasure of riding it in the skies, hovering above a river, and sliding around canyons, waterfalls, and valleys!

Monkey King in My Work

Riding the magic cloud just sounds like surfing and longboarding, and that's the way I want to present him, as a cloud rider having a blast. We've always seen the fighting and facetious side of him, and there are so many crazy transformations to be presented, but it is probably in a more spiritual, playful, and graceful way that I want to present the myth here. Now I promise to read the novel so I can pay my respect to Wu Cheng'en and his followers.

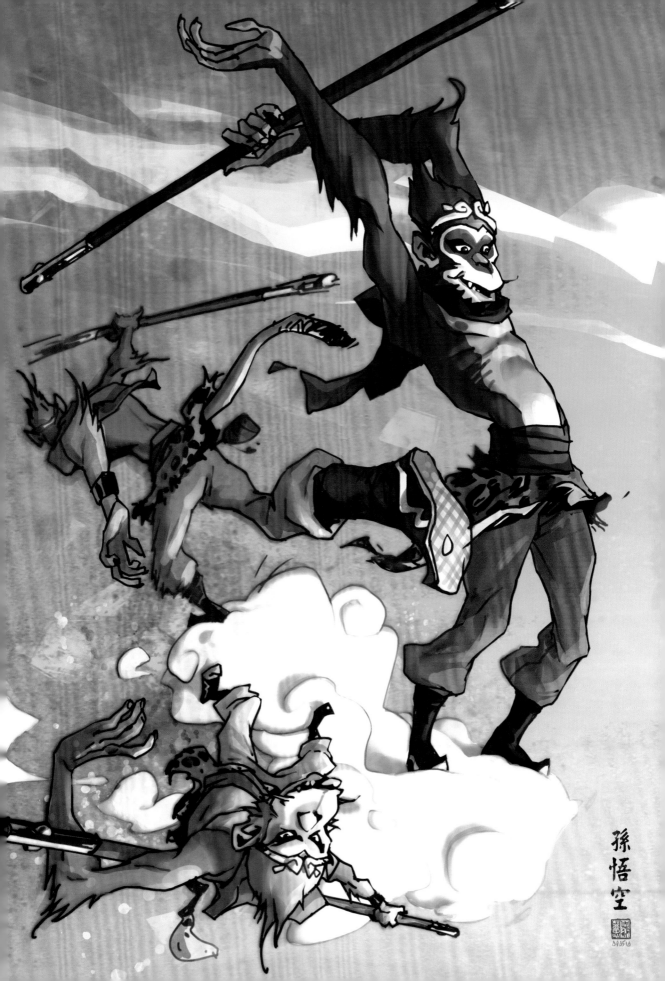

Tien Hee

Screen Name_**T-Wei** Profession_**freelance illustrator, student**

Tien Hee is a painting student who spends his days sculpting.

Http://tienhee.daportfolio.com Tien.Hee@gmail.com

Monkey King in My Eyes

I see a lot of myself in the Monkey King. Not only am I the spitting image of a monkey in human clothing, but we also have a lot in common in terms of personality. I remember the first time I heard about the Monkey King. My dad, in an attempt to get me to learn something cultural for once, sat me down and started talking about a monkey who despite being small of stature and low of status, worked hard, learned a ridiculous amount, and put this to use by defeating monsters and bad guys. I have to admit, afterward I still had no idea who the Monkey King was. What I was picturing in my head wasn't an image of a traditional Chinese setting created hundreds of years ago, but a story more likened to usual anthromorphic superheroes every kid in the mid-1990s seemed to idolize. An image reminiscent of the Street Sharks, Biker Mice from Mars, and the Teenage Mutant Ninja Turtles was what I conjured up. In my final work, supervillains were laughing maniacally as the Monkey King and his supercompanions battled against deadly creatures from the edge of the world. I suppose it was a good thing, as it helped hold my interest for longer than eight seconds.

Monkey King in My Work

The Monkey King in my work is an incredibly courageous, ambitious, and completely self-righteous character, whose personality enabled him to fight for his own sense of justice in the world. This is pretty much how I see myself as a child, a bit of a hell-raiser who went on adventures around the neighborhood, causing trouble but ultimately fighting for his own sense of justice. Once I'd learned about the Monkey King, it seemed to amplify those qualities about me. I would go on more adventures, jump off more rooftops, climb more trees. I think it's important for a kid to get out and have adventures when he has the chance, and to some extent the Monkey King inspired me.

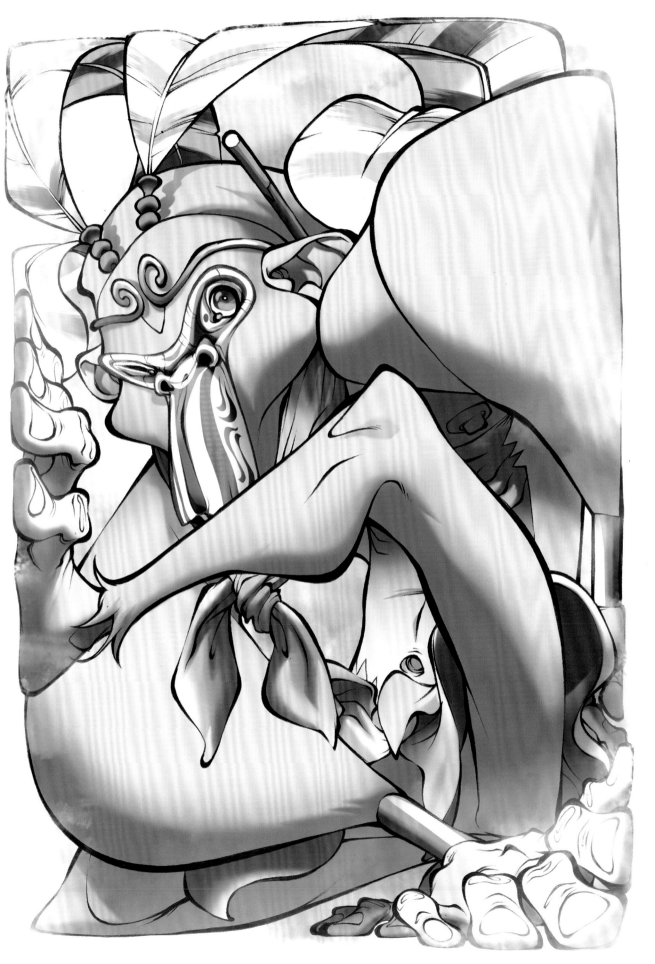

Tom Bancroft

Profession_animator cartoonist

Tom Bancroft has over twenty years of experience in the animation industry. During his eleven years at Walt Disney Feature Animation as an animator, he has been working on some classical films including *Beauty and the Beast*, *The Lion King, Aladdin, Mulan, Lilo and Stitch*, and *Brother Bear*.

http://www.funnypagesprod.com tom@funnypagesprod.com

Monkey King in My Eyes

Monkey King is globally renowned; I have heard him even in my country. There are many plots that have become classics.

He is so brave and resourceful. I think he has more than just a monkey. He is our example too. I like the stories about him.

Monkey King in My Work

My goal was to create a dynamic scene that would show the Monkey King's incredible abilities. I chose to have him fight a Fire Dragon while flying on the clouds because I thought that

would be an iconic image for him. I put a temple between them so it would seem that he was defending it.

Whenever I start a new story-driven illustration like this one, I do as much research as I can. I went online and searched for as much information as I could about the "Monkey King" character and his story. I found many different versions of how people have drawn him in the past and found some good information on his story, abilities, and personality. My first step was to start designing the Monkey King character. My first two character designs were fine, but not what I was really interested in. I wanted the finished illustration to have a stylized look, so I kept simplifying the design until I had one I liked. To get to know the character design a bit more, I did a few different facial expressions and poses.

Once I found something I liked, it was time to work out what kind of picture I wanted to create with him. Because of my animation background, I like to put as much "movement" as I can into my illustrations. I wanted to create a hand-fought scene, and through my research I discovered that the Monkey King had fought a few different foes. One of them was a Dragon King. I began creating small thumbnail sketches to visualize different ideas. I knew the illustration would be a two-page spread, so I made sure I planned out the composition so no important elements (like heads, arms,

or legs) are in the middle of the layout. Another goal was to create compositions that drew your eye through the illustration. In this case, I wanted the Monkey King to be the thing you looked at first, then the dragon, then what they were fighting over—the temple. By adding the temple into the illustration, I wanted to imply that the Monkey King was defending it. Some of my thumbnail sketches were not dynamic enough, some didn't work well with the two-page spread format, while others just didn't tell the story I wanted to tell. Finally, I created a sketch I liked.

With this sketch in hand, I could now create the final. I began redrawing all the elements separately. I inked each of them with Pitt Brush markers on separate pieces of paper. I then scanned each element into the computer and put the final inked image together to match my thumbnail. I gave the inked composition to my good friend, Chuck Vollmer. We discussed how the light could be used to accent and how the characters could stand out the best. A sunset scene was chosen, and Chuck created the final painting that you see in the next few pages.

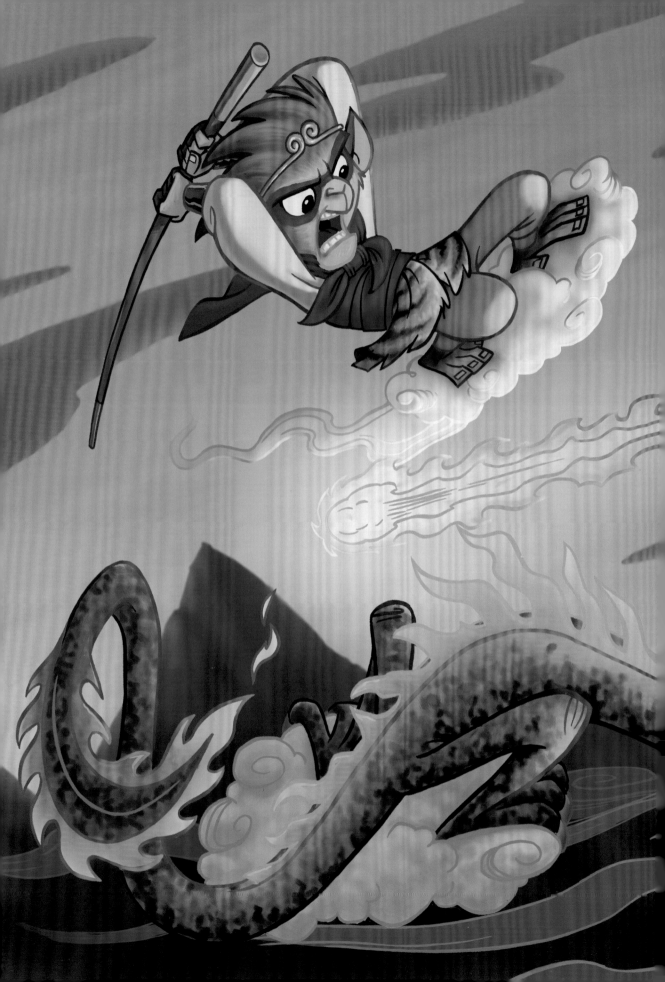

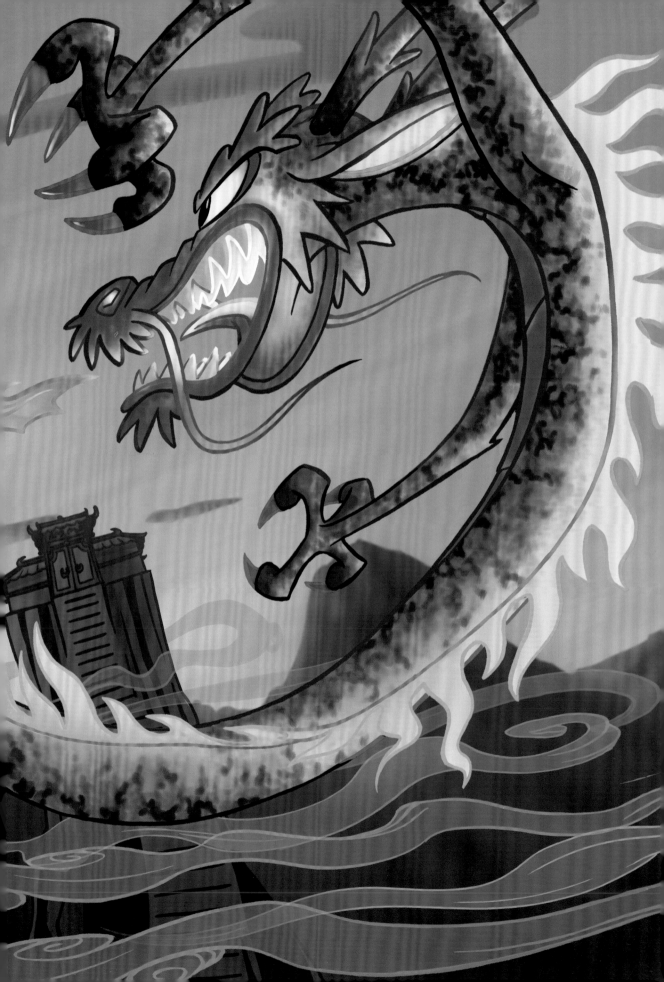

Wang Linning

Screen Name_**a.pipe** Profession_**game producer, illustrator**

Wang is a drawing geek with a mania for games, contemporary arts, and anything bizarre.

http://blog.sina.com.cn/inapipe inpipe@hotmail.com

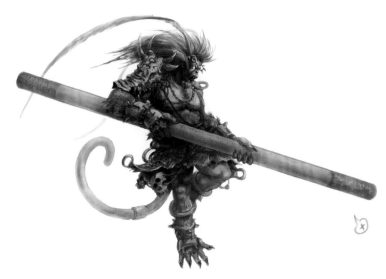

Monkey King in My Eyes

The Monkey King is one of the most distinctive legendary characters in China, perhaps even the world. He is the crystallization of wisdom and courage that are valued by Chinese culture. The novel *Journey to the West* is actually divided into two stages concerning the image of the Monkey King—the stage of the havoc in heaven and the stage of pilgrimage to the west.

Obviously, the Monkey King in the first stage seems to be more attractive to the professionals in the cartoon and game industry. During that time, the Monkey King exemplifies the determination to transcend the conventions. In decoding his name (Sun Wukong, meaning "aware of emptiness"), many religious scholars believe that he is finally aware of the true meaning of life—life is nothing but emptiness. His name

suggests that the vanity and emptiness of life is the current world order and expresses people's aspirations for a new order and freedom. This Monkey King is a fully developed character loaded with distinctive personality. I think this image is more true to life than many figures in European and American mythologies and cartoons, and it is easier for readers to see themselves in this particular figure.

Based on this, I think that to animate the Monkey King, it seems appropriate to make an adaption of the original fiction for a more idealized image. As the head of the demons, he is both divine and evil at the same time in his battles against the "Court." Such an adaption would enrich the story and demonstrate the distinctive personality of the hero in a dialectic way.

Monkey King in My Work

I want to illustrate a special image of the Monkey King that has moved away from his typical image.

I read *Hellboy* by an American cartoonist, which impressed me a lot, as it depicted a female hero. Thus, I believed that the Monkey King was only an exemplification of the aspirations to pursue freedom and defy the authority, which has nothing to do with the gender of this character. Thus, it would be a great fun to produce a female Monkey King. Later, I came up with an idea to depict her as the prelife of the Monkey King, who was the most powerful

demon in the age of Pangu who has separated heaven from earth, or that of *Shan-Hai Ching*. In terms of style, I have departed from my commonly used realistic approach with special touches. Another idea is about "modern Monkey King." By using the concept of time travel, which is common in European and North American cartoons, the Monkey King could also exist in modern times. He is hunting for demons and ghosts under different disguises at present or in the future. He carries an undisciplined and unrestrained air and has some ill-flavored inclinations.

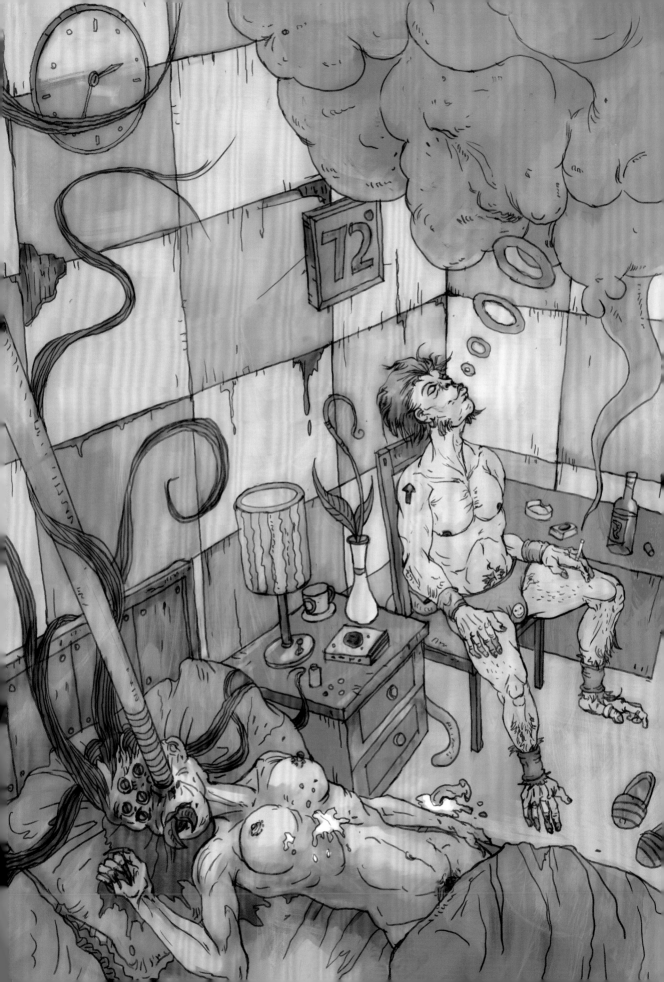

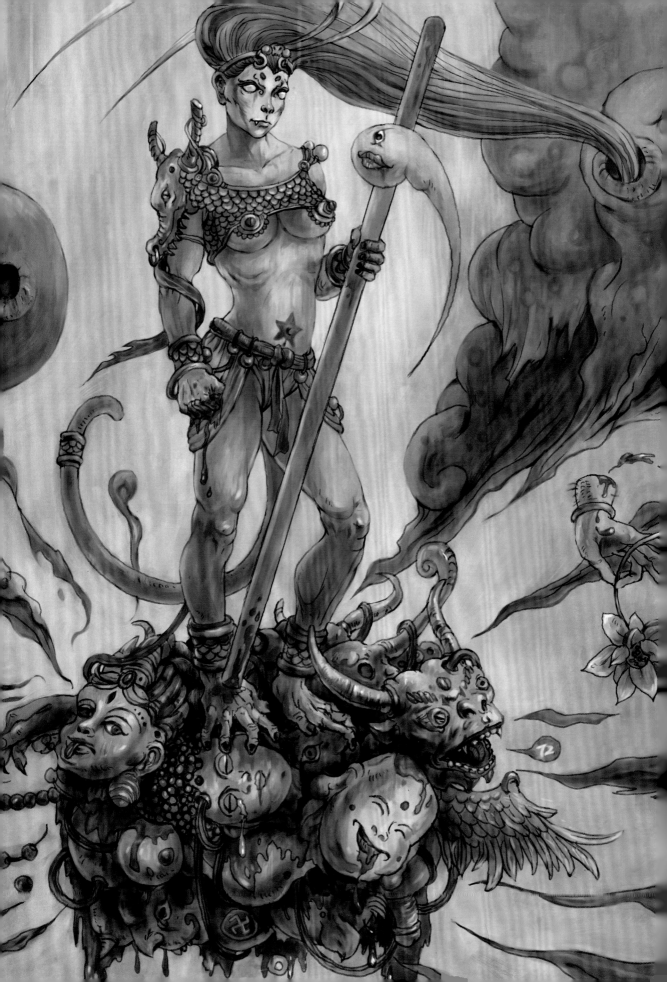

Step 1: I made a draft and decided on the rough composition.

Step 2: I elaborated on the draft to use it as base.

Step 3: I built up a line sketch.

Step 4: I started the coloring process in a casual style. Generally speaking, I observed the traditional principle of light and shadow, three-dimensional forms, and intrinsic color.

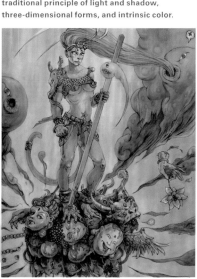

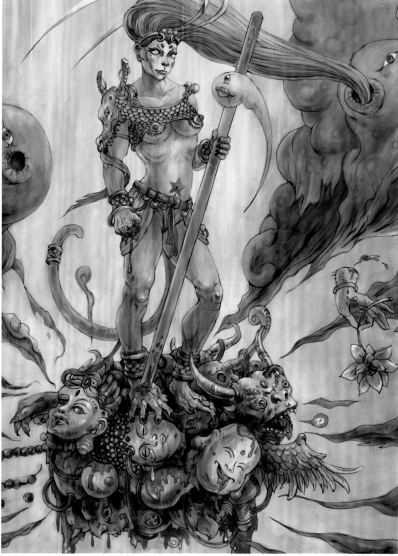

Step 5: I repeated the coloring process and added certain textures to highlight the effects of bronze sculpture and antique quality.

Step 6: I increased the contrast ratio and finished the details.

Wang Peng

Screen Name_**PON** Profession_**art director in the game industry**

Wang has worked in art direction since 2007.

http://papa.wong.blog.163.com/ ✉ papawong121@126.com

Step 1: This draft is rather random, just intended to capture what has flashed by in my mind. Therefore, no details are needed. Later, I can work from this image to collect reference materials in order to elaborate on every detail. Afterward, I would start to paint on the computer while referring to the draft. Relatively speaking, computer drafts require a higher precision. I have to determine the composition in the finished work at this drafting process so that the original draft will not be too different from the finished. I have been striving to achieve this objective at this step.

Step 2: I elaborated on the draft and set up the lighting source to construct the light and shadow, clarify the design concept, distinguish between the black, white, and gray, and give prominence to the highlight of the illustration.

Step 3: I overlaid the color to match with the basic color of the illustration and clarified the color relationship.

Step 4: I made further efforts to work on the background color and unified the basic color of the illustration. At this step, I found that some elements in the background in this illustration seemed to be distracting—the character could not stand out. Therefore, I decided to make some revisions to the background.

Step 5: OK. I have made considerable adjustments at this step by using some large lumps in the background to make it darker and more natural so that the Water Curtain Cave would seem more vivid. I unified the lighting source.

Monkey King in My Eyes

The Handsome Monkey King who used to command the wind and clouds has waited for five hundred years before embarking on the journey to the west to retrieve the sutras. He is capable of shape-shifting; he is fearless of anything; he can identify what is evil and what is righteous by depending on his fiery eyes and golden gaze; he can make a serious change at a critical moment; he is the incarnation of justice. This is how the Monkey King has impressed us.

Monkey King in My Work

Warfare is not exclusive to man. The Monkey King has been reinterpreted as a modern female who has incorporated beauty, confidence, and competence. Such females construct a highlight in this new age. Just like the Monkey King, they are courageous and quick witted and always have full control of the situation by depending on their sensitivities and determinations. In pursuit of happiness, they have proven themselves invincible.

I have employed a partial lighting source in the illustration to highlight the superiority of these female Monkey Kings. I have spent a lot of time on the details of the facial expressions—the heart-shape makeup represents an integration of tradition and fashion, exuding a sense of detached sex appeal and highlighting the hidden gloominess. The simple motifs on the forehead and cheeks have helped to enhance the sense of drama and loveliness. Coupled with the golden boots and warfare garments, all these elements have given prominence to the toughness and experience of the character. The female Monkey King seems to be lost in thought, frowning, with her eyes filled with gloominess, indicating that she still keeps a feminine heart despite her tough looks.

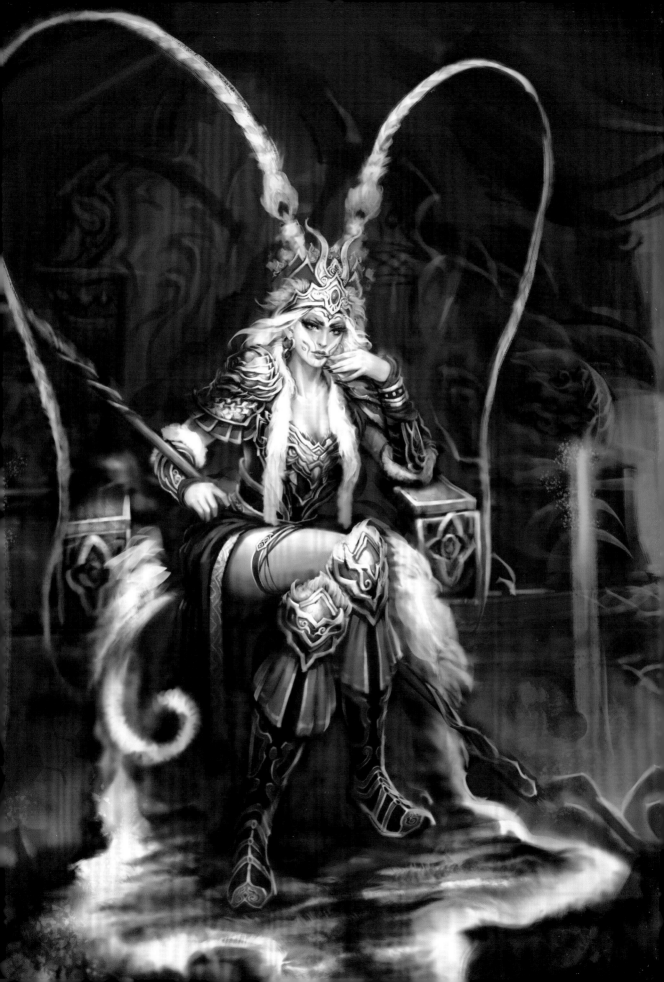

Wei Lai

Screen Name_**Popo** Profession_**concept designer, illustrator**

As a cool monkey of Aquarius longing for a beautiful future, Wei likes watching films and listening to rock music. He formed a band and served as the vocalist. He also used to work as the key framer for online games. Currently, he works in Concept Art House of the US, trying hard to realize his dreams.

http://blog.sina.com.cn/popoweilai popo@conceptarthouse.cn

Monkey King in My Eyes

"Brother Monkey" is a nickname that Pigsy calls the Monkey King. He also has other titles, such as Sun Ascetic, Handsome Monkey King, the Protector of the Horses, the Great Sage, Equal of Heaven, and Victorious Fighting Buddha.

However, only "Brother Monkey" sounds intimate and close to life. In ancient and contemporary drama, the Monkey King is constructed as an intelligent, courageous, naughty, almighty hero with distinctive personalities who abhors injustice and evil. He is not afraid to defy heaven and earth. The Monkey King in the TV series produced in 1986 impressed me most. I was born in the year of the monkey and was influenced by the Monkey King in every possible way. At an early age, I started to dream of traveling on clouds and acquiring all kinds of powers. In my adolescent years, the Monkey King was still my inspiration and I wanted to be a man like him, who is committed to pursuing freedom and safeguarding justice.

Monkey King in My Work

In producing this illustration, I want to stick to the realistic style that I do well and make some changes to the typical image of the Monkey King that everyone is familiar with. I believe that any artist could give full expressions to the wisdom and courage of the Monkey King in their work. Therefore, I want to challenge myself by illustrating him from another perspective to exploit his loneliness.

Inspired by such thoughts, I built up an illustration with my desired effects little by little. The Mountain of Flowers and Fruit, which is supposed to be like spring all year round, is shrouded in winter snow. The falls, fruit forests and monkey tribes are all gone, with no signs of life. Amid the boundless snow, the Monkey King sits in solitude in the forests, like a statue of a lonely aged man. His Golden Chainmail no longer shines with luster, and the unique golden band leaned against his shoulder like a rusted iron stick. His eyes look dull, glittering in blurring darkness. He has to learn to live with boredom and idleness; yet he is still pondering over his martial valor as a young man, sighing over the changes. I think he must be saying to himself, "I am a legend."

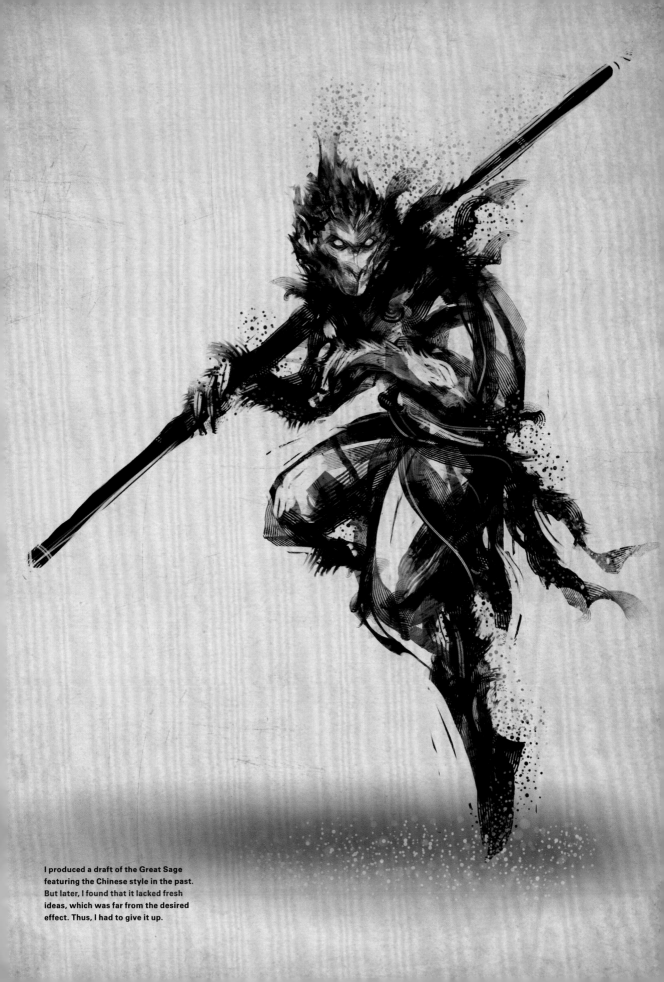

I produced a draft of the Great Sage
featuring the Chinese style in the past.
But later, I found that it lacked fresh
ideas, which was far from the desired
effect. Thus, I had to give it up.

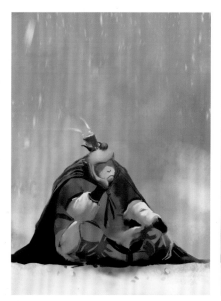

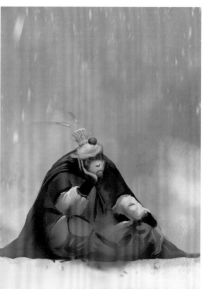

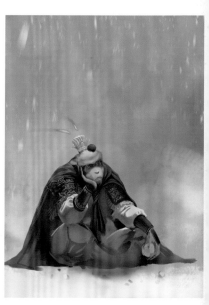

Step 1: I started by deciding on the color palette in a rough way. I used simple color lumps to illustrate the silhouette of the Monkey King.

Step 2: After finishing the color base, I started with the eyes, as the facial expressions would determine the artistic effects of the entire illustration.

Step 3: I expanded outward from fur on the head and elaborated on details while paying attention to the influence of the ambient color.

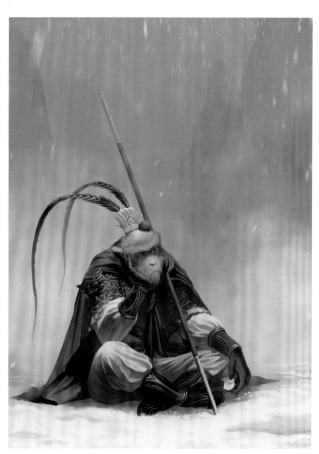

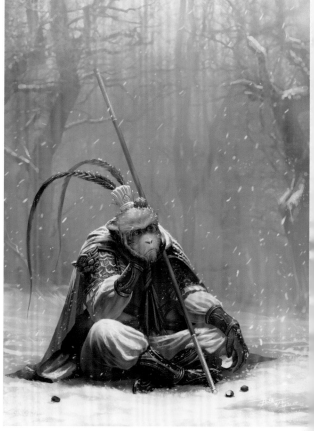

Step 4: After finishing the details, I added the golden band. I prepared to illustrate the surrounding snow and the drooping trees in the background.

Step 5: I added the flowing snow and the thin layer of snow accumulated on the Monkey King. I started to adjust the color relationship between the background and the Monkey King so that the character would blend into the snow scene.

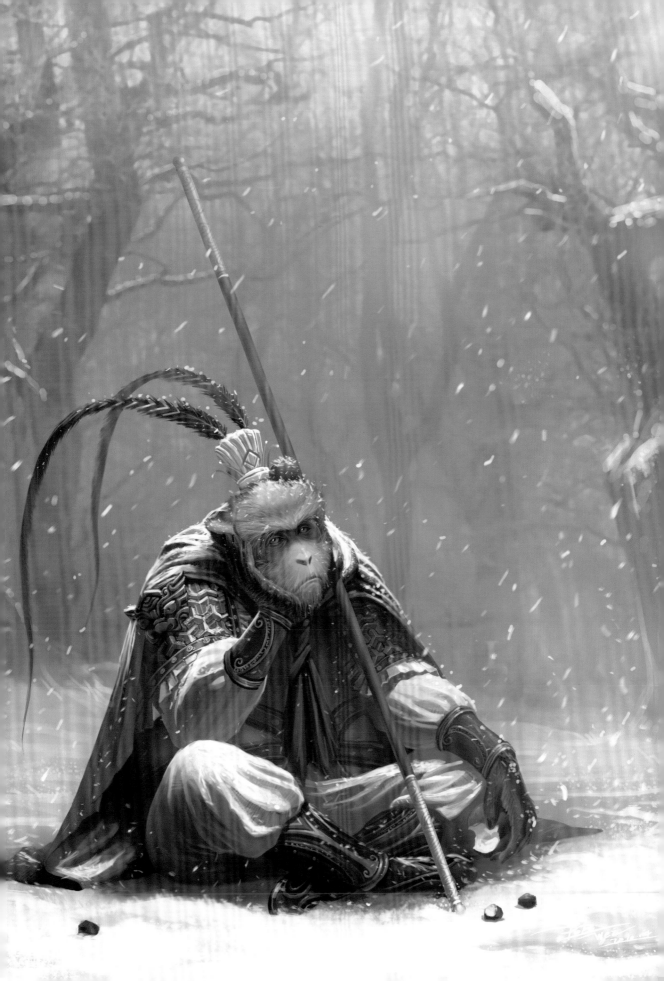

Wu Lin

Screen Name_**Instant Noodles** Profession_**freelancer**

Wu is a freshman striving to make progress.

http://ffnowaygo.com/ffnowaygo/blog/ ffnowaygo@hotmail.com

Monkey King in My Eyes

If you ask me what scene in the TV series *Journey to the West* impressed me most, I would answer that it is not about how courageous and almighty the Monkey King is. It is how the Tang Monk was teased by the female demons. That scene imposed a strong emotional impact on me in my childhood, as it exposed me to the notion of eroticism.

However, this illustration is themed on the Monkey King. Therefore, I have to think hard about how this character has impressed me. Though this character is less impressive to me than the Tang Monk, I finally selected a scene that interested me most. It was when he was honored as the king by the other monkeys at the Mountain of Flowers and Fruit before he embarked on the journey to the west to retrieve the sutras. I think this must be the most glorious and rewarding moment in his lifetime. When he put on the magical headband to serve the Tang Monk on his pilgrimage to the west, he totally gave up his true self. Therefore, when we are talking about his courage and invincibility, we refer to the Monkey King who has not met the Tang Monk yet.

Monkey King in My Work

I don't know much about portraiture. I love drawing cats. Therefore, though I like the interactions between the Tang Monk and female demons, I could not put them down on paper. Actually, in this illustration, the Monkey King looks like a cat to some extent.

However, the Monkey King is still Monkey King though he is portrayed like a cat, because there is a Monkey King in every mind and that's just the Monkey King in my mind. Therefore, I searched hard in my childhood memory, recalling what prestige he commanded when swinging the banner and shouting slogans on the Mountain of Flowers and Fruit. His confrontation with the Dragon King is also one of the highlights. Therefore, I selected these two scenes and reinterpreted them by using watercolor. It represents my experimental efforts. However, I believe I have exerted myself in this illustration, living up to the Monkey King's spirit of exerting himself for freedom in both looks and actions.

Xie Yunzhang

Screen Name_Bottle-Xie Profession_chief executive in the Design Department of GOG International

Xie is a Frankenstein.

http://www.bottle-xie.com 99280922@qq.com

Monkey King in My Eyes

For a long time, the Monkey King is driven by a firm belief, which inspired him to confront difficulties and challenges with all his skills. However, there are good beliefs and bad beliefs. Not all beliefs are worth adhering to. Just as we all know, the Monkey King is not always an incarnation of justice. He claims himself "Great Sage, Equal of Heaven" on the Mountain of Flowers and Fruit, demonstrating his fearlessness; he competes with the Buddha to exhibit his magical powers but ends up being imprisoned under the Five-finger Mountain for five centuries, revealing his ignorance; he has finally converted to Buddhism and accompanied the Tang Monk to retrieve the sutras, exemplifying the notion of commitment and perseverance. Therefore, as long as a man has gained perseverance and a consciousness to distinguish right from wrong, he will finally achieve glorious accomplishments. If he has been misled by an improprer objective, he might be scolded for generations. Enlightened by the Guanyin Bodhisatta, the Monkey King agreed to ensure the safety of the Tang Monk on his pilgrimage to the west and was therefore "gifted" a magical band. Actually, I believe that this band is of great importance to the configuration of the Monkey King's character. It might be said that under the joint influence of the magical headband as the external factor and the firm belief as the internal factor, the Monkey King has finally succeeded in gaining Buddhahood. Without the headband, he might have been misled by his emotions even after he has been enlightened by the Guanyin Bodhisatta.

Monkey King in My Work

I have chosen to reinterpret the Monkey King as a machine. According to my concept, the machines can take different forms. They can be seen as clones of the Monkey King or as what he has transformed into.

In the illustration, the golden band is intended to be a heavy instrument that has incorporated multiple functions. The ends are equipped with automatic and pneumatic tools. With the help of these tools, the Monkey King can invent more instruments and find resolutions to more complicated problems with higher efficiency and precision.

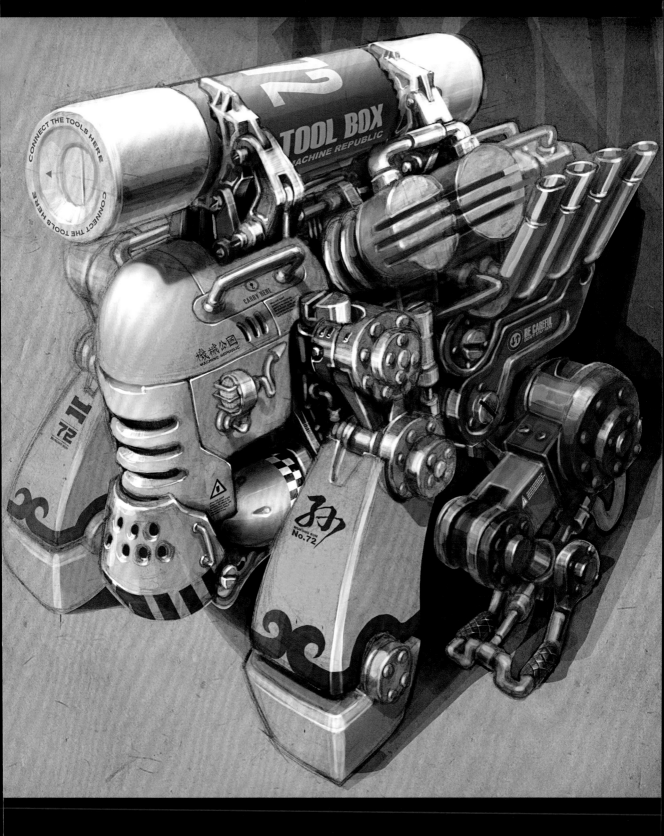

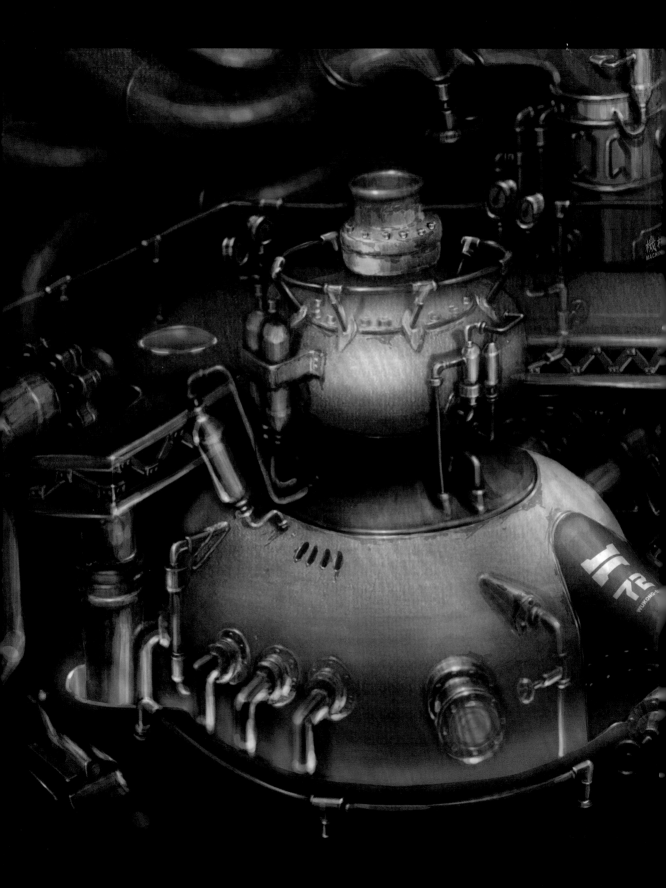

孙悟空

WUKONG SUN

No.72

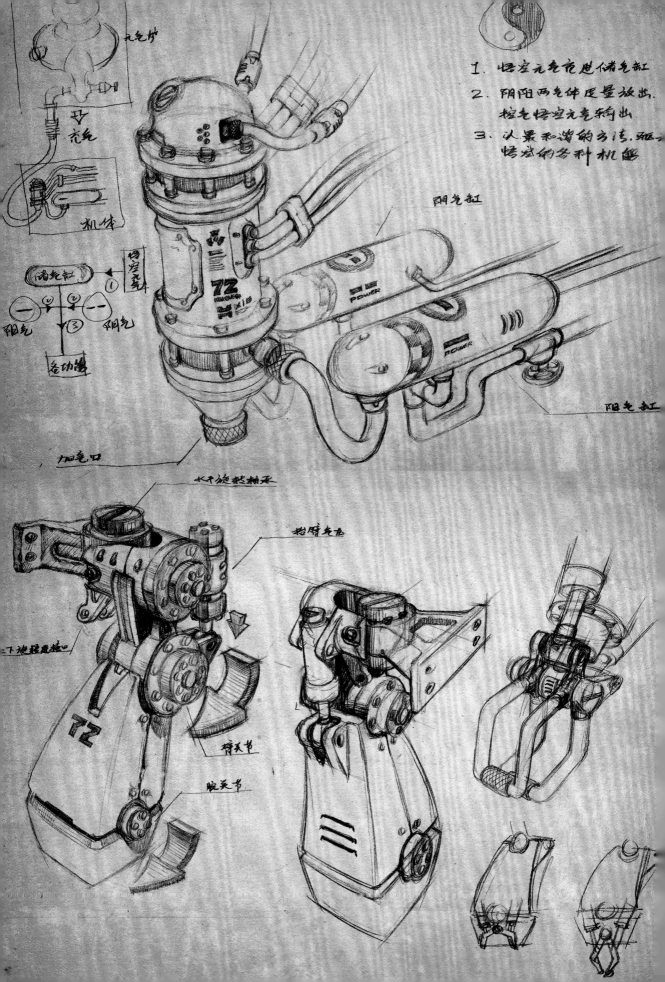

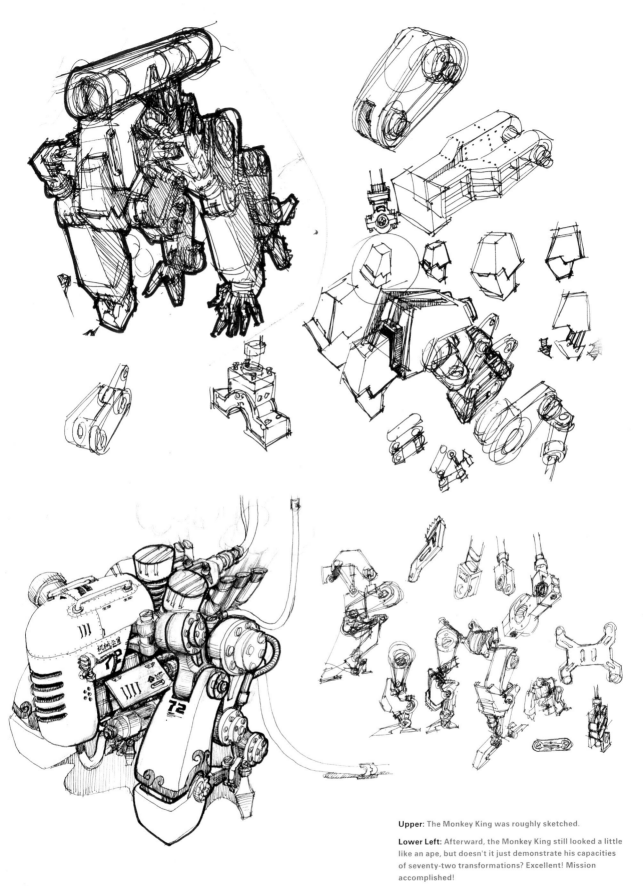

Upper: The Monkey King was roughly sketched.

Lower Left: Afterward, the Monkey King still looked a little like an ape, but doesn't it just demonstrate his capacities of seventy-two transformations? Excellent! Mission accomplished!

Lower Right: The concepts for the leg.

Xu Jiteng

Screen Name_**ADAM** Profession_**game designer**

Xu works in card illustrations and poster and game design.

http://adamsxjt.blog.163.com/ adamsxjt@hotmail.com

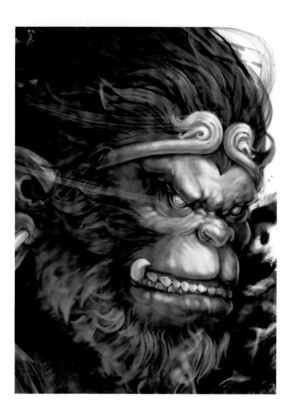

Monkey King in My Eyes

I believe that every one loves the Monkey King for different reasons. Unlike most protagonists, the Monkey King in *Journey to the West* is not just kindhearted and righteous. His wild and unrestrained nature, along with arrogance, seems more impressive to me. He has been my supreme icon since childhood. I dreamed of fiery eyes and the golden gaze, cloud-traveling, the golden band, monkey followers, and seventy-two transformations … Even when playing games, I would keep on chanting "I the Monkey King … Change …" subconsciously. The Monkey King is a recurring theme in my scribbles. In my mind, he is a classic that will not be easily transcended.

Monkey King in My Work

I'm so glad to be invited to participate in this project. I'm so eager to create a Monkey King featuring my unique style. Therefore, I picked up the pen and drew a pile of drafts. However, when putting down the pen, I felt that the drafts were far from what I had been looking for. They did not appeal to me at all. Therefore, after some reconsideration, I came back to the traditional Monkey King. After all, the traditional one had constructed a lasting memory in my mind. Therefore, I finally chose to work from the traditional image. I felt most amazed by his skills to produce thousands of clones with a single hair. Therefore, I decided to adopt traditional Chinese brush painting to encapsulate the moment of his summoning his clones. I believe that the integration of various traditions and the ink-splashing techniques will help to capture the charisma of the Monkey King.

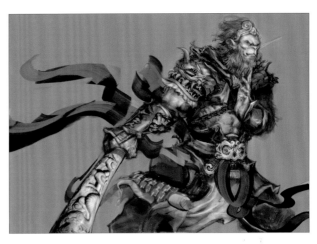

Step 1: I collected a large amount of references, including sketches of traditional costumes and traditional images of the Monkey King. Afterward, I drew some drafts to roughly illustrate the gestures and facial expressions to capture a roughly developed concept in my mind.

Step 2: I adjusted the composition and human anatomy. I designed the costume and armor and worked on the black, white, and gray tones.

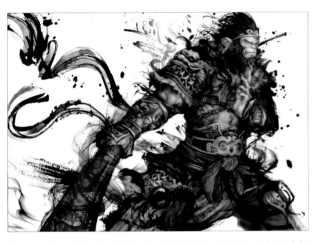

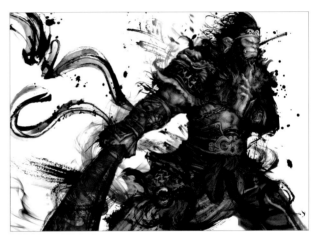

Step 3: I added some ink-splashing and brush-painting elements, enhanced the sketch, and highlighted the gray tones to make preparations for the later stages. I applied some rough strokes to produce a freehand style.

Step 4: I worked on the color palette and used the overlay function to add supportive colors to the monkey.

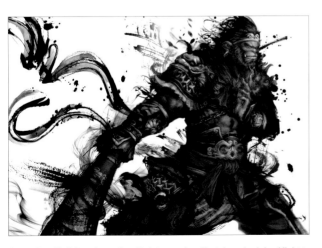

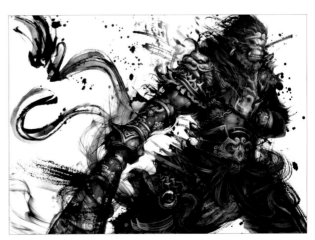

Step 5: I purified the color and applied the overlay effect. I used subdued light to brighten the color.

Step 6: The final stage was given to detailing, highlighting the major elements, and adding the special effects. The illustration was finished!

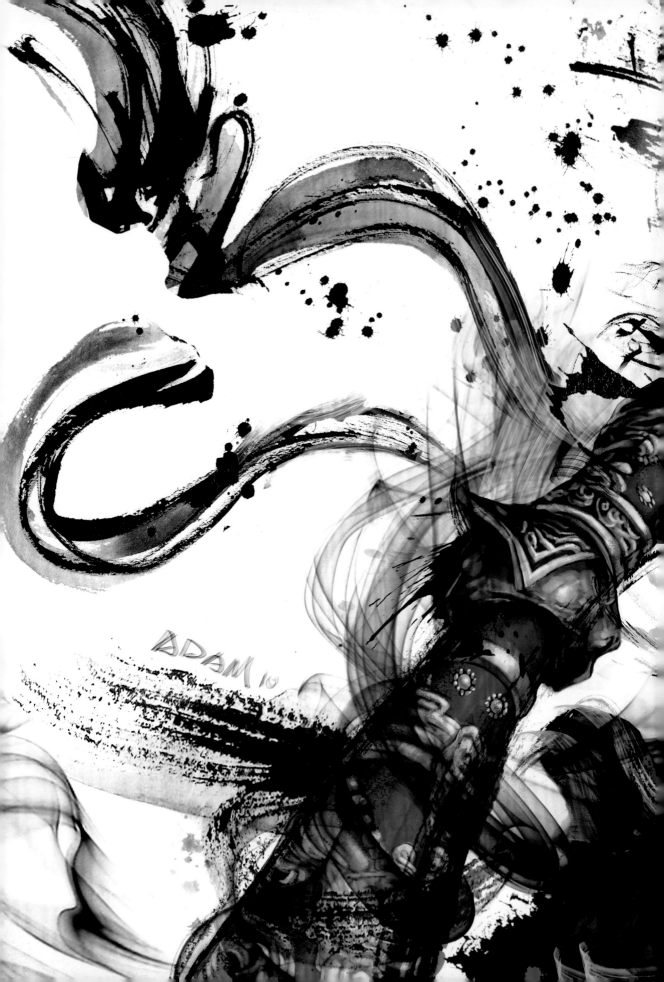

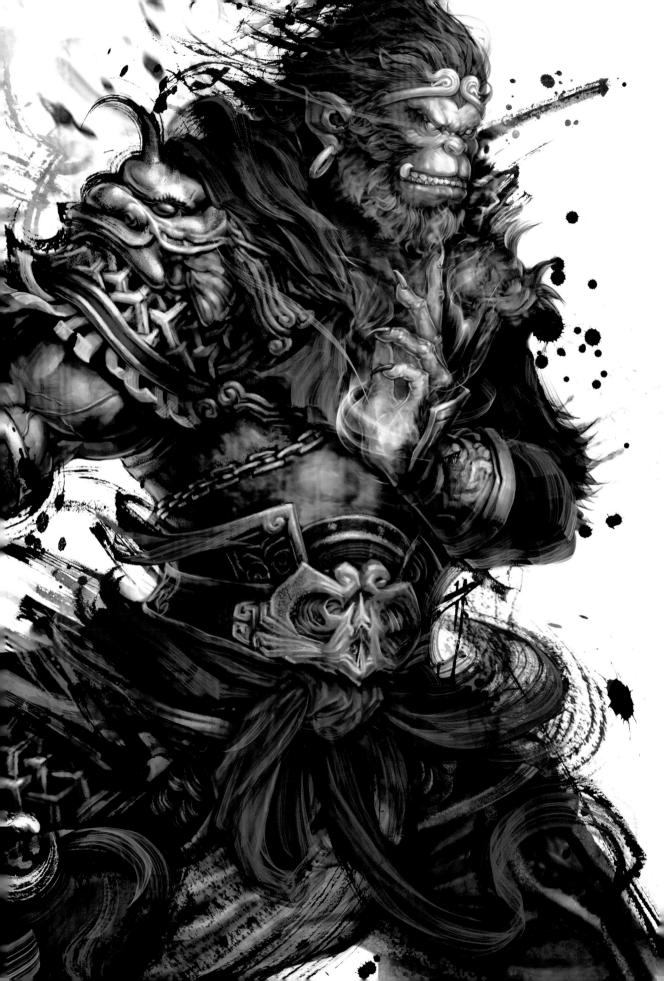

Xu Tianhua

Screen Name_**FlowerZZ** Profession_**concept designer**

Xu was involved in producing the first edition of *The Choice of Cult Youth*, an underground comic collection in 2006, and in concept design of the movie *Handsome Monkey King* in 2009. A graduate from the Digital Media Studio of CAFA (Central Academy of Fine Arts) in 2009, he worked as the chief scene designer in the animated film *Return of Goku and Friends* from 2009 to 2010 and as the preproduction concept designer of the movie *Women Generals of Yang Family* in 2010.

http://blog.sina.com.cn/flowerzzxu **flowerzzz@163.com**

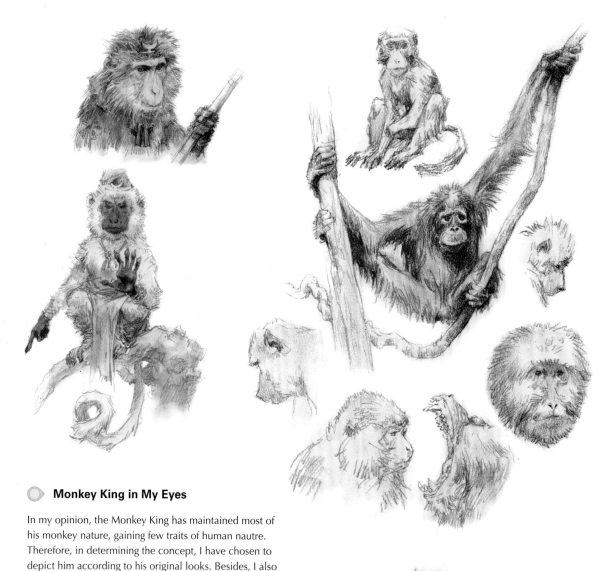

Monkey King in My Eyes

In my opinion, the Monkey King has maintained most of his monkey nature, gaining few traits of human nautre. Therefore, in determining the concept, I have chosen to depict him according to his original looks. Besides, I also want him to be lovely.

Monkey King in My Work

The Local Guardian God is one of the supportive roles who has made frequent appearances in the original story. Whenever the Monkey King wants to know something about his enemies, he would turn to the Local Guardian God. I find it very interesting and therefore included the Local Guardian God in the illustration.

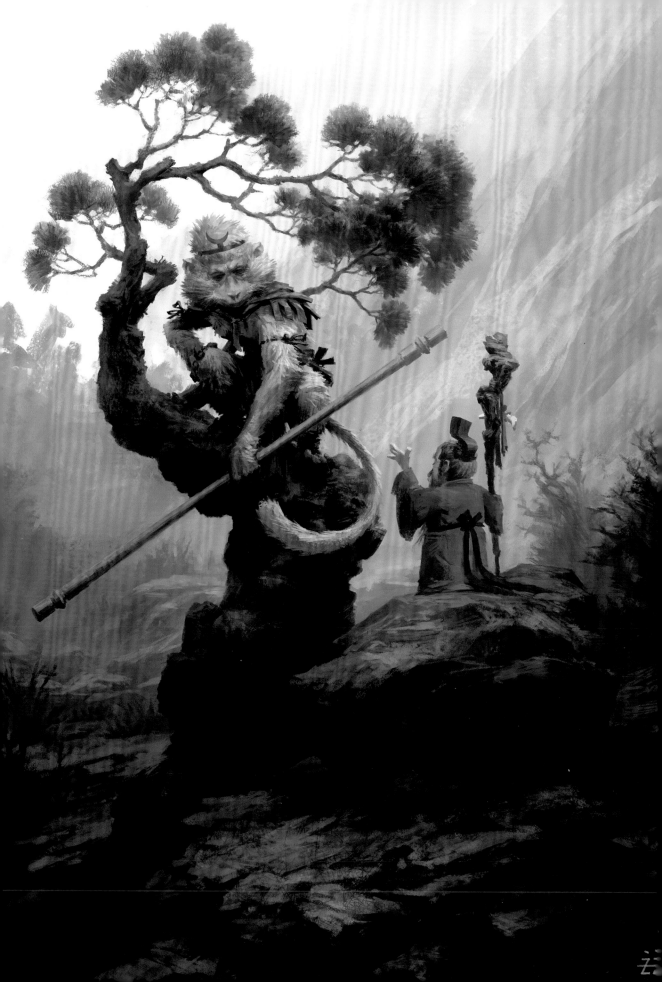

56 Xu Zhongrong

Screen Name_**X2R** Profession_**ACG designer**

Xu is an environmentalist and supporter of science and democracy. He currently works as an industrial designer, cartoonist, machine rendering artist, and electronic musician.

http://X2R.cn　　**X2-R@QQ.com**

Monkey King in My Eyes

The well-known Monkey King is a classical image exemplifying romanticism and incarnating human's celebration of fearlessness and frankness as well as the pursuit of capabilities to go anywhere and make indefinite transformations. This character has achieved something that is the most attractive and valuable for us. He has crystallized humanity's imagination and creativity and is thus well received by people all over the world. My encounter with the Monkey King came from the CCTV's *Journey to the West*, which was the first feature TV series in China. The Monkey King starred by Liu Xiao Ling Tong has proven to be more impressive than that in other versions.

Another Monkey King is the super Saiyan in *Dragon Ball*. Millions of people have interpreted, mimicked, and adapted this classical character, who has also showed up in other realms such as literature, paintings, movies, animation, etc. The Monkey King has turned out to be a recurring theme to a host of artists. Sometimes, we might start to wonder whether there is an end to its popularity.

I love the Monkey King for the following reasons: Firstly, he is natural and naive—he has never found a shelter under others' wings and is subject to no restraint, because he has no parents or relatives. He is handsome—don't forget that he is known as "Handsome Monkey King". He is courageous— he dares to dash into the Water Curtain Cave. He is awe-inspiring—he is respected as the Monkey King. He is a good learner—he has learned to make seventy-two transformations, achieve immortality, and travel on clouds. He is confident and proud—he claims himself as the "Great Sage, Equal of Heaven". He is an animal protector—he has once served as the Grand Guardian of the Heavenly Stables. He is never intimidated by challenges and struggles—he has raised a havoc in heaven. He delivers justice and celebrates truth— he has beaten the White Skeleton Demon three times. He is respectful of his master—he never intends to feast on the Tang Monk. He always has someone to turn to—the Buddha and the Guanyin Bodhisatta, etc. It seems that he is blessed by all the gods.

Monkey King in My Work

"Transformation" and "battle" are the most interesting elements to me. Of course, to depict this character in a lively and attractive way, I also have to work on certain plots and other supportive elements. Here, I would like to extend my thanks to the companions, gods, and demons of the Monkey King, who have functioned to give prominence to the character.

My *Machine to the West—Seventy-two Transformations* is a re-creation that has transcended the notion of time and space. The readers are encouraged to pay attention to the details and invent the notes themselves. Generally speaking, the design concept has departed from a traditional Chinese approach, being made up of 70 percent mechanical elements + 20 percent fantasy elements + 7 percent traditional elements + 3 percent crazy things. It is hoped that nobody will share a common concept with me.

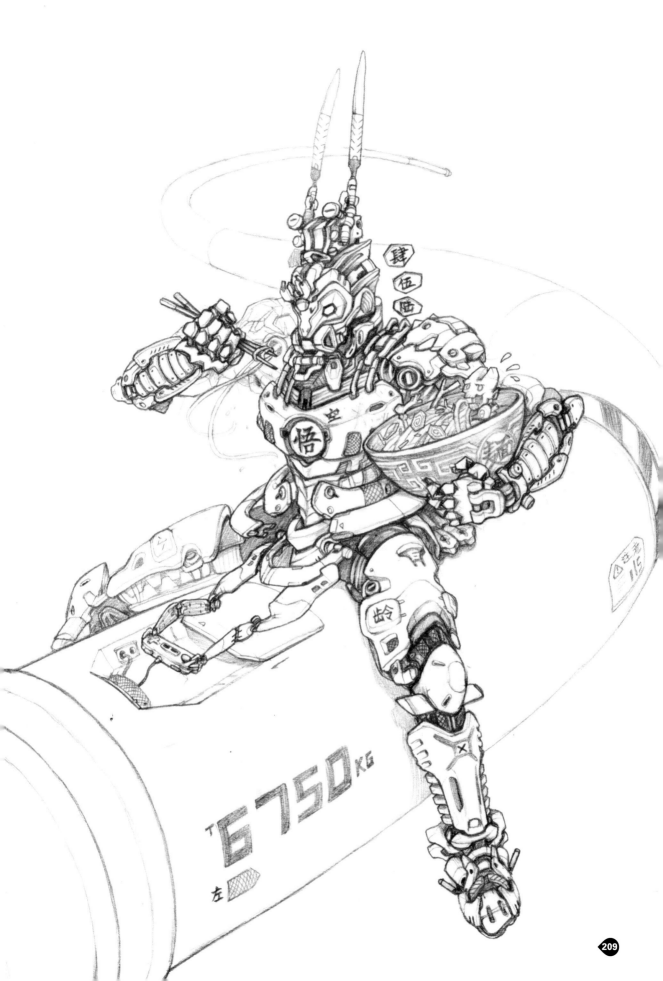

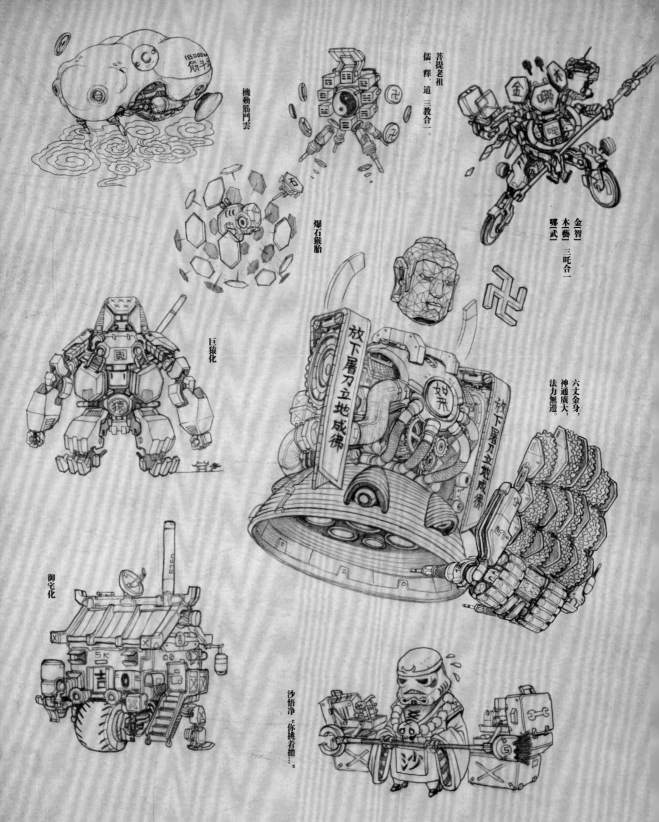

機動筋鬥雲

菩提老祖
儒、釋、道 三教合一。

爆石猴胎

金「智」
木「藝」 三吂合一
哪「武」

六丈金身，
神通廣大，
法力無邊。

巨猿化

放下屠刀立地成律

御宅化

沙悟淨「你挑着擔⋯⋯」

Step 1: I collected references. Even though this illustration is only intended for re-creation, I still researched on a lot of traditional reference materials available, including the images, original fiction, background information, and the story lines.

Step 2: Concept draft. At the stage of brainstorming, I shattered the traditional image of the character by adding mechnical, fantasy and Chinese elements, and re-assembled them to draw the draft.

Step 3: This step is mainly given to elaborating the draft, especially the details. In order to make it more like a hand drawing and save time, I relied on the photic jade plate to trace the draft.

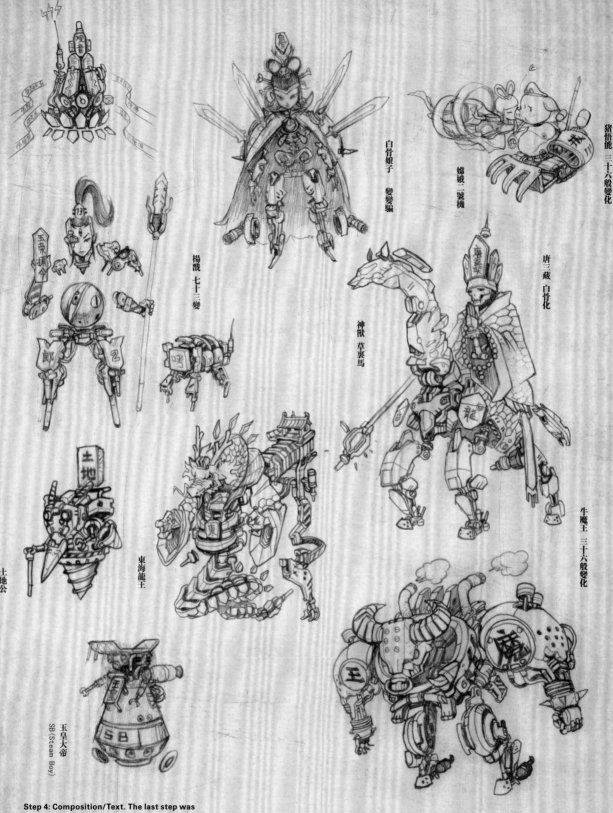

白骨娘子　變變騙

豬悟能　三十六般變化

嫦娥二號機

楊戩　七十三變

唐三藏　白骨化

神獸　草裏馬

牛魔王　三十六般變化

土地公

東海龍王

玉皇大帝
SB (Steam Boy)

Step 4: Composition/Text. The last step was about integration. As all these illustrations were done separately, there was no overlap among them. Besides, the postions and gestures have to be considered, which should also be finished when the concept is determined.

Yang Shengsheng

Screen Name_**RubberPixy** Profession_**interactive creation artist**

Your little friend RubberPixy is as flexible and resilient as elastic. However, he will stretch himself to the utmost at a critical moment and spring at anything around, taking everyone by surprise.

http://www.rubberpixy.com/ rubberpixy@gmail.com

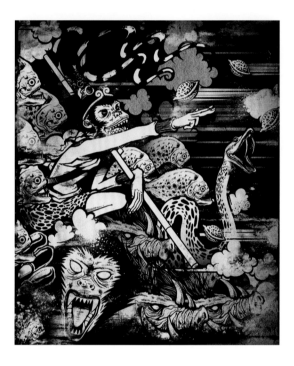

 Monkey King in My Eyes

I had watched the TV series *Journey to the West* no less than five times, and the image of the Monkey King became established as the icon in my childhood. From drama to Chinese storybooks, from Japanese manga to TV series, and the Hong Kong movie *A Chinese Odyssey*, a rich variety of work has been produced to construct the image of the Monkey King in various ways.

What I like most about the Monkey King is his arrogant and unyielding nature, as well as his optimism, pertinacity, almightiness, a good sense of humor, and kindheartedness. It seems that this single figure has crystalllized all the positive properties everyone is supposed to possess, which explains our lasting affections for him.

 Monkey King in My Work

When informed I would be doing this project with Messland, I was thrilled. Faced with so many classics of the Monkey King, we were still hoping to present a different image.

Inspired by this, the concept development phase was initiated. We came to the conclusion that we are meant for each other in work—we have a tacit understanding of each other, which is unique and rewarding. Thus, we decided to make full use of this advantage. We came up with an idea to make a large illustration, both producing a Monkey King featuring his trademark style; later, we will connect the two Monkey Kings with an identical theme or some common elements.

Finally, we decided on a theme of "true/false Monkey King," which sounded like a nice idea. Both of us would draw a Monkey King respectively, with no one knowing which one is true and which one is false. This idea is reminiscent of the scene in *Journey to the West*, in which the Monk had to sing the special chant to distinguish the two identical-looking Monkey Kings. However, we had no intention to include the Monk in our work. Thus, we turned to another way to illustrate the relationship between them—we put the true and false Monkey Kings in duel.

Guan Xiawei

Screen Name_**Messland** Profession_**interactive designer**

Why does he call himself Messland? To him, what's in his mind and in the exterior world is all a mess. In the past, the world has infused the mess into his mind. Now, he is trying to clean up the mess in the mind and throw it back to the world. For no good reason.

http://www.gotomessland.com/ guanxiawei@gmail.com

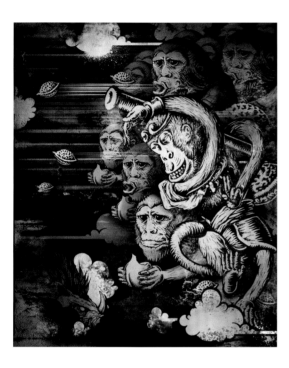

Monkey King in My Eyes

I have found something interesting, but I don't know whether it is commonly realized. No matter where I travel in China, if I turn on a TV set in a hotel and run through the programs of CCTV, local channels, or others, I always find at least one of them screening *Journey to the West*.

Journey to the West is probably as old as me. Other TV programs produced at the same time have already faded from memory, while it has survived the test of time. Over the years, I have reviewed this TV series many times, and I'm still willing to watch it again. Even though contemporary digital technology is able to produce striking special effects, the crude effects, as well as its original soundtrack in the style of acid rock, are still classic.

Monkey King in My Work

When I started to work on the general concept, I found that I was so deeply influenced by the cartoons or TV series that I was not able to think outside the box. Like many others, I came to know the Monkey King through TV. Thus, his image on TV was so established that my subconsciousness rejected any other ways to portray the Monkey King. Actually, the TV series was produced in a special period when some official ideologies were destined to find their way into TV productions, which were inconsistent with the original fiction in some sense.

Therefore, when working on this illustration, I racked my brain to restore the original image of the Monkey King. In my opinion, he was essentially a monkey who had acquired some supernatural powers due to a lot of coincidences. He claimed the Mountain of Flowers and Fruit and lived a carefree life as the king of a family of monkeys. Now and then, he battled with demons out of conflicting interests. Even so, he was still a monkey, simple and crude. His behavior is irrelevant to modern civilization, as the Monkey King is commonly interpreted.

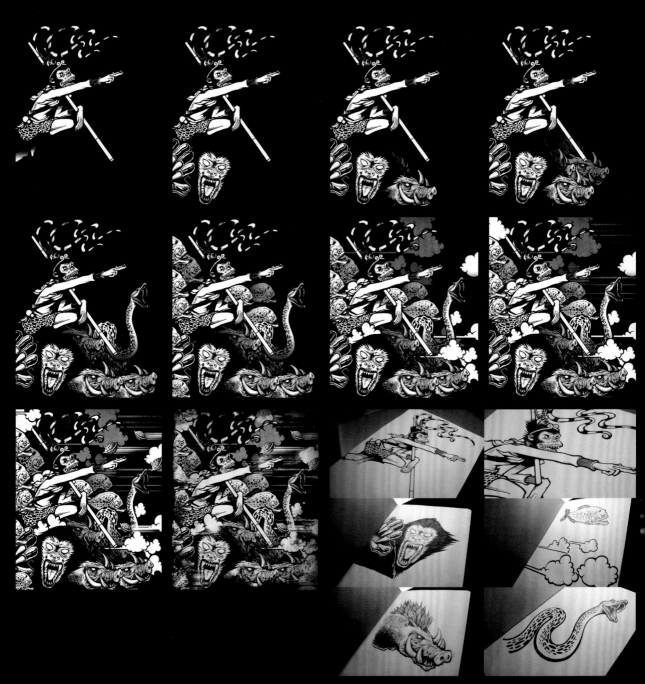

Step 1: I started to work on the draft, and discussed with Messland how to integrate the two illustrations. According to our original plan, both of us would come up with an illustration with the Monkey King, and there should be evident confrontations between the two Monkey Kings, who were about to throw themselves on each other the next second.

Step 2: I drew the Monkey King, ape, python, piranha, and boar on paper and sketchbook, and then scanned these elements into the computer for processing.

Step 3: I worked on the monkey and enhanced the depth in certain parts. Then, I placed it in a predetermined composition while starting to incorporate other elements. As to the ape, I wanted to keep it in the lower left corner, whose dark colors were intended to balance the entire illustration. Later, I would composite the finished boars. Just one? No, that's not enough. There should be several of them, threatening and aggressive, producing a ragged silhouette.

Step 4: I hoped that the giant python could rise above the herds of boar, mouth open wide and on the verge of joining the battle. Besides, there were also loads of piranha swimming by the monkey in an intimidating way.

Step 5: I made adjustments to single elements one by one while keeping others in mind. I amplified the vigor, reinforced the atmosphere, and enhanced the tensions. I added some lines, clouds, and fog.

Step 6: I still felt that the illustration was too vector-based at this step. I needed to make it ragged and ferocious. Thus, I utilized a lot of textures and tuned up the illustration little by little to create a sense of comfort. Meanwhile, Messland has finished his part. I took out the elements that needed to be overlaid and arranged them on my illustration. At the same time, I gave him my own file, expanding my elements into his illustration. Therefore, both our

illustrations started to blend together in some sense.

Then, our illustrations were composited together. We made some adjustments in certain details. We had skipped the coloring process, because we preferred black-and-white illustrations, which were crude and simple, producing more striking contrast effects.

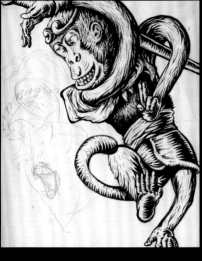
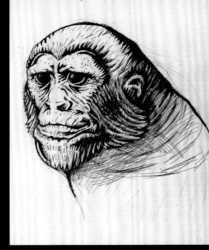

Step 1: I put down his image on paper after thinking a little about the composition. I tried to downplay his valor and probity, which seemed to be a defining feature of the Handsome Monkey King that we are so familiar with. Instead, I wanted to highlight his inherent nature as a monkey in the first place, his naughtiness and mischievousness.

Step 2: The scene in which the Monkey King plagued the Garden of Immortal Peach caught my attention, as it was one of the most interesting anecdotes in the story. Eying the ferocious-looking animals created by my coproducer Rubber Pixy, I felt my character should prioritize tact over force. Thus, I gave my character the peach stone as an easily accessible weapon to confront his rivals.

Step 3: I scanned all these elements into the computer. Due to inadequate practice in recent days, I found myself unskilled to such an extent that the scanned lines did not work under close inspection. Thus, I spent some more time to reproduce the lines.

Step 4: I started to work on the texture of the background jointly with Rubber Pixy. We are so obsessed with ancient styles that it has developed into a habit that is not easy to uproot.

Step 5: I continued to adjust the composition and added some texture.

Step 6: I exchanged the files with Rubber Pixy, composited the other's elements into the pictures, then made a few more adjustments to finish.

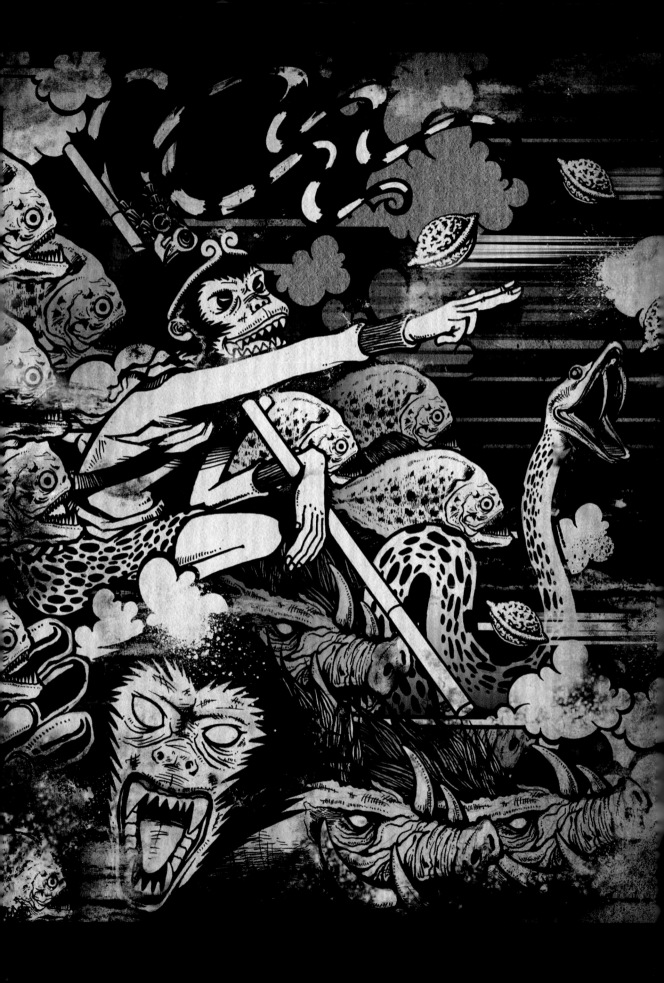

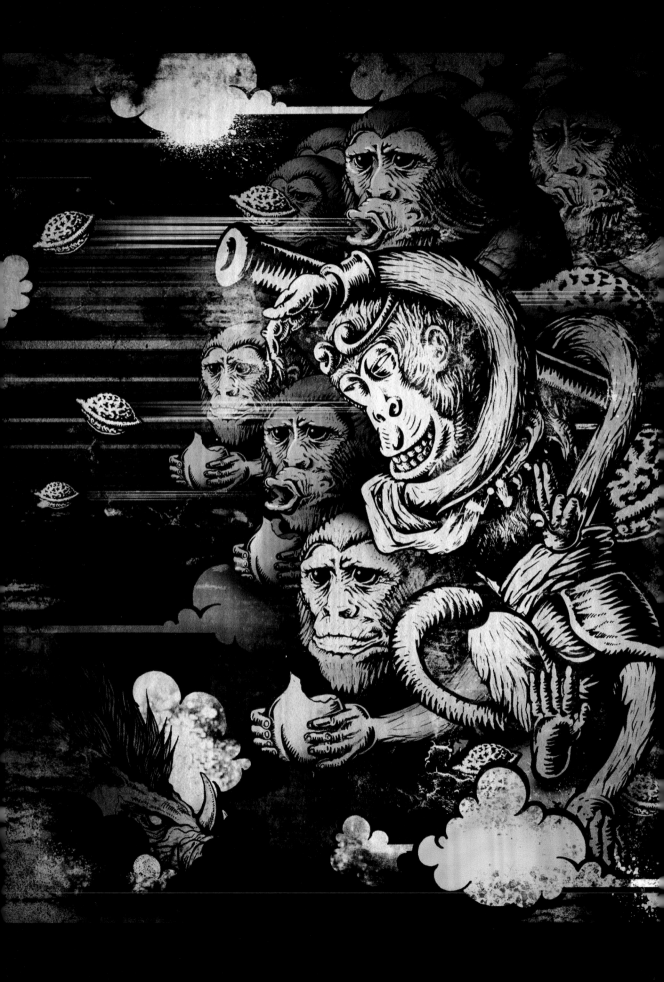

Yang Fenghua

Screen Name_**taoist** Profession_**game designer**

Yang works in game design and re-creation painting.

http://hi.baidu.com/taoist道/home ✉ bjfu.ada.love@163.com

◎ Monkey King in My Eyes

I still remember wearing quills as capes and flinging the mop, screaming "Here comes the Great Sage, Equal of Heaven!" Of course, many of us might have been punished by our parents for that. As an ultimate hero in the majority mindset, the Monkey King has experienced several stages in *Journey to the West*, including birth, receiving amnesty, rebelling, being suppressed, retrieving the sutras from the west, and gaining Buddhahood. However, my favorite is to see how defiant he is when raising havoc in the heaven. In contrast, his pilgrimage later seems less impressive … For me, being undisciplined and unyielding is a trademark feature of the Monkey King.

◎ Monkey King in My Work

This illustration is solely focused on the "Great Sage, Equal of Heaven." Actually, I have taken serious thoughts when deciding to what extent he would resemble a monkey. Though depicting a huge ape with buldging muscles seems to be a good idea, I finally chose a more aesthetics-oriented approach—after all, he is known as the Handsome Monkey King. In fact, this depiction is influenced by my personal feminine perspective—I have no idea whether my Monkey King will look handsome to the real monkeys.

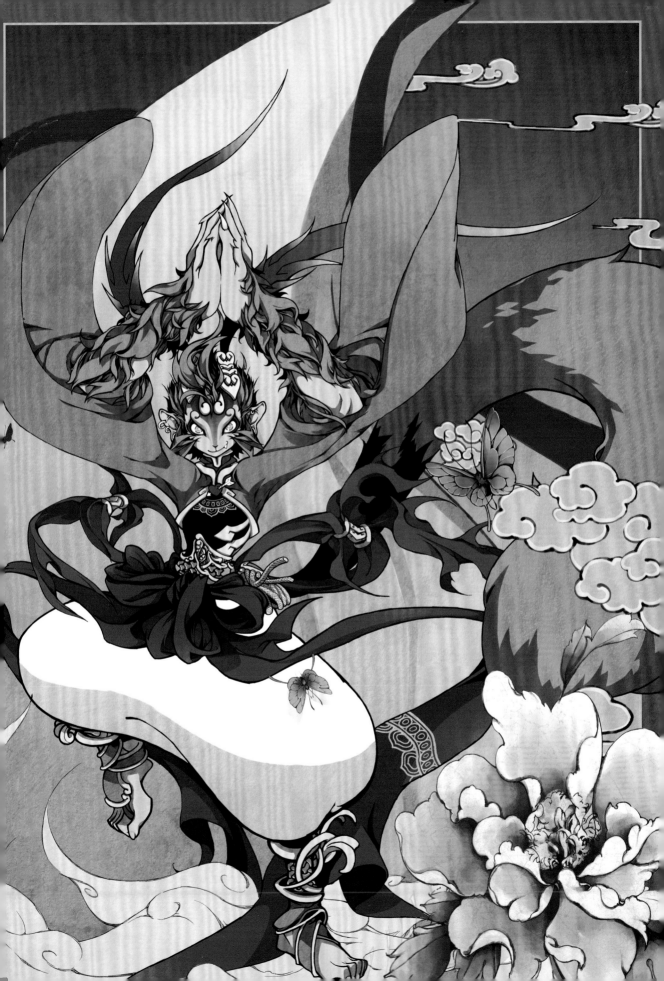

Yang Linlin

Screen Name_**MUMUMA** Profession_**game artist**

Yang has worked in game design since 2006.

http://mumuma.qzone.qq.com mumuma622@qq.com

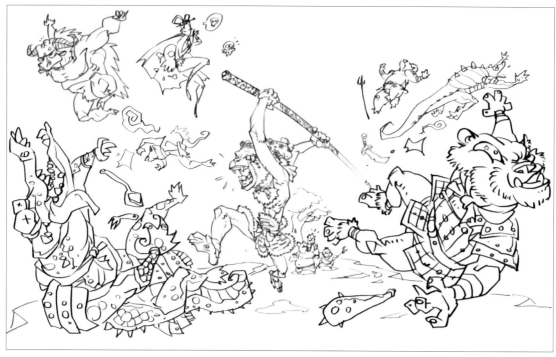

Step 1 : I skipped over the steps before the drafting process. To me, the effects of the drafts are very important, because it is much easier to revise drafts than finished illustrations, so I put a lot of effort into drawing the draft clearly before coloring.

Monkey King in My Eyes

If I were one of the characters in *Journey to the West*, I might be the Tang Monk. I might hate the Monkey King for his hot tempers and his warlike nature. Sometimes, I might give him a serious headache by reciting the magical chant, in order to show my stateliness. Sometimes, I might be so angry with him that I even wished to never see him again.

However, the Monkey King never takes to heart how he has been wronged. He would always go through fire and water for me. Though he is not eloquent, he cares much about me. Though he is almighty, he is willing to share a simple diet with me. Though I have dispelled him several times, he still follows me. What is the most amazing about him is that he could recognize who the demons are through his fiery eyes and golden gaze.

I am so dependent on him because I have always found myself in danger. The journey is ridden with hardships and hazards. Fortunately, he is always there for me. How lucky I am to have his company!

It is a pity that I am the Tang Monk.

Monkey King in My Work

I depended on my shallow understandings of the Monkey King when producing this illustration featuring the Monkey King fighting with a bunch of enemies. It has crystallized all his merits and shortcomings. Besides, the Tang Monk is based on me.

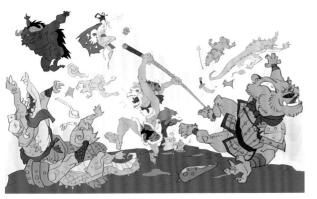

Step 2: I created an overall environment to get an idea of the overall color palette. I paved the color lumps. I like pure colors and LocoRoce effects. If the scriptwriter agrees, I will stick to the original concept.

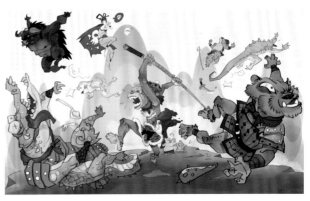

Step 3: I added light and shadow as well as the partial color. Some elements in the illustration seemed a little distracting. I chose to ignore it.

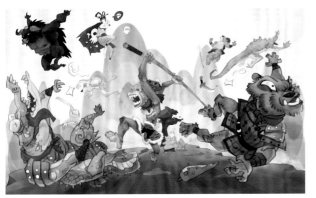

Step 4: I added the velocity line and enhanced the sense of uniformity.

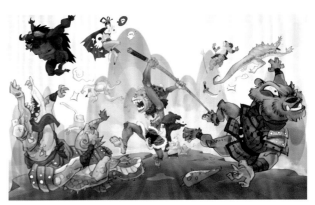

Step 5: I added some highlights.

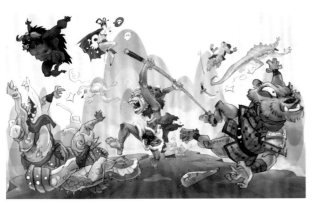

Step 6: I made adjustments to the details and the overall illustration.

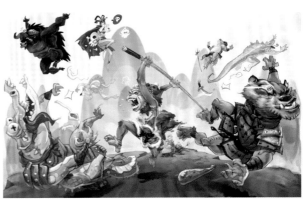

Step 7: I added certain effects, small symbols, velocity lines, motional blurs, etc.

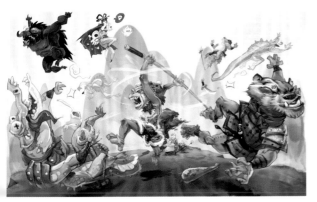

Step 8: I added more elements without being restrained. It was my own illustration and I could make it whatever I wanted it to be.

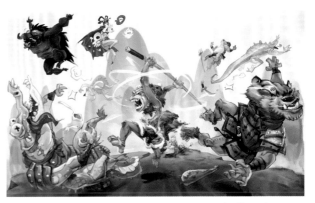

Step 9: I adjusted the overall color palette. It looked better. The illustration was finished!

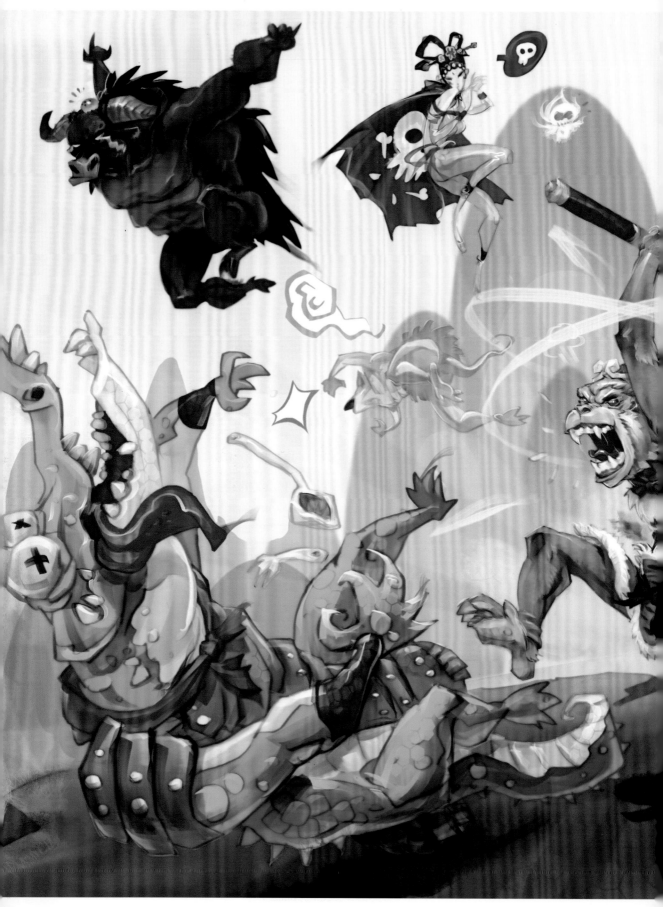

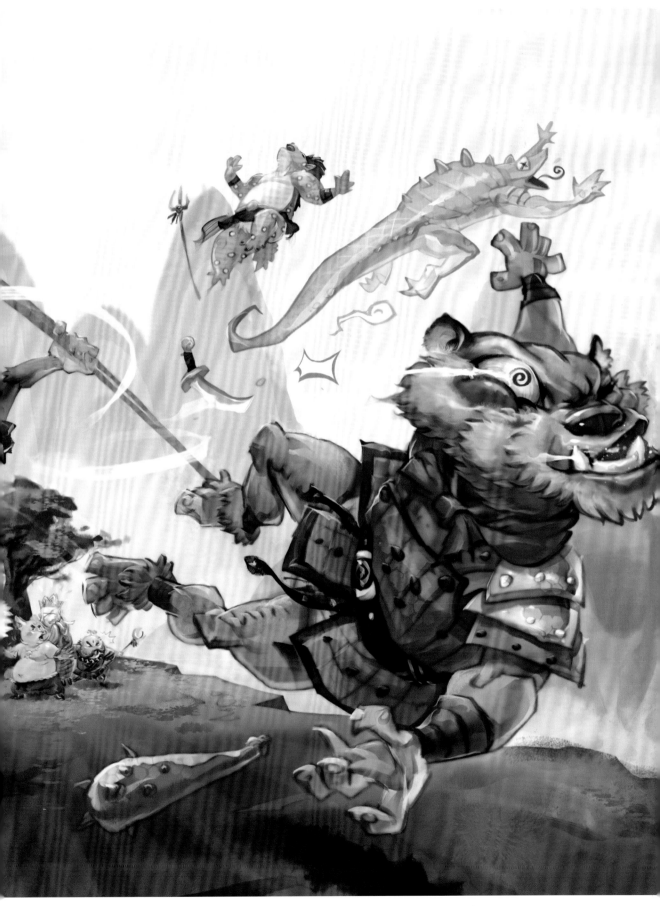

Yang Weiping

Screen Name_**Jubi** Profession_**game visual art designer**

Yang is a graphic designer, toy designer, and model sculptor.

http://www.jubiyang.com jubiyang@gmail.com

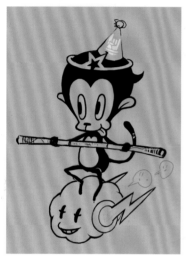

Step 1: I decided on the general concept. I finally chose a naughty expression with an extended tongue.

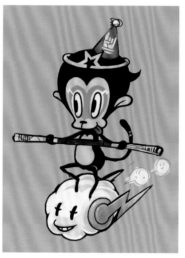

Step 2: I decided on the color palette and added motifs of Peking opera facial makeup on his face.

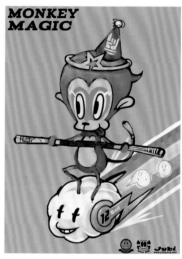

Step 3: Though the Monkey King is typically golden-furred, I myself still prefer blue.

Monkey King in My Eyes

I work in toy and game design, in which area the *Journey to the West* story is a common subject. The Monkey King is part of the collective memory for Chinese all over the world and is an exemplification of wisdom and courage in Chinese culture. With his tricks to seize the pillar that pacifies the seas (which became his golden band later), his fiery eyes and golden gaze, his cloud-somersault, and his seventy-two transformations, he is as mind-blowing as a super magician to me.

Monkey King in My Work

I researched on the Internet for relevant information and pictures. With these efforts, I familiarized myself with some stories that I almost forgot, restoring my childhood memory and reinterpreting the image of Monkey King.

I adopted a cartoonist approach, which was my favorite, to reconstruct this image. I incorporated the naughty figure with my preferred elements as well as lovely and amusing expressions, making the character fresh and vivid.

The illustration portrays the Monkey King traveling on the cloud-somersault, hoping to convey the Great Sage's ultimate pursuit for freedom in an easygoing way.

I came up with a circus-style monkey in my initial concept, who would be wire walking. I gave up this idea later, as it seemed to be irrelevant to the trademark personality of the Monkey King. Instead, I illustrated a Monkey King riding on the cloud-somersault. I favor the Bézier lines in Photoshop, which allows making some revisions or adding certain elements in the process. Therefore, the preproduction draft would not be very detailed.

MONKEY
MAGIC

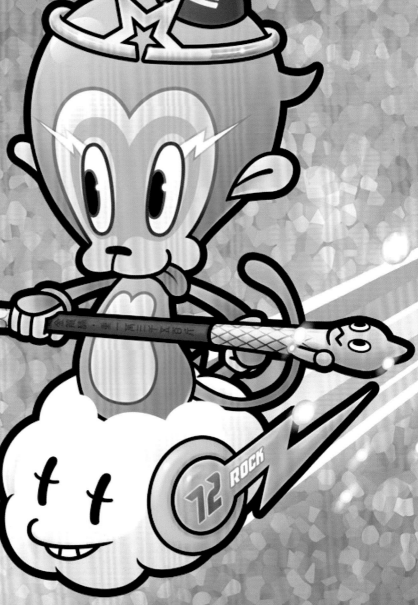

www.jubiyang.com

Yin Weiye

Screen Name_**Franc** Profession_**CG Artist**

Yin worked with oil paint for over a decade and switched to CG arts in 1997. By now, he has produced over one hundred works, all of which are heavily acclaimed internationally in the industry.

http://www.Franc-art.com/ IN3DCG@hotmail.com

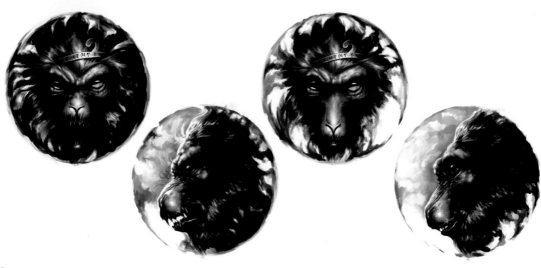

Monkey King in My Eyes

As the protagonist of *Journey to the West*, the Monkey King is an incarnation of perseverance, bravery, firmness, and loyalty. He is also reluctant to resign to one's fate. In order to follow his faith and pursue freedom, he dares to defy authority. Even though he may shed blood by fighting alone, he will not hold back or give up.

In *Journey to the West*, the Monkey King is usually brilliant, courageous, and unrestrained, but sometimes he is also sensitive and calm. Those who have not watched the TV series or animated film of *Journey to the West* will have different interpretations of the Monkey King when reading the original fiction.

In the earlier illustrations, the Monkey King wears armor or Taoist clothing. He is always scratching the ears or the cheeks and jumping up and down. The traditional outlining techniques were mostly employed. However, as time goes by, conflicts and pressures have intensified. This rebellious fighter who would sacrifice everything for freedom becomes a popular choice for the artists to express their inner emotions. With the development in creation tools, the Monkey King has become more detailed and colorful and crystallized the distinctive features of the artists themselves. His image as a brilliant monkey has been challenged—in some illustrations, the Monkey King is fierce and furious, by which the artist expresses his or her discontent with society.

Monkey King in My Work

This illustration is intended to capture how the Monkey King is seized by a sense of loneliness and calmness when confronted with defeated enemies. The Monkey King who has raised a havoc in heaven now acts like a frightened animal. When the battle came to an end and peace was restored, the Monkey King still maintained his alertness and sensitivity.

I'm used to taking full considerations of the composition, color palette, atmosphere, scene, features, and looks of the character before picking up the drawing pen so that all the doubts have dispersed when the production process starts. Therefore, I drew only a few drafts in the concept development process. This is my initial draft. Such a draft will become an integral part of the final when I elaborate on the draft. The illustration is intended to depict a character. I briefly scribbled down the illusion in my mind and then added the details and background.

In this illustration, I illustrated the Monkey King as a warrior with a monkey face and human body. His armor is stained, posing a sharp contrast with the golden armor of the heavenly generals and soldiers. Considering that the Monkey King got his first armor from the Dragon Palace, I incorporated elements such as seashells and clams.

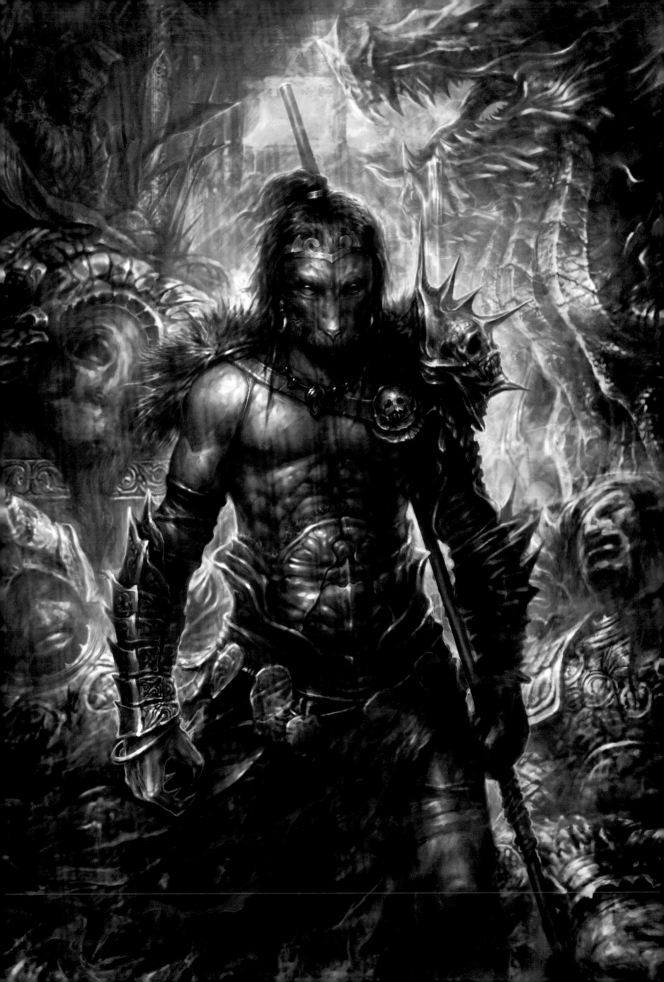

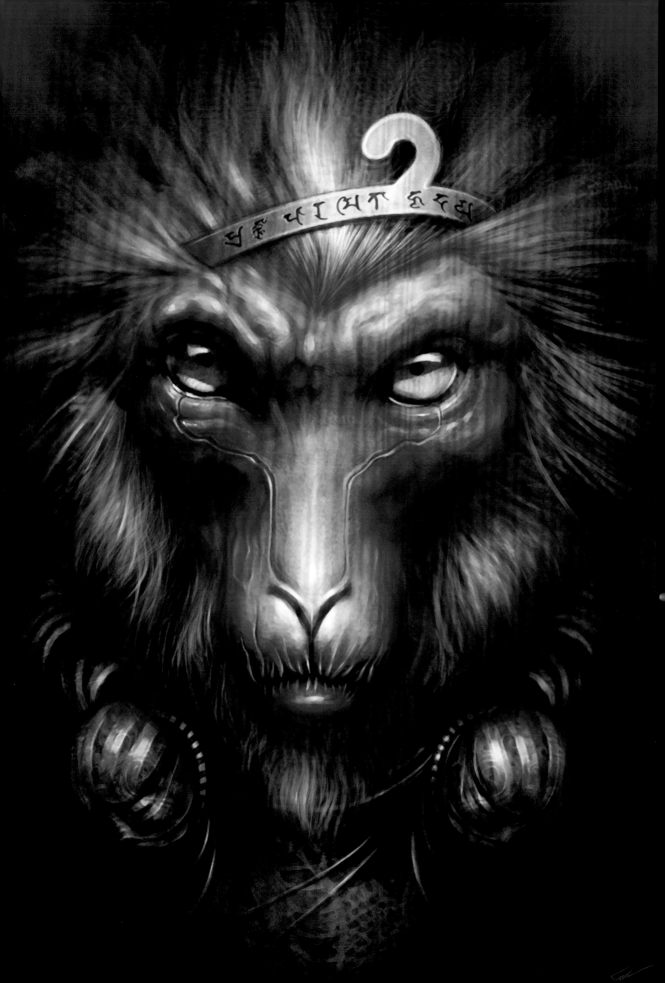

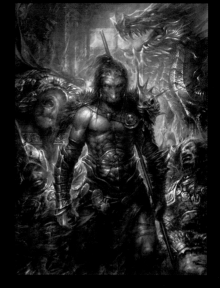

Step 1: I added background to the Monkey King. As the illustration was based on the story *Havoc in Heaven*, which took place in the hall of the Heaven Emperor, I set it as the background of my illustration. In order to highlight the dominant characters, the illustration has adopted a vertical composition in order to reduce the proportion of the background. Besides, the illustration has also captured the mess in the hall after the fierce battle. As a divine beast in ancient China, the dragon also exemplifies the supremacy. Therefore, I erected a row of pillars featuring coiling dragons on the left, while on the right stands a row of sculptures featuring flowing water and golden dragons.

Step 2: I adjusted the proportion of different characters and the position of different items so that the composition looked neater and more appropriate. Later, I elaborated on the background and the characters to ensure a coherent color palette and an integral light and shadow effect so that the Monkey King would fit into the background. I then moved on to the textures of golden bricks and tiles on the architecture and then the glittering shine on the armor of the heavenly generals and soldiers. I also worked further on the facial expressions of the supportive roles.

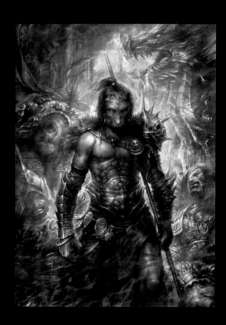

Step 3: As I overstated the splendor in the background, the dominant character could not stand out from the background scenery. Therefore, I enhanced the atmosphere effect and the lighting effects, producing a contrast between the dominant and supportive elements by using light and mist to make a difference between the close-shot, medium-shot, and distant-shot sceneries, highlighting the sense of space.

Step 4: I adjusted the contrast, illumination, and color palette and added light blue clouds and mist at the very front of the illustration to enhance the grandeur of the Heavenly Palace.

Yu Jianwei

Screen Name_**insect_494** Profession_**concept designer**

Yu graduated as a cinematography and television lighting major of the Stage Design Department, Shanghai Theatre Academy China. He has worked in the stage design profession ever since. Later, he switched to the CG arts. Currently he works as a concept designer in a domestic game company.

http://insect-494.blogspot.com/ insect_494@hotmail.com

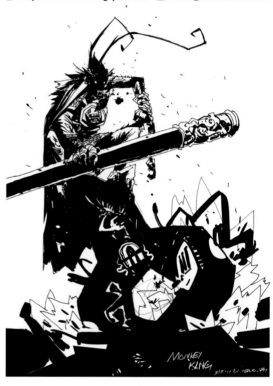

Monkey King in My Eyes

To each and every Chinese boy at my age, the Monkey King is definitely a superstar. We love him for a simple reason: No matter where his rivals are from, heaven or hell, no matter what they represent, the divine or the devil, few can gain the upper hand over him. Some are passionate about his seventy-two transformations, some crave his golden band, and some are fascinated by his cloud-traveling skills. I like something else about him. I like how he slighted his enemies. The scenes of the Monkey King making fun of the devils were my favorite in my childhood. Those ferocious-looking devils were kneeling down before him, begging for the Great Sage to have mercy. However, they all ended up being smashed by the golden band. These blood-shedding scenes were my favorite. One of the scenes still lingers in my mind now. On their pilgrimage to the west, the Tang Monk and his disciples stopped at a household in the mountains. The child and his grandfather were plundered by a group of gangsters. Though the Monkey King only wanted to teach them a lesson, all the gangsters were heavily injured or even lost their lives due to this "lesson." One of them was so unfortunate that at a slight push of the Monkey King, his head was smashed on the rock at the stream, with blood surging out.

Monkey King in My Works

I expect that this illustration will receive various reactions. Some may love it, while others may not. Though it was a commission, this picture had been lingering in my mind for a long time. Therefore, it only took me one hour to produce it. The readers may wonder where the inspiration came from. Me too. Maybe the Monkey King himself is also haunted by the same question. I was just thinking of making him live up to his nature in the illustration world. It might be said that the illustration was against the concept in the original novel or intended to celebrate violence. Anyway, this is *my* Monkey King. *My* Monkey King can definitely do this. Haha! Some viewers might ask "Where is Sandy?" Frankly speaking, I haven't thought about this. It was just believed that the Sandy was too upright to do something like this. After all, the Monkey King and Pigsy were animal-faced and might follow their animal nature to do this. Another reason was my laziness, so Sandy was excluded from this illustration.

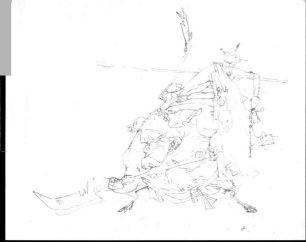

Step 1: I drafted the outline in a quick way. I took good consideration of the composition.

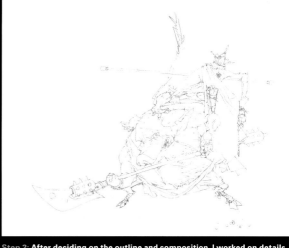

Step 2: After deciding on the outline and composition, I worked on details with pencil.

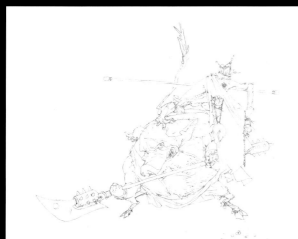

Step 3: I scanned the pencil draft and imported the scanned file into Photoshop to adjust the tone.

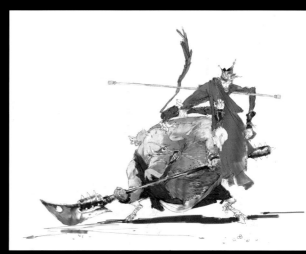

Step 4: I finishd the color pavement in a quick way, mainly focusing on the intrinsic color.

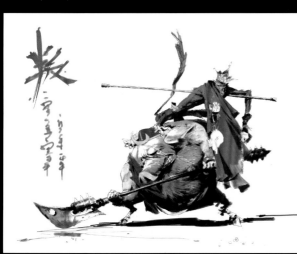

Step 5: I chose a proper lighting source and worked on the shades to enhance

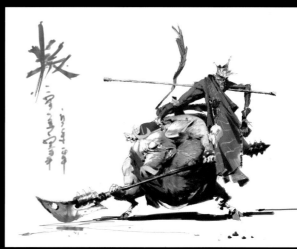

Steps 6–7: I elaborated on the details. I made adjustments to the draft. Pigsy's

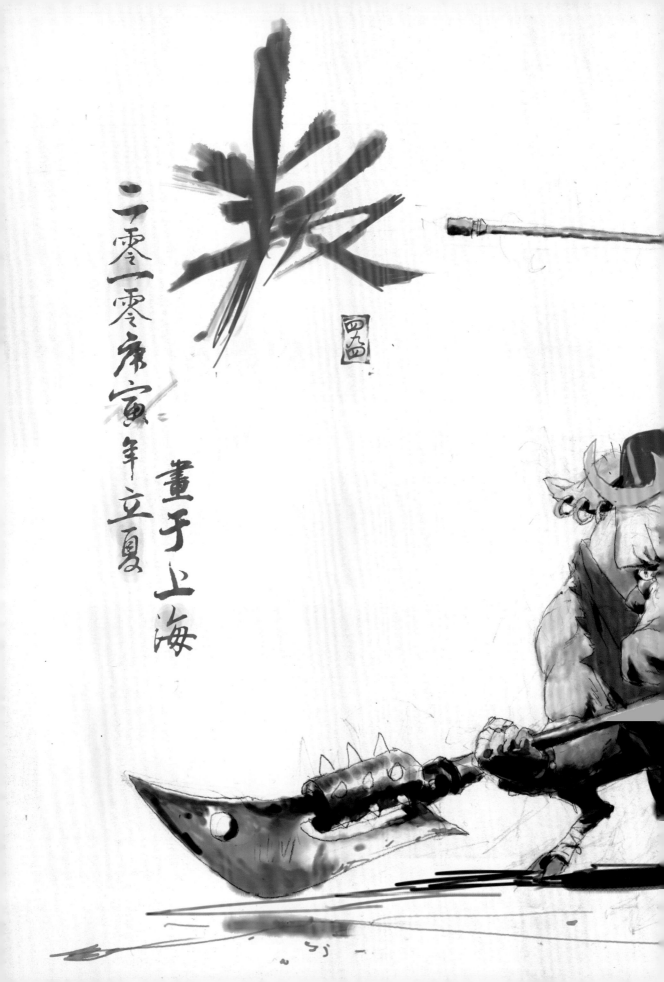

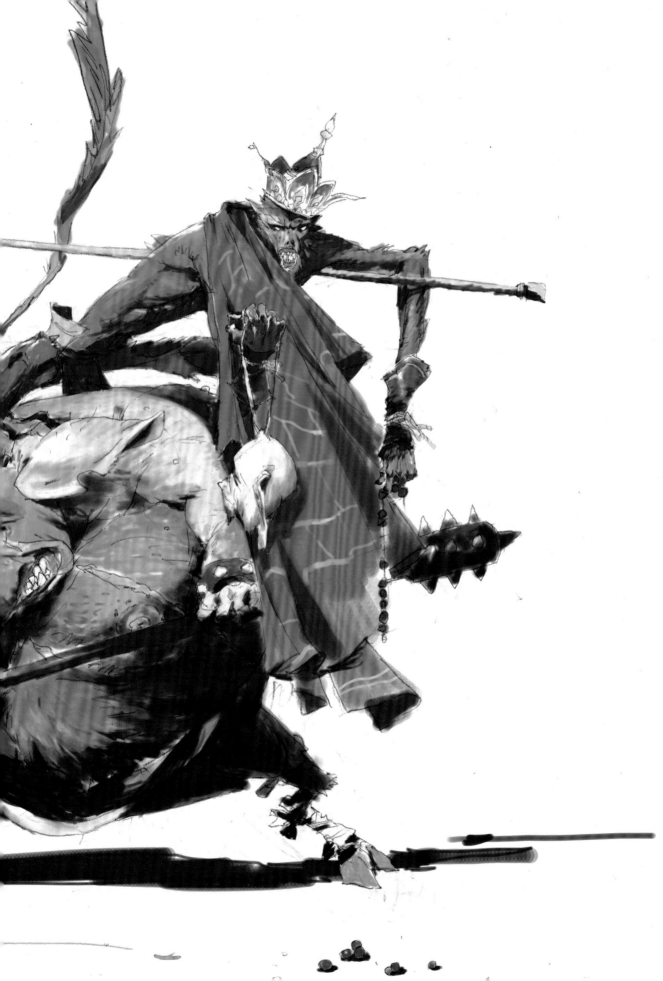

Zhang Bin

Screen Name_**Naughtyboy** Profession_**concept designer**

How to describe Zhang? Zhang is unsophisticated and unrestrained, who knows drawing but claims nothing else special.

http://blacktower.blogbus.com/ linnaught_142@hotmail.com

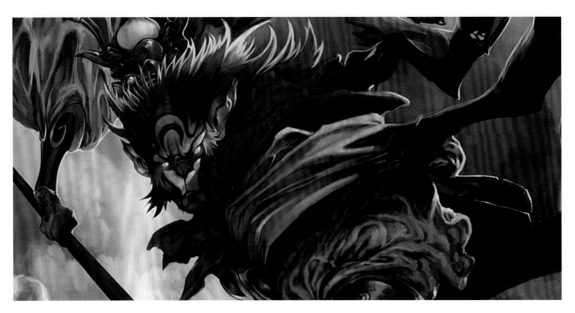

Monkey King in My Eyes

I was impressed by the storybook *Journey to the West* and the cartoon *Havoc in Heaven* to such an extent that when I was assigned this commission I found lingering images of the Monkey King combating the gods and creating a tremendous uproar in the Heavenly Palace. There were so many highlights in this scene—the fierce battles between the Monkey King and Erlang God, the Buddha's warrior attendants, and the Mighty Miracle God brought one classic climax after another. Among them, my favorite two are his duel with the Erlang God and the Buddha's warrior attendants. Thus, I found no difficulty in deciding on the concept and composition.

I'm very glad to share with the readers the creation process and relevant experiences. I also want to extend my sincere thanks to the authors and editors of this book for the invitation. They have offered me an opportunity to get acquainted with more outstanding illustrators and concept designers through this platform. *Journey to the West* is a theme with unlimited potential for further development and exploration. Even now, I am thinking of the subject for my next piece. Should I select *Subduing the White Skeleton Demon Three Times*, *The Cave of Silken Web*, or *Pigsy Carrying His Wife on His Back*? Haha! With so many ideas popping up in my mind one after another, I feel motivated again.

Monkey King in My Work

I first finished the illustration on the battle between the Monkey King and the Erlang God. In this piece, I have employed some typical expression techniques from Peking opera, hoping to capture the tension during the duel of the two sages. However, there was no actual physical collision. Instead, I employed the approach by which the Peking opera used to suggest battling scenes.

By avoiding the actual fighting scene, I was striving for a visual effect featuring choking tension. As this objective is a little abstract, it was difficult to put it on paper. After finally finishing the two pieces, I had to stop despite some dissatisfaction. After all, there is no such thing as perfect work. What one can do is constant experiment.

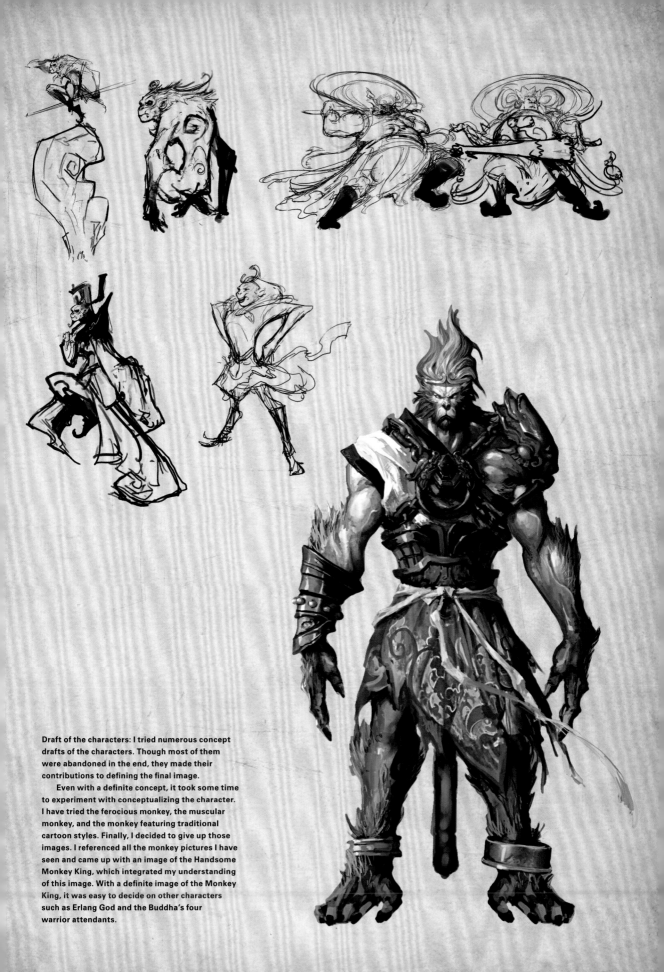

Draft of the characters: I tried numerous concept drafts of the characters. Though most of them were abandoned in the end, they made their contributions to defining the final image.

Even with a definite concept, it took some time to experiment with conceptualizing the character. I have tried the ferocious monkey, the muscular monkey, and the monkey featuring traditional cartoon styles. Finally, I decided to give up those images. I referenced all the monkey pictures I have seen and came up with an image of the Handsome Monkey King, which integrated my understanding of this image. With a definite image of the Monkey King, it was easy to decide on other characters such as Erlang God and the Buddha's four warrior attendants.

Step 1: A messy draft. But I was satisfied with the composition and illustration of motion, which I kept in the final work.

Step 2: I applied black, white, and gray to specific areas. I was too impatient to elaborate on it, which caused me great trouble in later steps.

Step 5: I was supposed to elaborate on the details without being too obsessed. Fortunately, I was pressed by a looming deadline, or I would not have been able to stop revising.

Step 3: Color pavement, major brush strokes, and interlayer effect were finished. The red was an eyesore for being a little dazzling, which I intended to adjust later.

Step 4: The color adjustment was basically finished, which approximated the desired effects.

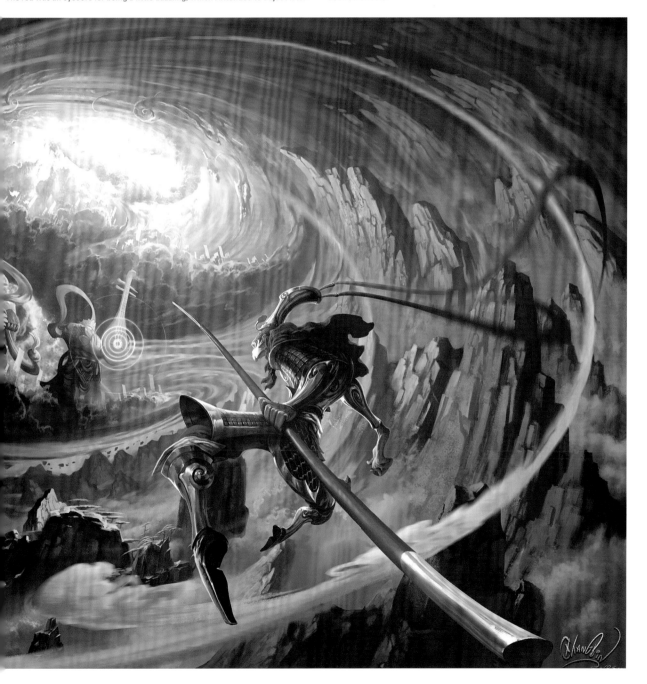

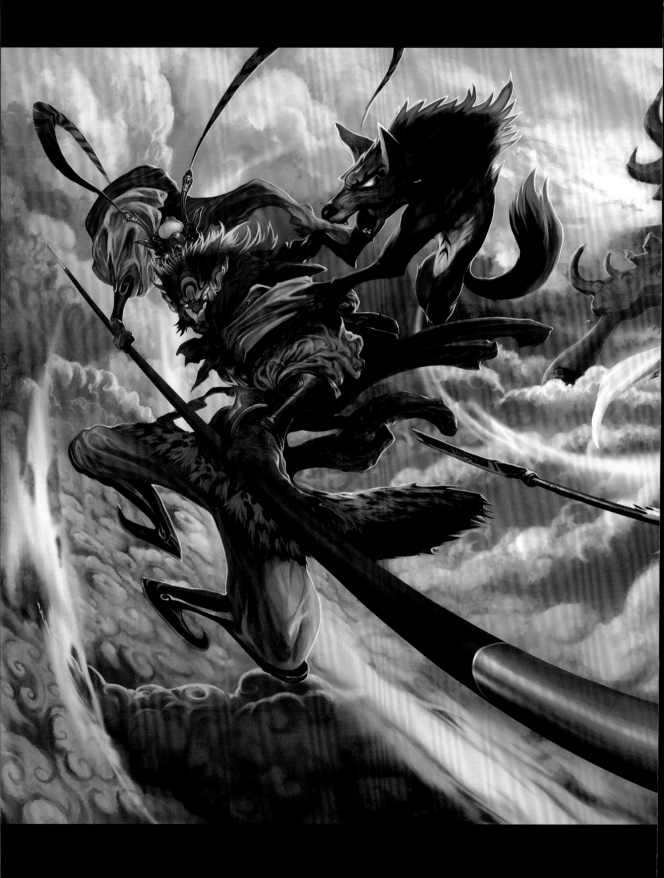

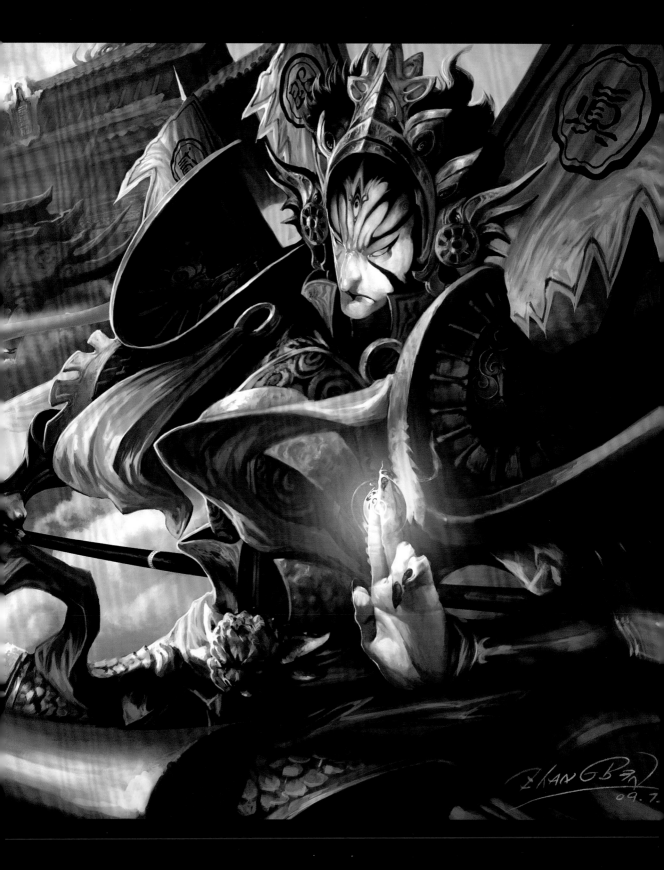

Zhang Lu

Screen Name_**LZHANGLU** Profession_**concept designer**

Zhang worked in Massiveblack Shanghai Inc. from the end of 2007 to September 2010. Currently he serves as concept designer for Dust514 in CCP.

http://blog.sina.com.cn/zhanglu007 zhanglu-mzl@hotmail.com

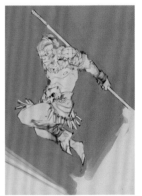

Monkey King in My Eyes

The Monkey King is an evident exemplification of oriental heroism. He is the icon for a whole generation, or even all the Chinese people. Like his Western counterparts, the Monkey King also has shortcomings so that the story will seem more convincing. However, these shortcomings have not prevented the readers from loving this character.

Journey to the West, as a common reading crystallizing Buddhism philosophy, is themed on how the four figures have determinedly pursued spiritual liberation while battling with demons on the way. Finally, they gained Buddhahood. This serial novel is based on the eulogization of heroism. I am mostly impressed by how the Monkey King has exuded a commanding air after suffering in the furnace for forty-nine days. He was so furious that he would slaughter whom ever stands in his way. He had trandscended the notion of life and death and dared to defy the gods. This is the most impressive episode in terms of plot, much better than the episode in which he committed to the Buddhahood.

Monkey King in My Work

I based my illustration on the moment when the Monkey King jumped out of the furnace. His motions have demonstrated how furious and eager he was, while the flames were intended to highlight the sense of tension so that the illustration would have a striking visual impact.

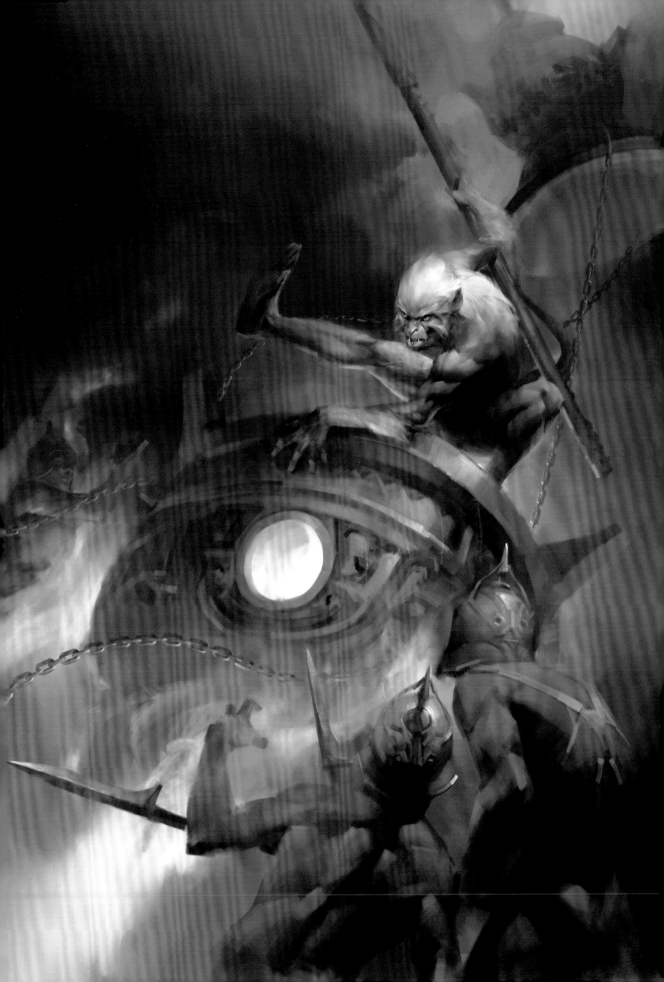

66

Zhang Shaokun

Screen Name_**Monkey King** Profession_**concept designer, cartoonist**

Zhang is a skill-based housebound male passionate about prototype modeling, Chinese culture, anything heretical, hot girls, and delicacy.

🌐 http://blog.sina.com.cn/kenpws ✉ kenpws@hotmail.com

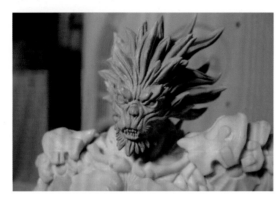

Monkey King in My Eyes

Imagine yourself as a monkey with an eccentric personallity and almighty powers, who abhors restraint but has been imprisoned under the Five-finger Mountain for five centuries. How would you react? If I were him, I would be mad, of course, only on the condition that I had survived the five hundred years of imprisonment to feel mad.

Actually, I believe the Monkey King evolved through several stages: from devil to pilgrim to Buddha. Even though the Monkey King was granted Buddhahood for serving as the Tang Monk's bodyguard on his journey to India to retrieve the Buddhist sutras, he was originally a devil in his debut, which he was identified with in the first place. When he took up the golden band to battle with the evil, he would be fierce-looking and merciless. However, he used to be one of them. Considering this, he would not be that appealing without his martial valor.

Like all my contemporaries, I was first exposed to the Monkey King through *Journey to the West* produced by

CCTV (China Central Television). How cool the Monkey King is in the TV series! He defies heaven by changing his destiny, proclaims himself to be the "Great Sage, Equal of Heaven," and creates an uproar in the Heavenly Palace. However, when reading the original fiction, I found that the Great Sage was not almighty. On their pilgrimage to India, there were few devils who he subdued single-handedly. It bothered me that the used-to-be all-powerful Great Sage was so powerless, which challenges my entrenched perceptions of the Monkey King. Driven by a preference for the heretical, I love his valiancy and aggression. Maybe I have seen too many lovely and comic versions of the Monkey King, thus, I would prefer that he transcends all the divine and evil, fighting with heaven with a fierce look and glaring eyes.

Monkey King in My Work

I had read *Monkey King* by Katsuya Terada, which triggered my feverish love for the ferocious Monkey King. I have always celebrated the way modeling masters such as Takayuki Takeya, Makoto Kobayashi, and Yasushi Nirasawa reproduce forms and their fanatic obsession with details. I wanted to illustrate how the Monkey King descended the world after acquiring the Buddhahood. All these factors combined to take force, giving birth to the "Victorious Fighting Buddha." Instead of typical Chinese style, the costumes looked more Indian. After all, the Monkey King

became a Buddha in India's Nalanda Temple. I referenced the fierce appearances of the angry-looking Buddha and Buddha's warrior attendants with angry glares to intimidate the mortal people. Except for his helmet, all his hair was colored to take on a metallic property in order to highlight that the Monkey King has bronze skin and iron bones. To produce a model, I carved fine-sculpting clay, took the inside out with silica gel, and reproduced it with CAST resin (foamless resin, commonly known as AB water).

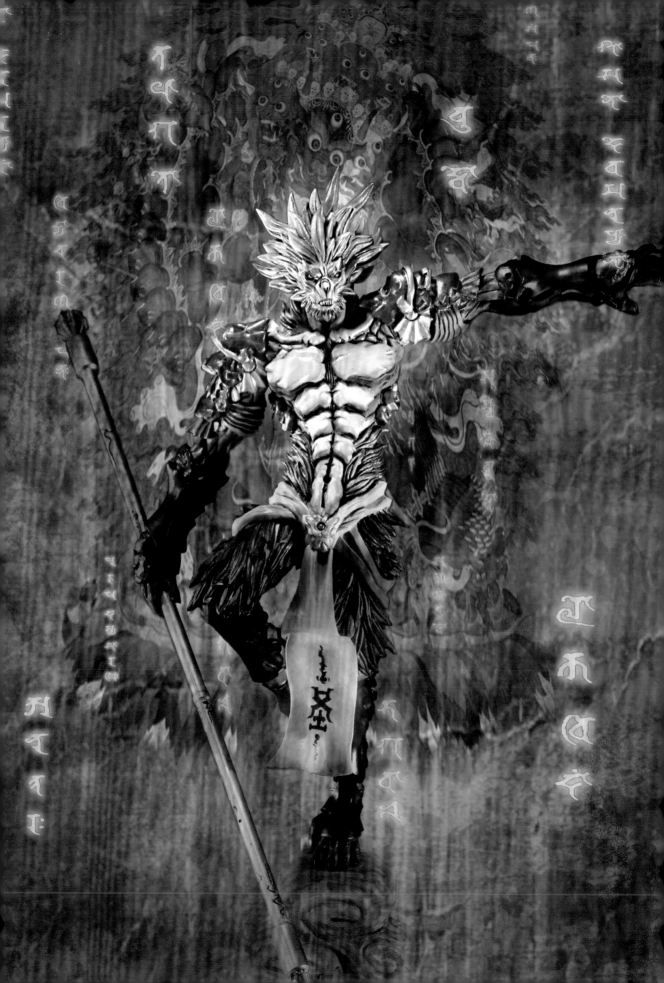

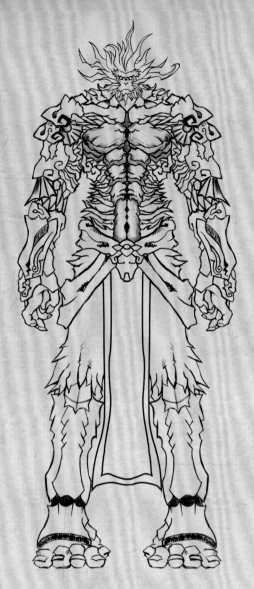
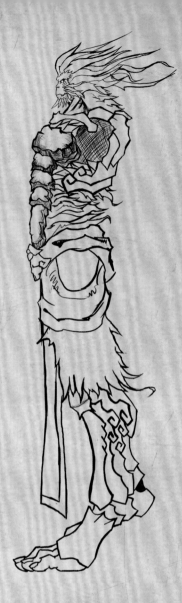

GK of "Victorious Fighting Buddha" in fine sculpting clay; the prototype of head, which was modified after being finished.

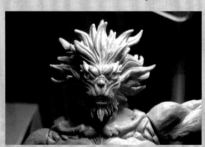
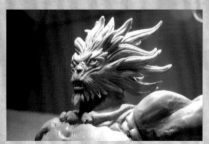
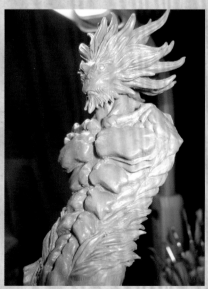
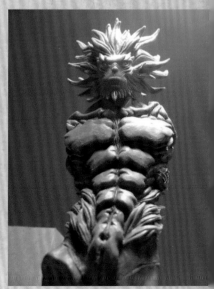

This is the modified head, looking even more murderous after being finished.

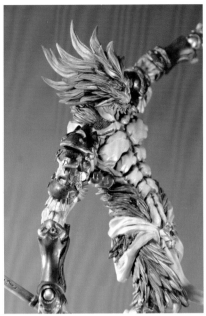

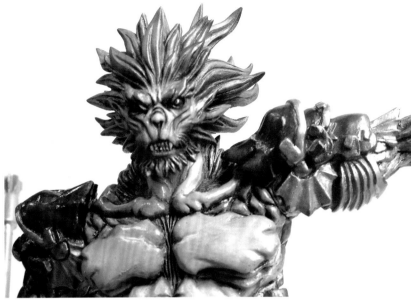

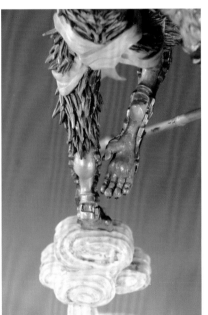

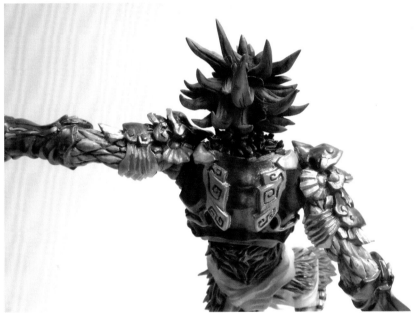

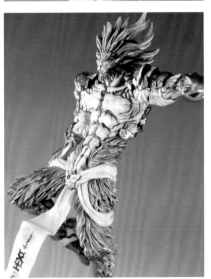

Fine-sculpting clay is most commonly used due to its reasonable price and outstanding formability. However, there are certain drawbacks with this modeling approach—such prototypes are neither good for precise coloring nor long preservation. Reproduction is required for the sake of preservation or coloring.

In producing the prototype, aluminum wires were used to construct the general skeleton. After fixing the size and anatomy, I wrapped the skeleton in tinfoil to build up the raw model; then I heated the fine-sculpting clay until it softened and melted, and I poured it lavishly onto the raw model. As there was already a coarsely produced tinfoil model within, only moderate tuning was required based on its silhouette.

Zhang Shunji

Screen Name_**MAOSOUL** Profession_**graphic designer, game designer**

Zhang is a zealous, warm-blooded fan of felidae.

http://i.yoho.cn/c-soul/index 309089134@qq.com

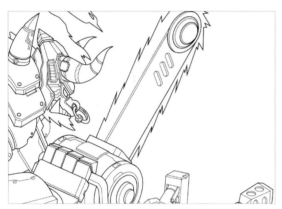

Monkey King in My Eyes

In my childhood, I watched a TV series called *Journey to the West* adapted from the classic novel of the same name, in which the Monkey King played a leading role. He was born out of a rock that was used to patch up the sky. As one of the four stone monkeys from chaos, he was also known as "Stone Monkey of Brilliance." He led a clan of monkeys into the Water Curtain Cave and was honored as their "Handsome Monkey King." Later, he became a disciple of Patriarch Bodhi and earned his official name "Wukong" (awareness of emptiness). It was due to Bodhi that he learned about shape-shifting (also known as the seventy-two transformations) and cloud-traveling. He wielded the golden band as his weapon, which used to be the pillar to pacify the Eastern Seas. It could change its size according to the whim of its owner, from that of a sewing needle or something hardly visible to a pillar that could connect the thirty-third layer of heaven and the eighteenth layer of hell. He was also able to travel 108,000 *li* in one somersault and could recognize evil in any form. He was marked for his courage, and showed no fear when confronting enemies.

I was wowed by the Monkey King, which drove me to learn more about him and reconstruct him in my work in different ways.

Monkey King in My Work

It was out of the intention to give the Monkey King a brand-new look that I have chosen to imagine him as a helmet and weapon bearer, which is my signature. This piece portrays a combat scene between the Monkey King and the Bull Devil. I hope people are impressed with its originality.

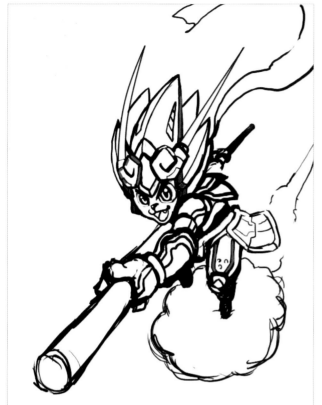

Step 1: I stretched out the composition of the picture.

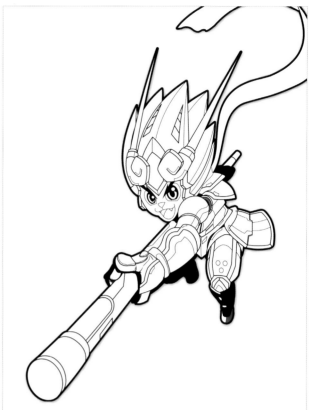

Step 2: I finished the stretch by adjusting the anatomy and details.

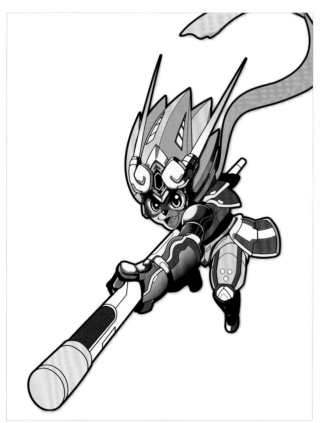

Step 3: I drew some body details in color.

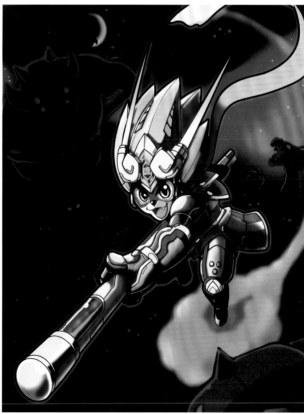

Step 4: I added light and texts.

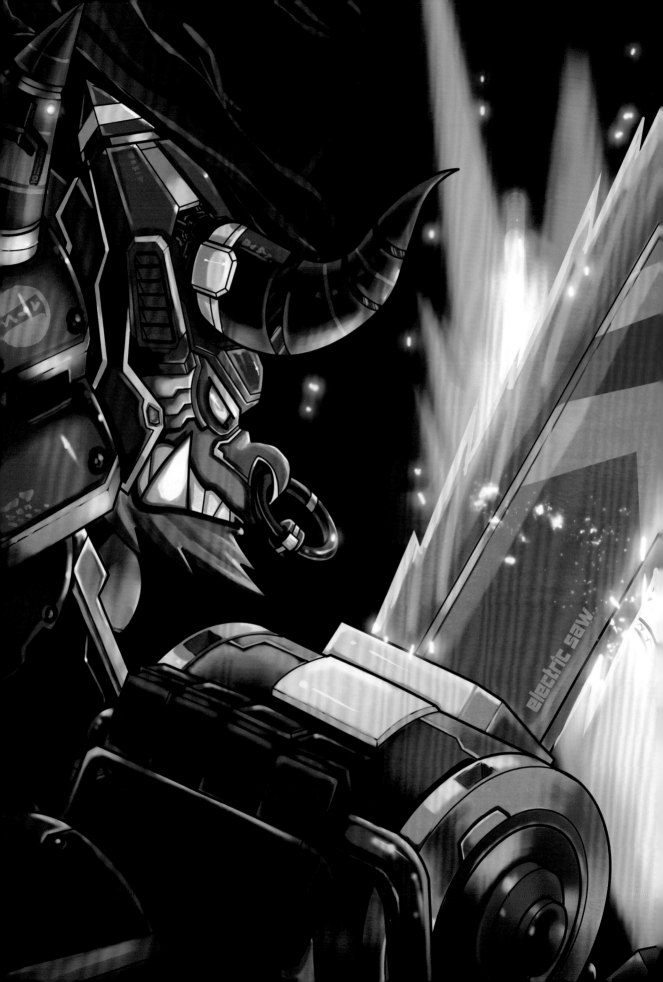

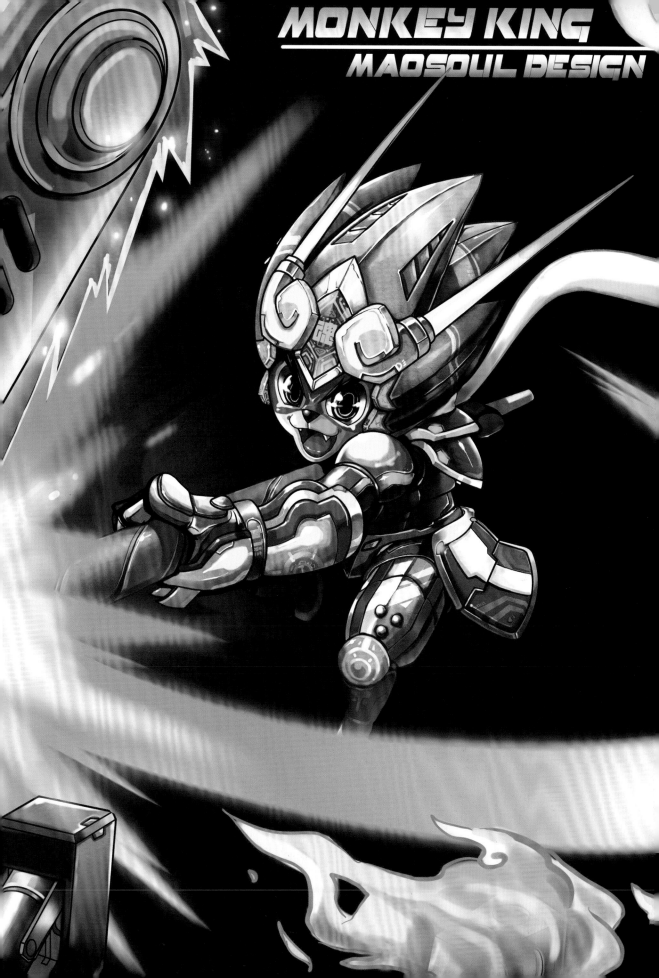

Zhao Kangkang

Screen Name_**MR.K** Profession_**concept designerr**

Zhao loves painting a lot. The margins in all his textbooks are filled with illustrations. Drawing in a passionate way has always been his pursuit. (he's a sentimental and optimistic soldier who loves arts.)

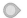 http://blog.sina.com.cn/WarBanner zk_work@163.com

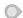 Monkey King in My Eyes

The Monkey King might be the most controversial character in *Journey to the West*. He was a mixture of righteousness and ill virtue in the very beginning but converted to a determined fighter to safeguard justice. His conversion indicated that he was a sensible figure. Ever since I saw the Monkey King on TV in my childhood, his image has been deeply rooted in my mind. However, it was not until the recent years that I finally came to the understanding that the Monkey King is more than a fictional character. He is an exemplification of certain spirits—unyielding, defiant, and righteous; he would sacrifice anything for freedom and never give up. In fact, every one of us has a Monkey King of our own in our mind.

Monkey King in My Work

I have drawn some illustrations on the Monkey King before. But all of them were based on the TV Series *Journey to the West* or the cartoon *Havoc in Heaven*. There was seldom something original.

In the beginning, I intended to create an undisciplined Monkey King as an incarnation of masculine prowess. This is a natural response of a male artist. This Monkey King represents what I want to be at the bottom of my heart.

Later, I considered another concept in order to make a breakthrough. This Monkey King shares little in common with real monkeys, especially in his countenance. This approach is intended to highlight how ruthless he is when confronted with enemies. Therefore, this Monkey King is both fierce-looking and muscular (which aligns with my understanding of masculinity). Besides, I gave him some modern elements, something typical of the twenty-first century. Finally, the draft is finished.

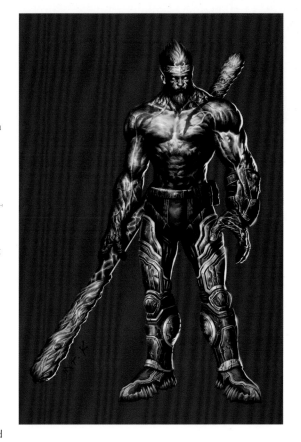

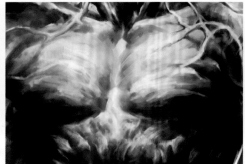

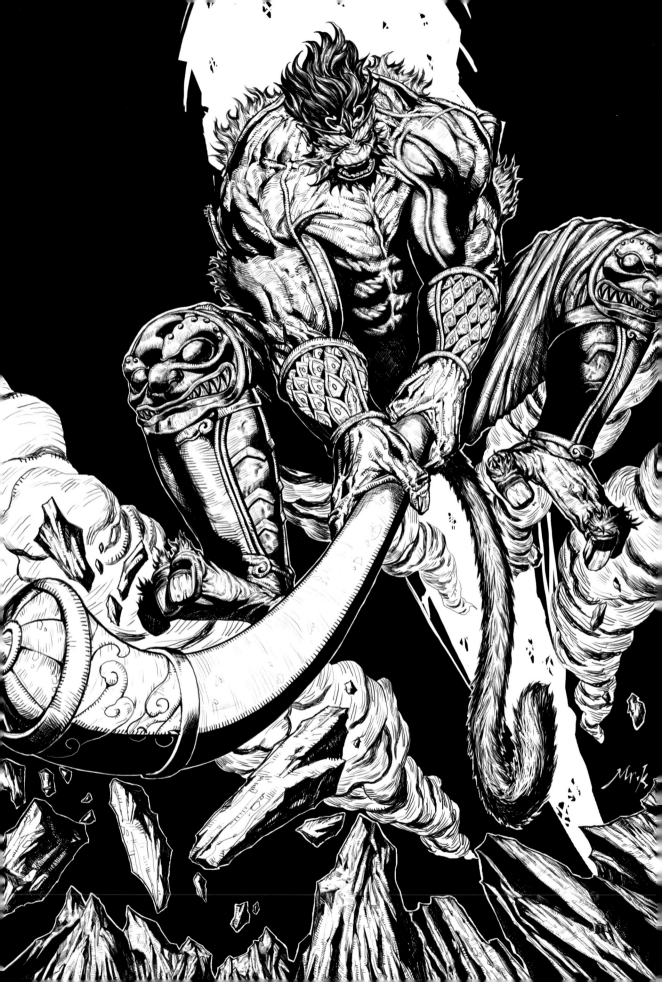

69

Zhao Qing

Screen Name_**Little Q** Profession_**designer**

Zhao's works touch upon graphic design, illustration, music, and motion graphics, and have been published in various magazines at home and abroad.

http://cargocollective.com/dearqqzhao dearqqzhao@hotmail.com

72 TRANSFORMATION MONKEYS

Monkey King in My Eyes

The Monkey King who was born out of a magical rock is a household name for our generation.

He is brilliant and rebellious and never yields to the suppressions and restrictions of the powerful authority; he is undisciplined but reserves a benevolent and sincere heart. On his journey to the west, he has never hurt or bullied the impoverished and the underprivileged.

This character impresses me as someone who is always actively pursuing his ideals. He claims to be the "Great Sage, Equal of Heaven," which has evidenced that he does not gain the status and honor for nothing. He has earned them through his own efforts. He likes freedom. Even the Heaven Emperor has no way to subdue him.

Monkey King in My Work

On his journey to India to retrieve the sutras, the Monkey King has confronted the obstructions of various evil spirits. However, each time he will succeed in defeating them with his strength and intelligence. His competence to perform the seventy-two transformations can always be at work. He will turn himself into the demon's family to know the secrets concerning how to subdue his rival, or into a mosquito or fly to slip into the demons' cave and spy on his rival, or break into the demon's body to coerce him into surrender. In a word, he knows so many tricks that can always take the demons by surprise and make them tremble with fear.

Therefore, when working on the "Seventy-two Transformations" project, I planned to highlight his indefinite shape-shifting powers through application of certain expressive techniques. I drew the original draft on paper, and then manipulated the draft after scanning it into computer. After applying the base color, I went through the coloring process again to create a sense of volume. I produced two color schemes. The final is just what you see. The monkey's face consists of various faces, just like various transformations that the Monkey King is capable of.

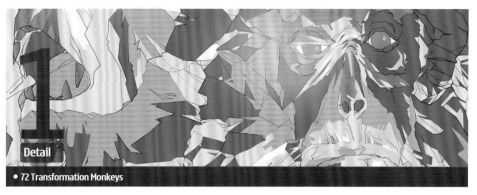

1 Detail

● 72 Transformation Monkeys

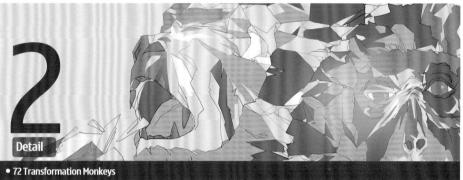

2 Detail

● 72 Transformation Monkeys

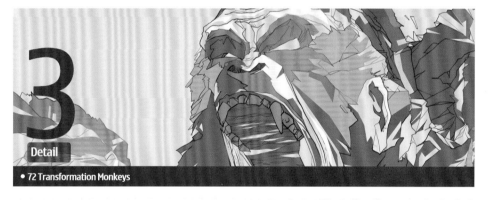

3 Detail

● 72 Transformation Monkeys

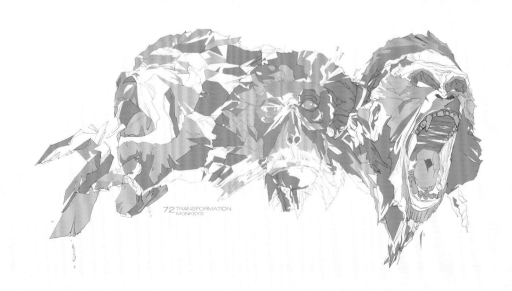

72 TRANSFORMATION MONKEYS

Zhao Yan

Screen Name_**Echo-CS** Profession_**game design artist and illustrator**

Zhao loves drawing, music, and *World of Warcraft*. He is a determined advocate for freedom and world peace. Up to now, he has been earnestly dreaming of finding a Shangri-la to live a cozy and carefree life.

70

http://t.sina.com.cn/echo820922 echogigi@gmail.com

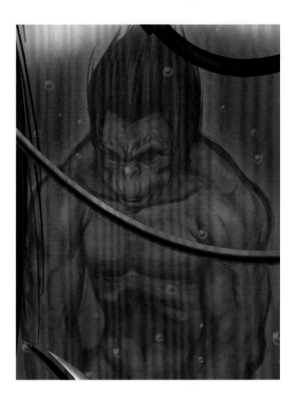

Monkey King in My Eyes

The TV series *Journey to the West,* which was popular in the 1980s, made up an enduring childhood memory for me. I liked watching the Monkey King performing the seventy-two transformations or cloud-somersault. It was so cool. Even now, I still imagine myself traveling on cloud, covering thousands of miles in a single flip, and arriving at my destinations in a flash. To me, one of the most impressive scenes in *Journey to the West* is about the real Monkey King and the fake one—six-ear mud monkey. Frankly speaking, I always feel panicked at the thought of this episode. It strikes fear into my heart to think about someone looking exactly the same as me living my life, while I'm about to fade in others' memory… it is so terrible!

Monkey King in My Work

After turning eighteen, the Monkey King has to confront something that is originally alien to him, such as duplicity, insidiousness, and beguilement. In order to fit into the society, he has to cater to others rather than escape. Therefore, at the ceremony signifying his passage into adulthood, he wore a mask to hide his true self from others so that he will not get easily hurt. The notion of duplicity is based on the assumption that the Monkey King himself is an emblem of unrestrained pursuit of freedom. He will not hold back from exhibiting his love and hatred or showing others what he truly is. In other words, the Monkey King stands for someone everyone of us wants to be—a true self.

In the picture, the Monkey King and the six-eared mud monkey are seated in a certain container, which is connected to a machine that can distill his true and fake properties. All these properties will be later infused into the mask. Her eyes glitter with a mixture of innocence and panic. Handcuffed, she has no way to escape from this ceremony of adulthood or from entering into this unknown adult world.

I named the picture *Adult Ceremony.*

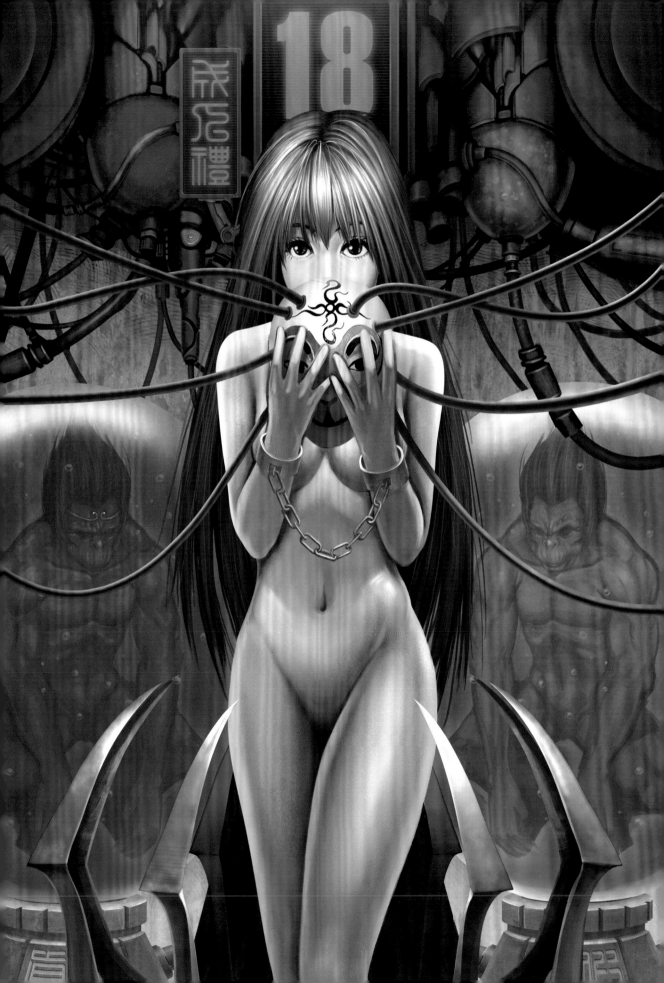

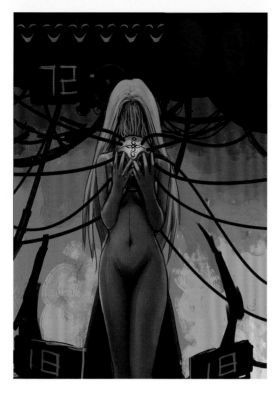

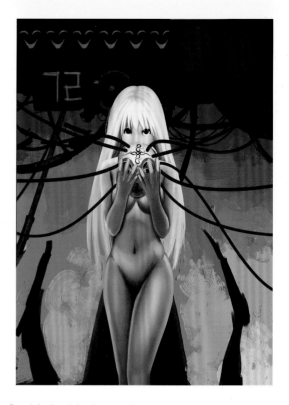

Step 1: At first, I merely wanted to draw a mask for the Monkey King, without thinking too much about the two monkeys. Therefore, they were not shown on this draft. I also wanted to attach the mask with many tentacles, which will then cling to the face. However, I found them too repulsive later and thus gave up.

Step 2: I colored the characters in a rough way and gave it light and shadow. Frankly speaking, I preferred such expressions in the eye, which seemed more emotionally provocative.

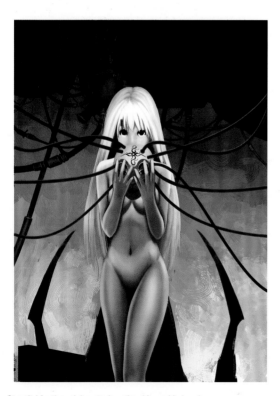

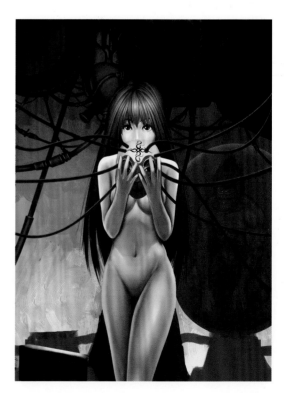

Step 3: I further elaborated on the skin and hair color.

Step 4: I roughly bottomed the background and made revisions to the machine above. I had planned to draw various facial expressions on the screen. However, I rejected this concept later, because it seemed unnecessarily complicated. At this step, I started to include the real and fake Monkey Kings in the background.

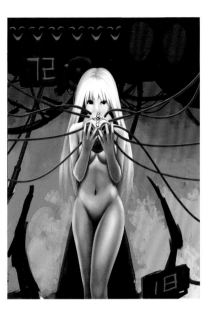

Step 5: I had intended to color the hair yellow. However, I found that she would look better with darker hair. Therefore, I started to work on the characters in a detailed way.

Step 6: I elaborated on the facial expressions and the Golden Hoop to distinguish the real Monkey King from the counterfeit.

Step 7: I made further distinction between the real and fake Monkey Kings by using different colors. There was number "18" on the screen to indicate that this was a ceremony of passage into adulthood.

Step 8: I further elaborated on the machine and the background.

Step 9: I adjusted the size and position of the characters and the overall tone. I gave her a pair of handcuffs to imply that she has no escape from his fate. I added some textures to make the picture more detailed and diversified. OK. I have got what I want. Mission accomplished!

Zhou Xiangjun

Screen Name_**Liyue** Profession_**game keyframer**

Zhou is an E.T. with an attachment to the Earth.

🅮 **http://blog.sina.com.cn/foxliyue** ✉ **zhouxiangjun@kingsoft.com**

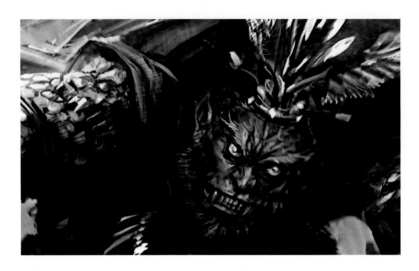

Monkey King in My Eyes

To me, the image of the Monkey King is not unified. Actually, I would prefer to consider him as two separate persons, rather than one individual. His meeting with the Buddha is so meaningful that it divides his whole life into two distinctive parts.

I prefer the one who is arrogant and unyielding, wonderfully shrewd, and courageous enough to defy the authorities, challenging various established powers. He is more an expression of rebellious nature inherent in every-one than a fictional character. There never existed such a creature like him. He is born to smash conventions.

I believe that there is a Monkey King in everyone's heart, while my Monkey King will make the conventional and the divine tremble all over. He is more like a demon evolving from darkness. Even thinking of his name would make the so-called divines toss and turn in bed, unable to fall asleep. He is self-proclaimed as the "Great Sage, Equal of Heaven." How arrogant and self-engrossed!

Monkey King in My Work

I intend to illustrate the Monkey King appearing in the nightmare of the divine and the devil. I want to scare the shit out of them even at the thought of this image. The Great Sage with the fiery eyes and golden gaze does not belong to the three realms (heaven, earth, and hell), or the five elements. He is carrying an intimidating air, spurring the gods and demons in their dreams like a sharp thorn. Haha!

Something bothers me most in the phase of motion design. According to the original fiction, the almighty monkey was born out of a magical stone. Generally speaking, monkeys are crouched and astute in our mind, with a small stature. However, in order to make the picture imposing, the character is supposed to be towering and intimidating, which is the opposite of a typical monkey that has a small stature. Thus, I found myself in a dilemma. Fortunately, the Japanese illustrator Katsuya Terada provided me with inspiration. His work *Monkey King* was based on the *Journey to the West*, while he imagined the Monkey King as a giant ape like King Kong, instead of an ordinary monkey. In this sense, in order to be towering, the Monkey King must be an ape instead of a monkey. Thus, in designing the gesture, I incorporated the ape's characteristics while keeping typical appearances and poses of monkeys, to produce a fierce nightmare for the demons.

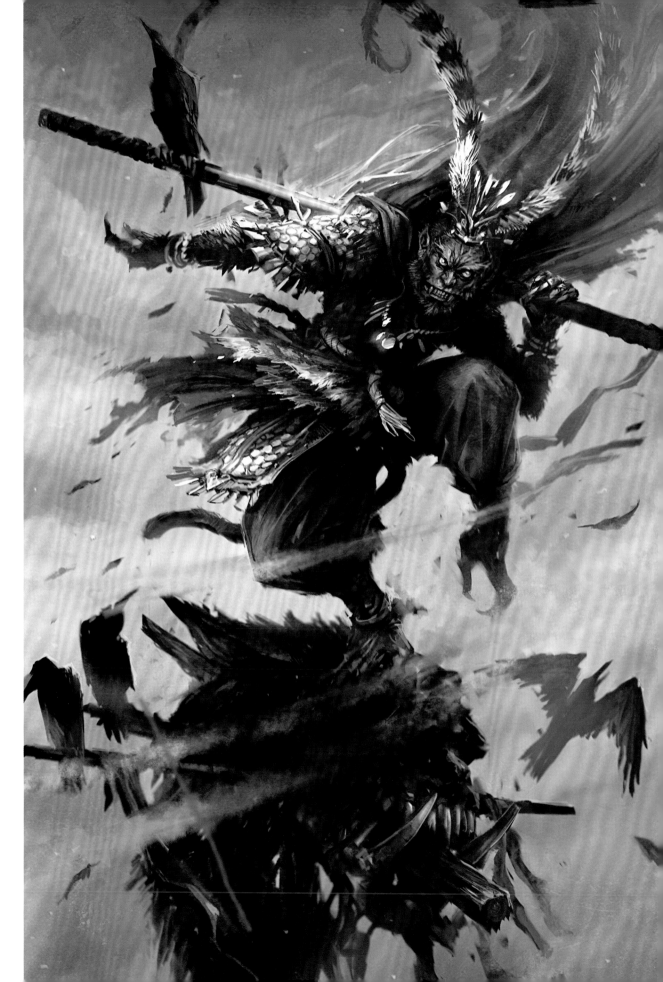

Zong Shu

Screen Name_**zoezong** Profession_**concept artist in the game industry**

Zong's lifetime objective is to create one illustration after another that can amaze and please the audience.

http://shuzong.deviantart.com/ zoe.zong@hotmail.com

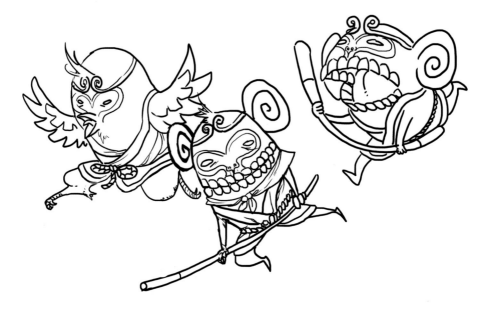

Monkey King in My Eyes

The Monkey King is one of the collective memories in our childhood. Storybooks and storytelling performances based on *Journey to the West* as well as the animation *Havoc in the Heaven* were our company when we were young. Therefore, I felt that the theme of this project is "seventy-two transformations." It is hoped that my Monkey King will bring the audience joy and fun.

Initially, I assumed that the Monkey King can only transform into seventy-two fixed appearances. Later I found it was a serious misunderstanding—seventy-two means "countless" here. Maybe others have already known about it. It was just me who was ignorant. I thought of something interesting. For example, what if the Monkey King transformed into Jedi Knights or Pikachu. If the Monkey King really exists, then he might transform into something more incredible. Thus, I decided to start with some interesting concepts as a warm-up. Haha!

Monkey King in My Work

In this illustration, the Monkey King is flying above a thriving modern cosmopolitan, without being distracted by urban life. He exudes a carefree air, heading for his destination by subduing all the temptations.

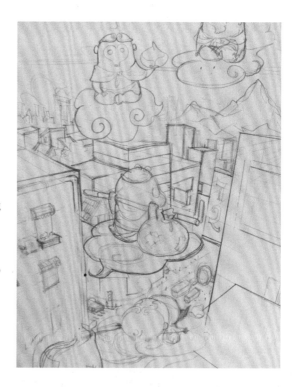

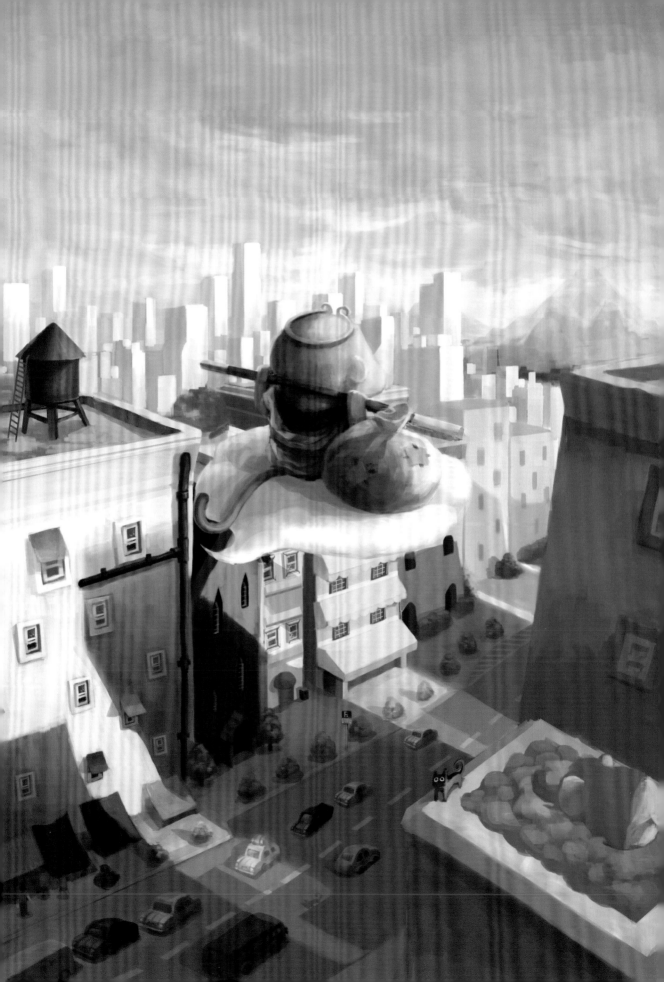

INSIGHT EDITIONS
PO Box 3088
San Rafael, CA 94912
www.insighteditions.com

First published in the United States in 2012 by Insight Editions.
Originally published in the United Kingdom in 2011 by CYPI PRESS.
Copyright © 2011 by China Youth Press, Roaring Lion Media Co., Ltd.,
and CYP International Ltd.

Library of Congress Cataloging-in-Publication Data available.
ISBN: 978-1-60887-117-9

ROOTS of PEACE REPLANTED PAPER
Insight Editions, in association with Roots of Peace, will plant two trees for each tree
used in the manufacturing of this book. Roots of Peace is an internationally renowned
humanitarian organization dedicated to eradicating land mines worldwide and
converting war-torn lands into productive farms and wildlife habitats. Together, we
will plant two million fruit and nut trees in Afghanistan and provide farmers there with
the skills and support necessary for sustainable land use.

Printed in China

10 9 8 7 6 5 4 3 2 1